W9-ATY-477

THE SECRET LANGUAGE OF THE
STARS *and* PLANETS

THE SECRET LANGUAGE OF THE
STARS *and* PLANETS

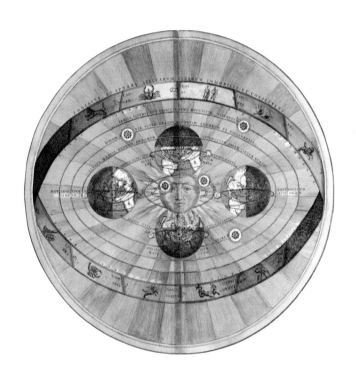

A VISUAL KEY TO THE HEAVENS
GEOFFREY CORNELIUS AND PAUL DEVEREUX

CHRONICLE BOOKS
SAN FRANCISCO

The Secret Language of the Stars and Planets
A Visual Key to the Heavens

First published in the US in 1996 by
Chronicle Books

Copyright © 1996 by Duncan Baird Publishers
Commissioned artwork copyright © 1996 by Duncan Baird Publishers
For copyright of photographs, see page 176 which is to be regarded as an extension of this copyright. All
rights reserved. No part of this book may be reproduced without written permission of the Publisher.

Conceived, Edited and Designed by
Duncan Baird Publishers
Sixth Floor
Castle House
75-76 Wells Street
London W1P 3RE

Editor: *Judy Dean*
Editorial assistant: *Clare Richards*
Designers: *Paul Reid, Jen Harte*
Commissioned artwork: *David Atkinson, Darren Dubicki, Lorraine Harrison*
Picture research: *Jan Croot*
Indexer: *Brian Amos*

Science consultant: Giles Sparrow

Library of Congress Cataloging-in-Publication Data

Devereux. Paul.
 The secret language of the stars and planets: a visual key to the heavens / by Paul Devereux and
Geoffrey Cornelius.
 p. cm.
 Also published in England as: The secret language of the stars and planets.
 Includes bibliographical references and index.
 ISBN 0-8118-1225-1. -- ISBN 0-8118-1200-6 (pbk.)
 1. Astrology. 2. Astronomy, Ancient. 3. Sacred space. 4. Constellations. I. Cornelius, Geoffrey.
II. Title.
BF1711.D46 1996
133.5--dc20

 95-23316
 CIP

Typeset in Ehrhardt MT
Colour reproduction by Colourscan, Singapore
Printed in Singapore

Distributed in Canada by
Raincoast Books
8680 Cambie Street
Vancouver, B.C., V6P 6M9

2 4 6 8 10 9 7 5 3 1

Chronicle Books
275 Fifth Street
San Francisco, CA 94103

These symbols are the sigils representing the zodiacal constellations (above) and the Sun, Moon and planets (below). They are derived, in part, from glyphs found on ancient stone reliefs and Egyptian papyruses.

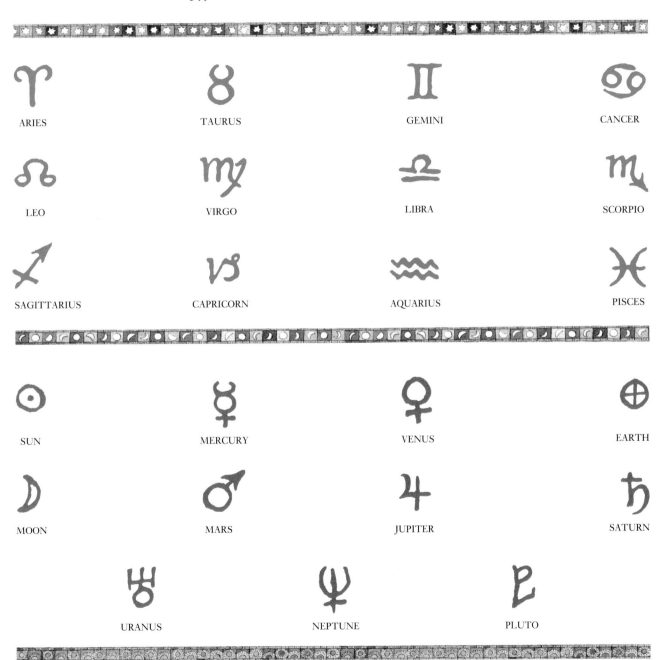

ARIES

TAURUS

GEMINI

CANCER

LEO

VIRGO

LIBRA

SCORPIO

SAGITTARIUS

CAPRICORN

AQUARIUS

PISCES

SUN

MERCURY

VENUS

EARTH

MOON

MARS

JUPITER

SATURN

URANUS

NEPTUNE

PLUTO

CONTENTS

INTRODUCTION

This book begins with an illustrated account, for the lay reader, of those key aspects of astronomy, and of the technicalities of the zodiac, that are most useful in helping us to understand celestial lore. The language of the stars and planets is also the language of humankind's attempts, in different cultures across the world, to construct a worldview that defines our place within an ordered cosmos: this is the subject of the second chapter, "The Grand Design". A parallel theme is the evolving relationship between the skies and the realm in which we live – a thread traced in the third chapter, "Correspondences", which looks at divination, astrology (including the Chinese tradition), and the interpretation of celestial symbolism and myth in terms of archetypes. The two Visual Directories, on the "Sun, Moon and Planets" and on the "Constellations", narrow the focus by looking at the symbolic associations that have clustered around some of the most significant individual celestial bodies and star-groups. Finally, in "Sacred Alignments", our attention shifts to monuments and architectural sites around the world that show evidence of a profound impulse in the remote past to trace connections, probably for ritual purposes, between the earthly and heavenly realms – to make sightlines to the Sun, Moon and stars at special times of the year. These sites are symbols in stone of the correspondence between the Earth and the heavens.

A NOTE ON STAR NAMES

The star maps on pp.76–109 of this book follow the astronomical convention of naming the stars of any constellation according to the letters of the Greek alphabet: in most cases *alpha* is the brightest star, *beta* the next brightest and so on. The following table gives the letters of the Greek alphabet alongside their spelled-out equivalents.

THE GREEK ALPHABET

α	alpha	ι	iota	ρ	rho
β	beta	κ	kappa	σ	sigma
γ	gamma	λ	lambda	τ	tau
δ	delta	μ	mu	υ	upsilon
ε	epsilon	ν	nu	φ	phi
ζ	zeta	ξ	xi	χ	chi
η	eta	ο	omicron	ψ	psi
θ	theta	π	pi	ω	omega

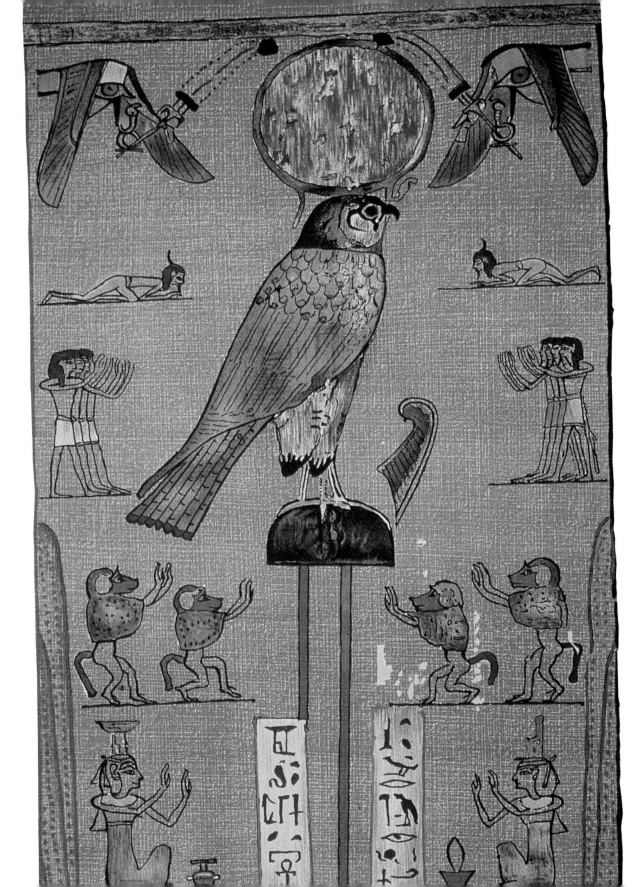

THE SCIENCE OF
THE SKIES

The symbolic associations of the heavenly bodies, and the skies in which they swim, cannot be understood without reference to astronomy. Eclipses, the phases of the Moon, the zodiac, key dates in the year such as the spring (vernal) and autumn equinoxes and the summer and winter solstices, and the whole notion of the great ages, including our entry into the Age of Aquarius, reflect the vast machine of the Earth, Sun, Moon, planets and constellations, all changing their relative positions in complex ways that night by night, month by month, year by year affect what we see in the skies from our terrestrial viewpoint.

Right: This instrument, dating from the 19th century, is an orrery – a mechanical model of the Solar System used to replicate the comparative orbits of the planets around the Sun. The device is thought to have been invented in the mid-18th century by Charles Boyle, 4th Earl of Orrery (Ireland).

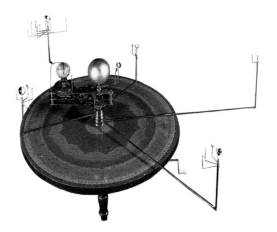

A diagram of c.1543, showing the band of the zodiac around the successive orbits of the "ancient" planets (the modern planets Uranus, Neptune and Pluto were not known at this time). Such a Sun-centred view of the Solar System would have been unthinkable before 1510 when the Polish astronomer Nicolaus Copernicus first put forward the idea that the Earth was not at the centre, as had previously been thought.

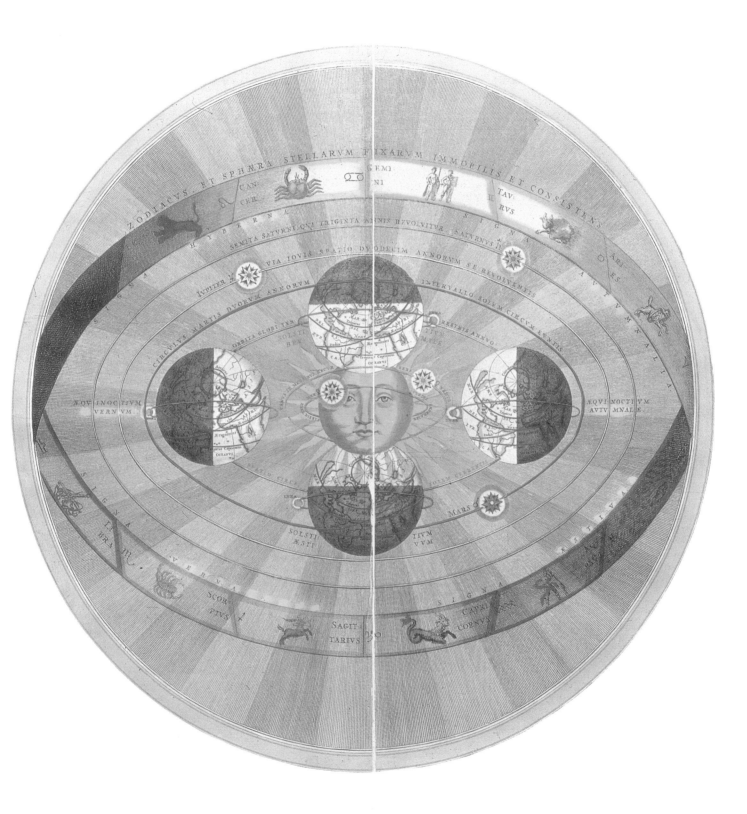

THE EARTH AND SUN 1

The Sun, the brilliant, fiery star
at the heart of our Solar System,
controls not only night and day, but
also the length of the seasons, and our
measurement of time. It is little wonder that the
Sun was so important to the ancients, who celebrated its daily
and annual motions in various types of sacred architecture
around the world.

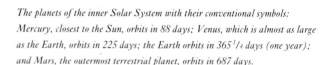

In fact, the Sun does not move at all – its apparent motions
are the result of the Earth's movements shifting our point of
view. The Earth is one of four rocky, "terrestrial" worlds (the
others are Mercury, Venus and Mars) in the inner Solar
System, all of which orbit the Sun counterclockwise. The
Earth orbits at an average distance of 93 million miles (150 mil-
lion km) from the Sun, rotating on its own axis once a day, and
completing a full orbit in 365¼ days, our solar year: the quar-
ter days add up to make a leap day every fourth year.

The planets of the inner Solar System with their conventional symbols:
Mercury, closest to the Sun, orbits in 88 days; Venus, which is almost as large
as the Earth, orbits in 225 days; the Earth orbits in 365 ¼ days (one year);
and Mars, the outermost terrestrial planet, orbits in 687 days.

The imaginary flat disk centred on the Sun and passing
through the Earth's orbit is called the "ecliptic"; this is also
the plane of the Solar System on which all the planets orbit the
Sun. From the viewpoint of the Earth, the ecliptic is the path
traced by the Sun as it travels around the sky. Most of the
other planets' orbits lie close to this plane, so that from the
Earth these planets too seem near the ecliptic.

Over the course of one day, the Earth moves only a short
distance along its year-long orbit, so that in this respect from
one day to the next the Sun rises and sets in almost the
same position. As the Earth rotates on its own axis,
any particular point on its surface will turn to
face the Sun and then turn to face away
from it (day and night respectively). To
an Earth-bound observer anywhere on
the planet, the Sun appears to be cir-
cling the Earth, rising in the east and
setting in the west.

However, the Sun does not sim-
ply repeat the same circle in the sky

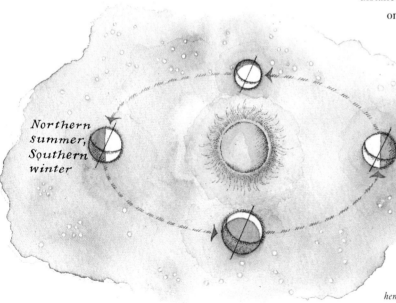

Northern
summer,
Southern
winter

Northern
winter,
Southern
summer

As the Earth moves around the Sun in one year, its
axis of rotation remains pointing in the same direction.
For half the year, the Northern hemisphere is tipped toward
the Sun; while for the other half of the year, the Southern
hemisphere receives more sunlight. This is the basis of the seasons.

North Pole

Tropic of Cancer (+23½°)

23½°

Equator

Tropic of Capricorn (-23½°)

43°

Light from Sun

90°

South Pole

At noon on midsummer's day in the Southern hemisphere, the Sun is overhead to a viewer on the Tropic of Capricorn. At the same time in the Northern hemisphere, a viewer on the Tropic of Cancer sees the Sun rise to only 43° above the horizon. Because it is so far away, the Sun seems to be in the same direction for both viewers.

day after day. In the winter, it stays close to the horizon, even when highest in the sky at midday, while in the summer it passes high overhead.

The seasons arise because the orientation of the Earth toward the Sun changes during the Earth's orbit. The Earth's axis of rotation (the imaginary line through the Earth joining the North and South Poles) is tilted at 23.5° from the "upright" (perpendicular to the ecliptic), causing the Earth to move around its axis like a spinning-top about to topple over. This axis is effectively "fixed": it always points in the same direction. When the North Pole points toward the Sun (that is, the Northern hemisphere is angled sunward), the Sun appears higher above the horizon: this is Northern summer. On June 21 every year the tilt of the Northern hemisphere toward the Sun is at its most extreme: this is the summer solstice, when the Sun reaches its highest point in the sky on the longest day of the year (midsummer). Simultaneously, in the Southern hemisphere (angled away from the Sun), it is the winter solstice and the shortest day of the year (midwinter). Six months later (December 21) the situation is reversed.

Between the solstices lie two occasions in the year on which the length of day and the length of night in both hemispheres are equal – the equinoxes. At the spring (vernal) equinox in one hemisphere, it is the autumnal equinox in the other.

THE EARTH AND SUN 2

For an observer on the Earth, our planet's yearly orbit around the Sun translates into cycles of (apparent) movement manifested by the objects in the sky. Although we now know our true place in the universe as a small planet orbiting a single star in a single galaxy, astronomers still use, for navigating their way around the sky, the ancient idea of a "Celestial Sphere" (see diagram, p.22) on which all the objects in the sky are projected, with the Earth at its centre. This sphere is an extension of the Earth's surface into the sky. As the Earth spins on its axis, any point on the Celestial Sphere follows a circular path in the sky, around the North or South Celestial Pole. Dividing the sky into hemispheres creates an imaginary line separating its northern and southern halves; this is the celestial equator – an extension of the Earth's equator into space.

Our view of this Celestial Sphere is largely dependent on our position on the Earth's surface. At the Earth's North Pole,

Opposite: The changing path of the Sun through its yearly (apparent) motion for the latitude of Stonehenge (51°N). The sunrise and sunset points (measured as "azimuths": see diagram below) are closer to the north in summer and to the south in winter. The illustration also shows how the Sun is highest in the sky in midsummer, and how it rises due east at the equinoxes.

the North Celestial Pole lies directly overhead (that is, at the "zenith", the point on the Celestial Sphere directly above an observer), while at the South Pole the South Celestial Pole is at this point. At the terrestrial equator, the celestial equator passes overhead, and the sky rotates around the North and South Celestial Poles on opposite sides of the horizon.

The tilt of the Earth's polar axis to the plane of the Solar System, the eliptic, means that this plane is angled at 23.5° to the celestial equator. Therefore, for half its annual (apparent) path around the ecliptic, the Sun lies in the Southern hemisphere of the sky, and for the other half, in the Northern. The point where the Sun's path crosses the equator into the Northern hemisphere marks the beginning of Northern spring, known as the spring (vernal) equinox, or the "First Point of Aries". Since the celestial equator always crosses the

The chart shows the rising and setting azimuths (the direction along the horizon) of the Sun at the solstices and equinoxes at the latitude of Stonehenge (51°N). Azimuth is measured from 0° to 360° around the horizon. North to east is 90°, south is 180°, and west is 270°.

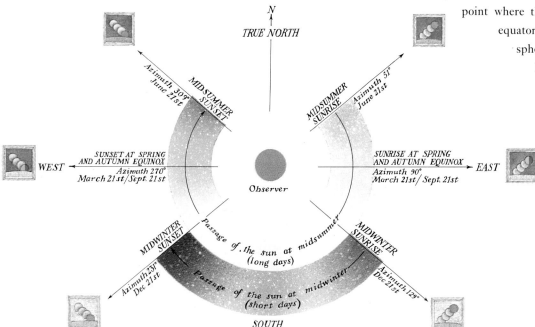

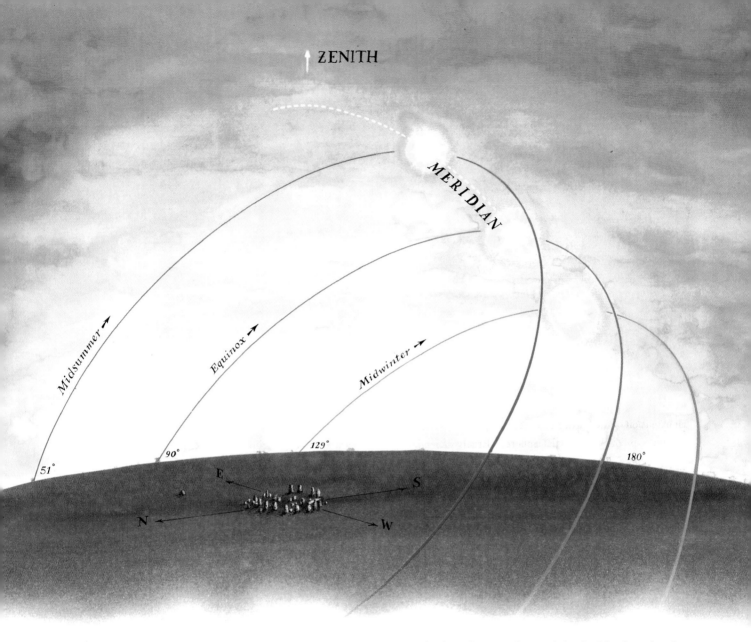

ZENITH

MERIDIAN

Midsummer

Equinox

Midwinter

51°

90°

129°

180°

E

N

S

W

sky at the same height for any particular latitude, the Sun will sometimes cross the sky below the celestial equator, and sometimes above it. The highest point in the Sun's daily path is when it crosses the line that runs from the zenith to due south: the "meridian" (see illustration above). Local midday at any particular location is when the Sun crosses the meridian.

Objects on the celestial equator rise due east and set due west, and this is true of the Sun at the equinoxes (when day and night are equal). When the Sun is south of the celestial

equator, it rises closer to the south in the Northern hemisphere, and the days are shorter. At the poles, the Sun, once it is in the opposite hemisphere of the sky, cannot be seen, and the winter darkness lasts for six months.

Thus, the Sun's motions in the sky relative to the celestial equator can be tracked by its rising and setting positions on the horizon. Ancient observatories used this principle to monitor the seasons, most obviously marking the extreme northern and southern sunrise and sunset points at the solstices.

THE MOON 1

The Moon is the Earth's only natural satellite, a rocky body a quarter the size of our planet. It orbits at an average distance of only a quarter of a million miles (400 thousand km), and so seems large in the sky. Its pull on the Earth, together with the Sun's, is responsible for our daily tides. The gravitational forces exerted by the Earth and the Sun have slowed the Moon's rotation so that it now matches its orbital period, and only one hemisphere of the Moon ever faces the Earth. By another remarkable coincidence, from the Earth the Moon's size and distance make it seem the same size as the Sun. This leads to spectacular eclipses that must have seemed even more magical centuries ago – it is little wonder that the ancients were interested in studying the Moon's complex movements. In fact, the Moon has a much more complicated cycle than the Sun (see pp.12–15), taking 18.6 years to complete.

Perhaps the most obvious feature of the Moon is its phases, which change over a 29½-day period. In this time, the satellite swells from a New Moon, through a crescent, to first quarter, "gibbous", and then Full, before shrinking back to New. However, the Moon has no light of its own, and shines only by reflecting sunlight from its hemisphere that faces toward the Sun. Over the course of a month, the Moon's orbit takes it from a position between us and the Sun, with light

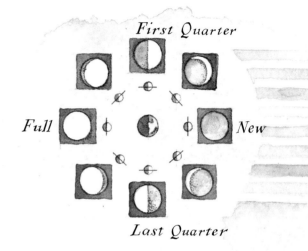

First Quarter

Full

New

Last Quarter

Above: *The lunar phases are caused by the changing proportion of the sunlit side that we see as the Moon orbits around us. The red lines on this diagram mark the Earth-facing hemispheres, but the amount of illumination on this side changes throughout the month, to create the phases shown.*

Below: *Eclipses occur only when the Moon lies on the ecliptic, which happens twice in each orbit. In a solar eclipse, the Moon's shadow on the Earth is quite small, and so limits the area on the Earth from which the eclipse can be seen; but in a lunar eclipse the Earth's shadow is much wider and thousands of miles long, so the Moon can be eclipsed for much longer periods over a larger area.*

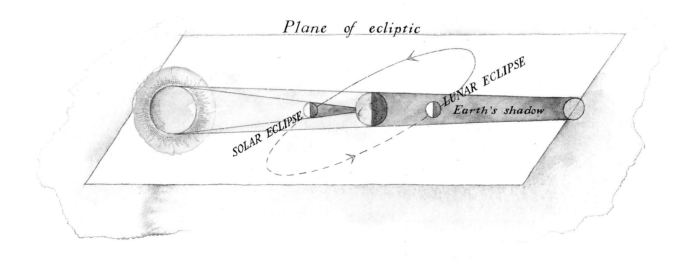

Plane of ecliptic

SOLAR ECLIPSE

LUNAR ECLIPSE

Earth's shadow

shining only on the side facing away from us – a New Moon – to being opposite the Sun in the sky, so that we can see the Earth-facing hemisphere fully illuminated. The crescent Moon's dark regions can sometimes be seen to glow faintly – a phenomenon known as "Earthlight", caused by sunlight reflected back from the Earth's clouds and oceans. In later phases this effect is "drowned" by the greater brightness of the sunlit surface.

From the Earth the Moon's features, caused by impact craters and planes of solidified lava, appear to change every night as the angle of illumination changes. Shadows are strongest at first and last quarter, while the Full Moon can appear "washed out" by direct sunlight. The Moon's appearance alters so rapidly that the aspect of mutability has entered lunar symbolism in many different cultures (see pp.59–61).

The 29½-day period in which the Moon's phases complete a full cycle is slightly longer than its orbital period, as the Moon has to "catch up" with the apparent distance travelled by the Sun before each New Moon can occur. Most of the time when the Earth, Moon and Sun are aligned (at New and Full Moons), the Moon is either above or below the Earth-Sun plane: its orbit is tilted at 5.2° to the ecliptic. Twice in each orbit the Moon lies on the ecliptic, at points called the "nodes". If a New or Full Moon crosses a node, an eclipse will occur.

The solar eclipse, when the New Moon passes directly in front of the Sun's disk, is the most impressive. The Moon casts a con-

ical shadow toward the Earth's surface, where it sweeps across a relatively small area, plunging day into night, and allowing sightings of the Sun's fiery halo, as the Moon blocks out the intense brightness of the solar disk. Less spectacular are annular eclipses, where the Moon is at the outer reaches of its orbit, and just too small to cover the disk completely, creating a "ring" effect. Lunar eclipses, when the Full Moon, crossing a node, passes into the Earth's shadow, are more widely seen. They last longer, owing to the larger size of the Earth's shadow, but the Earth's atmosphere can act as a "lens", refracting a dull red light onto the lunar surface, diminishing the effect.

Partial lunar and solar eclipses, where the Moon or Sun is only partly obscured from sight at a given point on the Earth, are more common, but less impressive, than total eclipses, which require a precise alignment. At a total solar eclipse, the central region which falls directly into the shadow will be surrounded by a broader "penumbra" (a ring of paler shadow) where the eclipse is partial.

The Moon's orbit is not a perfect circle, but an ellipse. The inclination of the orbit at 5.2° to the plane of the ecliptic means that the Moon spends most of its orbit above or below this Earth-Sun plane. The points where it crosses the ecliptic are the ascending and descending nodes; the line through the Earth linking them is the "line of nodes".

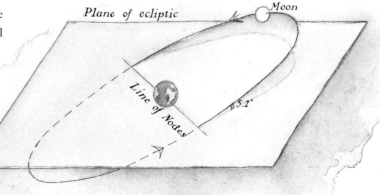

Plane of ecliptic

Moon

Line of Nodes

5.2°

THE MOON 2

The Moon orbits the Earth once every 27⅓ days, and we have already seen (pp.16–17) how this causes the appearance of the different phases as the satellite is illuminated by light from the Sun. However, the Moon's path through the sky changes each month, in a complex cycle which takes 18.6 years to complete.

If we could "freeze" the rest of the sky, the Moon's path through a single month would be fairly clear – a full circuit of the sky, with half its orbit below the ecliptic, and half above, appearing at a maximum of 5.2° in either direction. But from our vantage point on the moving Earth, the Moon's movement in the sky is influenced by other factors, which ensure that it does not take the same path across the sky each month.

Because the Earth is inclined at 23.5° to the ecliptic, the Moon shows seasonal variation similar to that of the Sun. This is clear when we remember that, for example, the Full Moon must always be on the opposite side of the sky to the Sun – so

when the Sun sets in the extreme northwest around midsummer, the Full Moon must rise in the southeast. In order to picture the Moon's movements, it often helps to concentrate only on the Full Moon, and to ignore the monthly rotation.

Over a year, then, the successive paths of the Full Moon go from one extreme to the other, always opposing the Sun. In Northern midsummer, the Moon rises in the southeast and sets in the southwest, and hangs low throughout the night, while in midwinter the Moon rises in the northeast and sets in the northwest, when it passes high overhead.

But over a longer period, these extreme southerly and northerly rising points appear to move as well – at one time, the extremes of the Moon's motion are quite close together, and 9.3 years later they are at their widest separation.

This second element of the cycle is due to the fact that the Moon's elliptical orbit revolves around the Earth once every

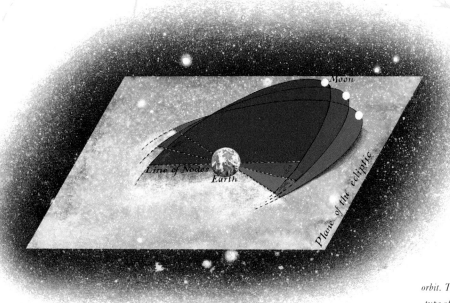

Opposite page: Seen from the ground, the Full Moon's path across the sky shows wide variation through its 18.6-year cycle. At major standstill, it rises at its northernmost extreme in midwinter, and six months later, in midsummer, far to the south. At minor standstill, 9.3 years later, its rising paths are confined to a narrower band in the east. The same principles apply to the setting points.

Left: The gravitational forces of Earth and Sun pull the Moon's orbit around in a circle once every 18.6 years. The Moon's orbit is inclined at 5.2° to the ecliptic, so the line of nodes, joining the two points on the ecliptic where the orbit crosses, also moves around with the orbit. This effect is known as the precession of the nodes. (Another type of precession – that of the equinoxes – is explained on p.23.)

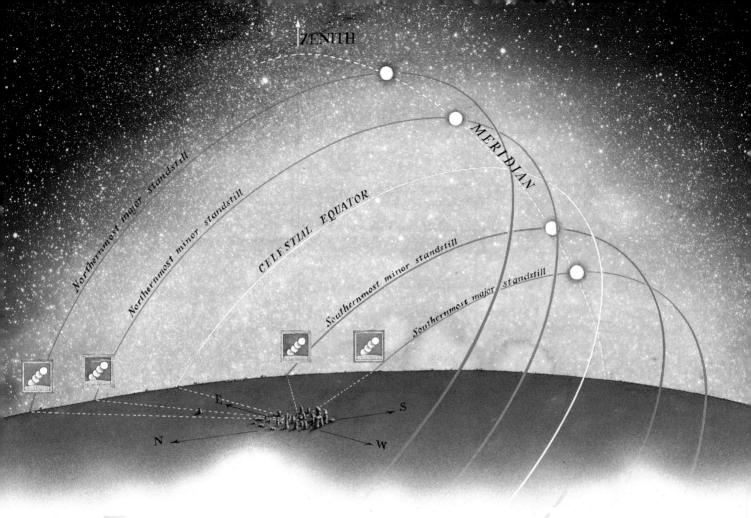

ZENITH

MERIDIAN

Northernmost major standstill

Northernmost minor standstill

CELESTIAL EQUATOR

Southernmost minor standstill

Southernmost major standstill

E

S

N

W

18.6 years. Since the Full Moon has to be on the opposite side of the Earth from the Sun, lying on a short arc perpendicular to the ecliptic, it occurs where this arc intersects with the Moon's orbit. As the orbit revolves, the point of intersection occurs at differing distances from the ecliptic: when the Full Moon is at the outermost point on the elliptical orbit, it is also furthest from the ecliptic (see illustration, opposite page). When this has the effect of exaggerating the seasonal motion of the Moon caused by the Earth's inclination to the ecliptic, a "major standstill" occurs. This moment, when the Moon shows the widest range of motion through the year, is called a standstill for the same reason that the solar solstices are so called ("solstice" means "sun stands still"): the Full Moon's cycle of movements temporarily slows to a halt, before reversing. At the other end of the cycle lies the "minor standstill".

This is when the Full Moon's inclination to the ecliptic acts to "damp out" the oscillation, rather than exaggerating it.

As the Moon's orbit revolves, the line of nodes where it crosses the ecliptic turns as well. We have already seen that eclipses can only occur at a point when the New or Full Moon lies on the line of nodes, so that the motion of this line creates an 18.6-year eclipse cycle. However, because 18.6 years does not include a complete number of lunar months, the Moon will not return to the same point in its orbit until it has gone through three such cycles; hence, there is a longer cycle of just under 56 years.

There is some evidence that ancient astronomers were aware of this eclipse cycle, and constructed calculating machines to keep track of it – an example being the Aubrey holes at Stonehenge in Wiltshire, southern England (see pp.116–17).

THE PLANETS

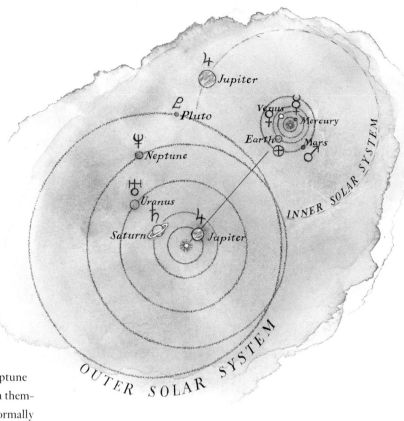

Against the "fixed" background of stars, which rotate across the sky in the same relative positions night after night, ancient astronomers observed the Sun, the Moon, and five "wandering stars", termed planets. Today, these wanderers are named after the Roman gods Mercury, Venus, Mars, Jupiter and Saturn. They move in complex paths across the sky, changing their brightness and appearance, and ever since they were first observed they have been imbued with mystical significance (see pp.54–73).

Today, we know of three more planets, Uranus, Neptune and Pluto, and we understand that all eight are worlds in themselves, fellow members of our Solar System, which is normally divided into two distinct sections. The inner section contains relatively small, rocky worlds – Mercury, Venus, the Earth itself, and Mars. Beyond the asteroid belt (see diagram, this page) that lies between Mars and Jupiter, lie four "gas giant" planets – Jupiter, Saturn, Uranus and Neptune. Pluto, a tiny, rocky world beyond the gas giants, is probably the largest member of another debris belt.

Each of the planets has its own orbital period and characteristics. Mercury and Venus, with orbits smaller than that of the Earth, are often called inferior planets. Their orbital path always lies close to the Sun, so they are usually seen near sunset or sunrise. Venus, the closest planet to the Earth, has a highly reflective atmosphere which makes it the third brightest object in the sky, after the Sun and Moon. Its appearances close to the rising and setting Sun have led to its being known as both the Morning and the Evening Star.

When an inferior planet lines up on the opposite side of the Sun from the Earth, this is known as a superior conjunction; and when an inferior planet lies closest to the Earth, this is an inferior conjunction. Through binoculars, it is possible to see

THE OUTER PLANETS

Jupiter	The largest planet. Orbits the Sun in 11.86 years.
Saturn	Orbits in 29.46 years. Best known for its spectacular rings.
Uranus	Tilted at 98°, it "rolls" around its orbit in 84 years.
Neptune	A small gas giant, similar to Uranus, orbiting in 164.8 years.
Pluto	Orbits in 248.6 years: an elliptical orbit which brings it closer to the Earth than Neptune for a brief period.

The inset shows the inner Solar System, which fits entirely within the asteroid belt (made up of rocky debris from the birth of the Solar System).

that the inferior planets show phases similar to the Moon's. They also pass across the face of the Sun in a similar fashion to the Moon, although their smaller apparent size leads to "transits" (literally, crossings) rather than eclipses.

The superior planets can also come into conjunction, both with each other – at times when they appear to line up in the sky – and with the Sun, which happens when the planet is on the far side of the Sun from us. An "opposition" occurs when the superior planet is at its closest to the Earth and in line

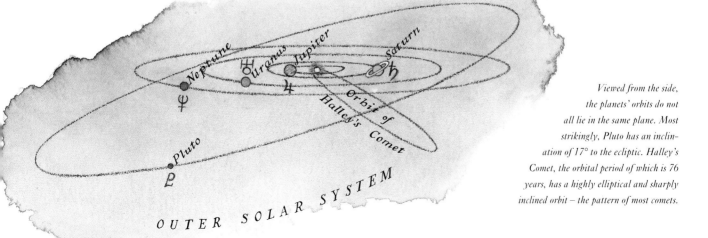

with the Earth and Sun but, unlike in an inferior conjunction, it is on the opposite side of the Earth from the Sun.

One of the most intriguing features of planetary motions is the looping motion that many planets take in the sky as they approach an inferior conjunction or opposition. This complication to the planet's path around the sky in its normal orbital period is caused by a line-of-sight effect as the Earth catches up with the other planet (see diagram, right).

Other celestial objects regarded with awe by the ancients were comets. Brief visitors to the inner Solar System, these apparently fiery bodies are in fact small chunks of rock and ice, their surfaces vaporized by the Sun's heat to create a spectacular "coma" (a cloud of gas and dust surrounding the comet's nucleus) and tail often stretching for millions of miles from a core mass usually only a few miles across.

For the astrology of both China and the Greco-Roman world, the conjunctions of planets, particularly those of Jupiter and Saturn, marked significant changes in Earthly affairs. The theory was developed in Islamic astrology into a sophisticated interpretation of history, accounting for the stories of the Old Testament as well as the rise and fall of world religions.

The apparent backward ("retrograde") motion of some planets is caused by the changing line of sight as the Earth passes close. For example, over the course of its opposition (see opposite page), Mars appears to complete a slow loop against the background stars in the sky.

Viewed from the side, the planets' orbits do not all lie in the same plane. Most strikingly, Pluto has an inclination of 17° to the ecliptic. Halley's Comet, the orbital period of which is 76 years, has a highly elliptical and sharply inclined orbit – the pattern of most comets.

THE STARS

Unlike the Sun, Moon and planets, the stars do not change position noticeably over short periods – except for the apparent motions caused by the Earth's rotation, rising, setting and rotating around the poles. Their locations on the Celestial Sphere can be plotted with remarkable accuracy, and consequently constellations have been used for centuries as stationary markers to chart the motions of other celestial bodies.

Cultures all over the world have identified constellations based upon mythology. The system that we know in Western civilization was formed around the 1st century BC, consisting of 48 constellations, although more have been added since.

The constellations are, in reality, line-of-sight effects – the stars within them are rarely connected in any real way, and can often be many light-years apart from each other.

While the constellations seem to be static, in fact every star moves very slowly. In a few thousand years, most of the patterns now known will have gone. For example, five of the stars in the Plough (Big Dipper) are a joined cluster moving in one direction, while the other two move the opposite way. But in the short term, stars do not seem to change relative positions.

The coordinates of stars are recorded in terms of "declination" (the angle from 0 to 90° above or below the

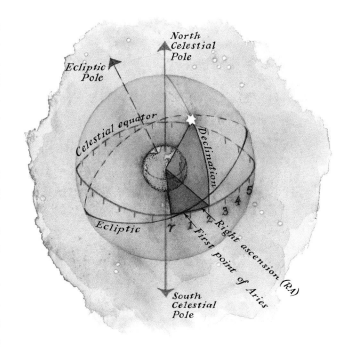

The Celestial Sphere is a projection of the Earth's poles and equator onto the sky. The coordinates of any star are measured in terms of its declination in degrees above or below the celestial equator, and its Right Ascension in time from the First Point of Aries, where the ecliptic crosses the celestial equator.

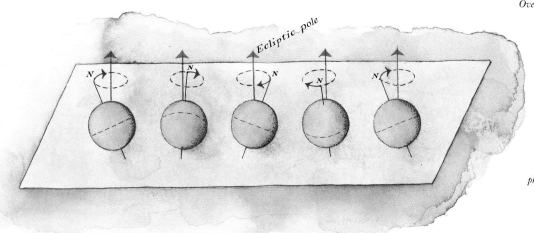

Over 25,800 years, the combined pull of the Moon and Sun acts on the Earth's equator, causing the planet to wobble, as a spinning-top slowly wobbles before it falls over. This means that the pole points to different distant stars during this cycle, although its orientation within the Solar System does not change. The phenomenon is called "precession of the equinoxes" (see pp.36–7).

celestial equator) and "Right Ascension" (RA). RA is the period between the moment when the First Point of Aries (the first house of the zodiac) crosses the meridian and the moment when the object of interest crosses the same point – giving a reading in hours, minutes and seconds, up to 24 hours. The point in the sky with a declination of +90° is the North Celestial Pole, marked by the star Polaris, which lies within half a degree of it: the South Celestial Pole (at -90°) has only the faint star Sigma Octantis to mark it.

Over an extended time-scale the stars do show apparent movements, which are particularly important when we consider how they might have been observed from ancient observatories. Like the paths of the Sun and Moon in the sky, the stars are also affected by the Earth's motions, but over a much longer period. The Earth is tilted at 23.5° to the ecliptic plane, in which the Sun lies, and near which the Moon orbits. The Earth's daily spin causes the fastest-moving regions at the equator to "bulge" outward by 13$\frac{1}{2}$miles (21.5km). The gravitational forces of the Sun and Moon pull on this bulge, causing the Earth's axis of rotation to wobble slowly like a gyroscope, completing a great circle around the "Ecliptic Pole" once every 25,800 years. The North Pole does not change position in relation to the Earth itself (Earth and Pole wobble together): only the direction in which it points changes. So Polaris will not always be the Northern Pole Star – it just happens to lie on the circle of the Pole's motion through the sky. For long periods there is no Pole Star, and once in every cycle the North Pole passes near Vega, one of the brightest stars.

The farther you are from the Pole, the lower the Celestial Pole sinks in the sky (its height above the horizon is equal to the latitude in degrees) and the fewer "circumpolar" stars are visible - that is, those which never set. The illustration shows how at 35° South, when the faint Southern Pole Star lies 35° above the horizon, the Southern Cross is circumpolar, while nearby Gamma Centauri dips just out of view.

Because the Pole is constantly changing, the paths of the stars change slowly too. If Vega is the Pole Star, then the circumpolar stars in the Northern hemisphere will be those in a circle around that star. Some new stars will rise and set, and other familiar stars will rise at different points on the horizon. Because of this effect, termed "precession" of the equinoxes, complicated calculations are required to correct the RA and declination of objects, even over relatively short periods – astronomers have to update their atlases at least every 50 years. Only the apparent motions of Solar System objects are unaffected: because the Earth's inclination to the ecliptic remains a constant 23.5°, the ecliptic is the one fixed line in the sky. When looking back to the earliest astronomy, we must remember that the sky would have been quite different then and its mythology inspired by an ever-changing celestial realm.

23

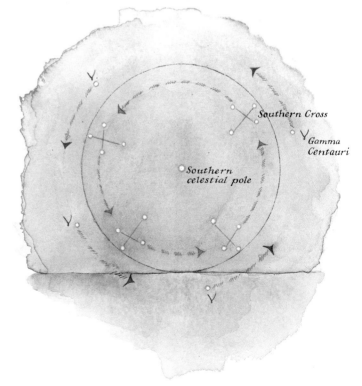

Southern Cross

Gamma Centauri

Southern celestial pole

THE ZODIAC

The Sun, Moon and Planets appear to us to move against the background stars in a very narrow band of sky, because they all orbit on or close to the ecliptic plane. The significant stars around this band are divided into the twelve constellations of the "zodiac", from the Greek for "circle of animals" (Libra, the scales, is the only non-bestial zodiacal constellation). Astronomically there is also a thirteenth zodiacal constellation, Ophiuchus, into which the planets (and the Sun and Moon) also venture; astrologically it is usually ignored (see p.93).

Modern astrology is based on the 2nd century BC writings of the astronomer-astrologer Ptolemy, but its roots go back much further (see pp.44–5). Simplifying the astronomical zodiac, the "houses" (as opposed to the constellations) separate the zodiac's band into equal sectors: the 360° of the sky divide into twelve houses of 30° each.

Opposite: At mid-European latitudes, the zodiac passes high overhead. This illustration shows the zodiacal constellations lying on the ecliptic, between Virgo and Pisces. In terms of the mundane houses, Virgo is in the ascendant, rising in the east, with the autumnal equinox point just on the eastern horizon. Next is Leo, which is in the twelfth house, while Gemini is in the tenth house, or midheaven, high in the south. The First Point of Aries, on the nearside western horizon, is in the seventh house, the descendant. Below this, our perspective view shows the position of Pisces, which is in the sixth house.

When the zodiac was first calculated, the Sun crossed the equator heading northward at the boundary of Aries and Pisces – this point then marked the beginning of Northern spring, and is termed the origin, or First Point, of Aries. Over thousands of years, the precession of the equinoxes has moved this point into the constellation Pisces (see pp.36–7). This has led to a major departure of method between Indian astrology, which has stayed with a fixed zodiac pegged to the actual constellations, and Islamic/European astrology, which moves its zodiac with the spring equinox point. Astrologers themselves suggest that both zodiacs, moving and fixed, have their own relative orders of symbolic truth.

Astrologers also need to measure the relative positions of planets in the sky for a specific location and time. For this, they use twelve "mundane houses", also of 30° each, to mark different directions on the Celestial Sphere as seen from the ground. The first of these mundane houses is the "ascendant" centred around the point to the east where the zodiac rises. The houses are then counted anticlock-

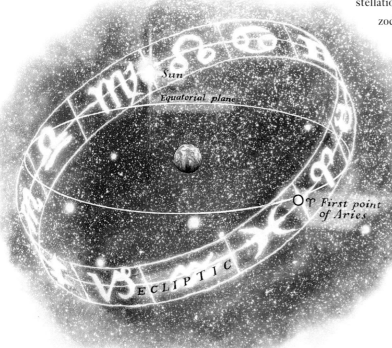

Sun

Equatorial plane

♈ First point of Aries

ECLIPTIC

The zodiac can be imagined as a band encircling the Earth. It is tilted at 23.5° to the celestial equator. The ecliptic runs along its centre. At 0° Aries (now in the constellation Pisces), the Sun's path on the ecliptic crosses the equator heading north. On the opposite side of the zodiac, it crosses back, heading south.

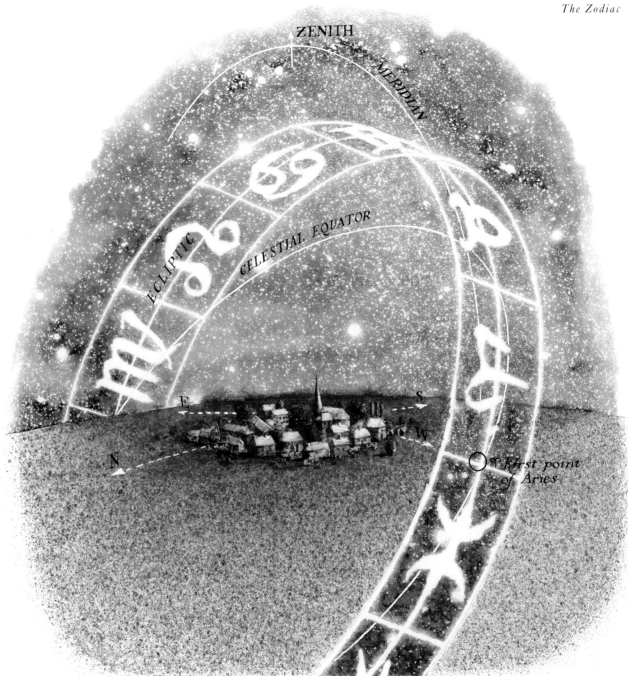

wise around the horizon, dividing the sky into twelve equal segments. So the fourth house lies due north, where the zodiac is lowest. The seventh house, where the zodiacal constellations set, is the "descendant", and the tenth (due south) is the "mid-heaven". Because of the Earth's rotation, the twelve zodiacal constellations circle the sky once every 24 hours, so that each of the planetary houses spends two hours every day passing through each of the mundane houses. By saying, for example, "Mars is in the seventh house", astrologers simply mean that Mars is setting on the western horizon at the time of interest.

THE GRAND DESIGN

In the collective imagination of any culture there is a strong impulse to map the cosmos. The tendency in early civilizations has been to imagine a vertical hierarchy, with mysterious realms above and below the visible. In the West, with the development of scientific knowledge, a spherical conception evolved, and this is reflected today in the way that we imagine the Celestial Sphere (see pp.14 and 22). The power of these ancient images of the cosmos comes from their evocation of subjective human experience. In them resides a poetic vision that strikes our imagination, if not our reason, with the force of a profound truth.

Right: *The Celestial Sphere is an ancient conception that is used even today in positional astronomy to measure and locate objects in the sky. It has a strong poetic appeal, which may reflect the profound human instinct for visualizing a self-contained cosmos. This engraving from an atlas of the heavens (1660) shows the Celestial Sphere with the band of the zodiac and a horizon projected onto the sphere from a location in Europe. Other circles show the equator and the tropics of Cancer and Capricorn.*

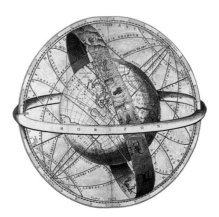

Opposite: *This illustration of c.AD950 refers to the Book of Revelation, 12:1–18. Apocalyptic scenes are played against a background of Earth, Heaven and Hell. The woman "clothed in the Sun" bears a son, whom the dragon tries to devour. God snatches the child to safety. Angels fight the dragon, banishing it to Earth. Here the dragon chases the woman and tries to drown her, but the water is swallowed by the Earth. Finally, the dragon (as Satan, the black figure)and his rebel angels are thrown into Hell.*

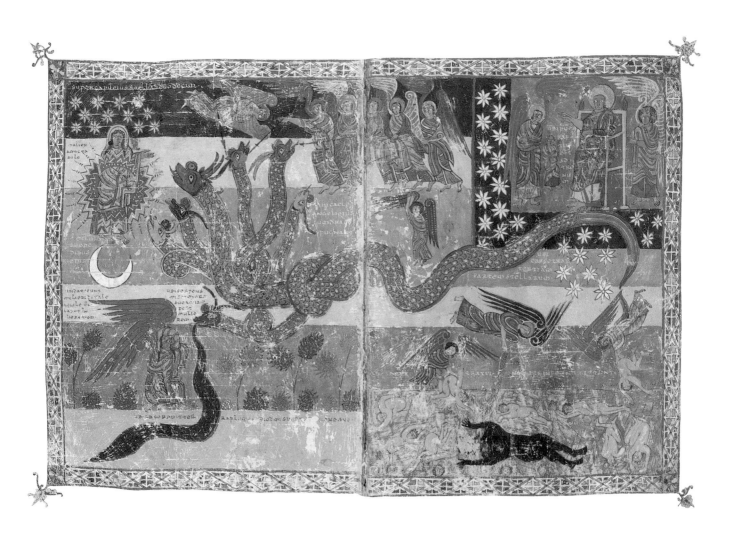

THE EARTH AND SKY

The primordial phenomenon, earth and sky constitute the foundation for our understanding of space and, as a consequence, time and order. The earth on which we live streams in four directions before, behind and at either side of us toward the overarching vault of the sky above: this is how we know space. We experience the alternation of day and night as the Sun rises and sets around us: this is how we know time.

The root myths of all cultures embody cosmogony, a description of the genesis of the cosmos, in which the earth-sky pair feature among the first elements. In ancient times the priests of Heliopolis, the City of the Sun in Lower Egypt, taught that in the midst of the unformed primordial ocean (known as Nun or Nu), and slumbering in a lotus bud, lay Atum, whose name means "not to be" as well as "complete". Eventually, by the power of will, he drew himself out of non-being and manifested himself as the Sun-god Ra, and was therefore known also as Atum-Ra. This supreme divinity bore from himself the twin boy and girl Shu and Tefnut, who in

This papyrus dating from c.1000 BC shows the Egyptian sky-goddess Nut in her stretched position, while Geb, her lover, lies on the Earth trying to reach her. Shu is shown between them, separating the Earth from the sky.

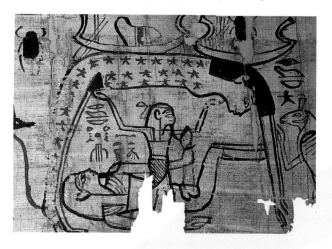

turn bore Geb, who was the god of the Earth, and Nut, who was the goddess of the sky.

These two illicitly lay together. Then, learning of their misdeed, Ra ordered Shu, the god of air and space, to force his way between their bodies and prize them apart. Nut was thrust upward, and there she stays for eternity, stretched out in her classic posture above the Earth supported by her arms and legs, the four pillars of the firmament. The stars lie along her belly, and every day from rising to setting, the boat of the Sun-god Ra passes along her back. Below, Geb wails and tries to lift himself to reach his beloved, and the agonized contours of his body form mountain chains on the earth.

Ra henceforth decreed that his granddaughter could not bear a child in any month of any year, but Nut found a way to circumvent this seemingly absolute prohibition. Coming to her aid with a clever trick, the god Thoth played checkers with the Moon (with which he is identified in Egyptian belief) and over a number of games won a seventy-second part of the Moon's light. With this light he created five new days that did not belong to any of the months of the 360-day Egyptian calendar, and in this limbo out of the regular order of time Nut was able to give birth to five children, whom she named: Osiris, Horus, Set, Isis and Nephthys.

The appearance of the sky-goddess in a mythic description of *intercalation* (the addition of days to the calendar to keep it in line with the solar year) alerts us to an important principle: cosmogonic myths go beyond the earth-sky frame as a spatial entity and refer to time and time-keeping, which are themselves derived from celestial motions and are of the greatest importance for both the practical and ritual regulation of ancient society.

Hesiod's *Theogony*, written around the 8th century BC, is the earliest record we have of the ancient Greek understanding of the creation of the cosmos. Despite a transposition of gender,

The Egyptian sky-goddess Nut stretches out, with the stars, the Sun and Moon travelling across her body. The illustration is based on a painting found on the inside of a coffin dating from the 8th–11th centuries BC.

the Greek account has significant parallels with the Egyptian conception, and these were acknowledged by the Greek authors themselves.

In the beginning was dark Chaos, and then the coming of the fertile Gaea, deep-breasted Earth. She produced Uranus, the great sky-god crowned with stars and equal in magnificence to Gaea herself, and the sky-god covered the Earth and mated with her. However, the children of their union were two races of monsters, the Titans and the Cyclopes, and Uranus pushed them back down into the earth. In revenge for this atrocity, Gaea fashioned a sickle for her last-born son Cronus, who castrated his father when he came again to consort with Gaea. Black blood dropped from the wound, and from this sprang the Furies (evil and fearsome female deities, thought to reside in the underworld from where they sent misfortune to those on earth); while the genitals, flung onto the sea, broke into a white foam from which was born the beautiful goddess of love, Aphrodite.

Thus, in the Greek myth we find the theme of Cronus, later identified with Time and with the astrological interpretation of the planet Saturn, violently preventing the union of earth and sky.

The separation of the two realms, a recurrent theme in mythology all around the world, is often linked with the needs or misdemeanours of humankind, rather than being an episode of primordial creation. The ancient Sumerians are thought to have believed that the *an* (heaven) and *ki* (earth) were one place, until the *ki* was annexed as a realm for human habitation. Sometimes the separation is an act of divine justice: the Dinka people of southern Sudan believe that the heavenly and terrestrial

worlds were formerly much closer together but were pulled apart as a form of punishment for humankind's misdeeds.

Frequently, the heavenly and terrestrial worlds are perceived as being linked by a tree or ladder. In one myth of the nomadic Yakut peoples of Siberia, a shaman was said to have rescued a woman from the upper world who had been abducted by raven-headed sky people as a bride for one of their kind – one of many stories that have parallels with the Western children's tale of Jack and the Beanstalk.

The notion of the sky as a dwelling-place of the gods is widespread, and explains the sacred significance in many cultures of high-soaring birds such as the eagle. For the Aztecs the eagle was the celestial power of the rising Sun, which joins battle with darkness embodied as a serpent. Many Native North American tribes attach all-powerful status to the Thunderbird, the Spirit of Thunder, an eagle-like creature whose wingbeats are heard as thunderclaps. The Thunderbird is said to be the messenger between the earth and the sky: whenever the people prayed to Father Sun, their thoughts were taken skyward by the bird.

The sense of a vital relationship between earth and sky – the founding principle of astrology – is often captured in the gestures of ritual and ceremony. In the baptism rites of many African peoples as well as those in both Native North and South America, new-born babies were lifted to the night skies to prompt the initiation of their sky-bound destinies.

29

HEAVENLY ORDER

The birth of the universe as recounted in the Mayan creation epic, the *Popol Vuh* (a collection of texts collated in the 16th century), is mysterious and evocative: "Whatever might be is simply not there: only murmurs, ripples, in the dark, in the night. Only the Maker, Modeller alone, Sovereign Plumed Serpent, the Bearers, Begetters are in the water, a glittering light. ... 'Let it be this way, think about it: this water should be removed, emptied out for the formation of the earth's own plate and platform, then comes the sowing, the dawning of the sky-earth. But there will be no high days and no bright praise for our work, our design, until the rise of the human work, the human design.' "

Coeval with the division of heaven and earth is the archetypal figure of the maker-god who establishes the cosmic design, and also brings forth human beings as a key element in the great work. Who would there be to know, praise and serve the god without humankind?

The image of the maker of the world as a heavenly smith is a recurrent motif in mythology. In Norse and Anglo-Saxon myth we find the shadowy figure, often lamed, known as Waldere, Volund or Wayland the Smith, for centuries suppressed by Christianity. His Greek counterpart is Hephaestus (Vulcan to the Romans). Once a fire-god, Hephaestus was born lame and weak, but was a master of metalwork and construction. From his anvil, with twenty bellows working spontaneously at his bidding, he built all the palaces on Mount Olympus.

The heavenly smith performs his greatest and most celebrated work in the *Timaeus*, the cosmological myth drawn from archaic sources by Plato (*c*.428–*c*.348BC), which has had

an incalculable influence on later Greek, Islamic and European cultures. In this myth Plato lays the groundplan for the physical construction of the visible cosmos along lines which dominated the course of science and philosophy for the next two millennia (see pp.32–3); and at the same time he shows the cosmological foundation of intelligence and ethics.

Plato's maker-god, the Demiurge, created the universe in the image of the most perfect form, which is a single rotating sphere. The English word "universe", derived from the Latin *uni-versare*, meaning "to make one turn", describes this, because the perfect being of the heavens is that which turns in one plane on its axis – none other than the Celestial Sphere (see p.14). The sphere was created by a harmoniously proportioned arrangement of the four elements: fire, earth, air and water. Fire gave it visibility and earth made it tangible; and

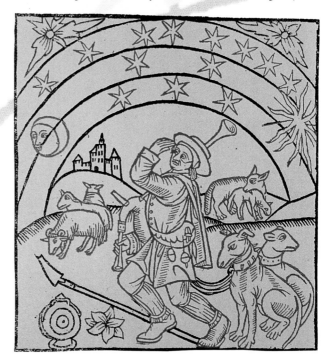

This 15th-century woodcut from an English "shepherd's calendar" shows the heavenly spheres, the Sun (on the right) and the Moon (on the left). In the centre the bagpiper responds to the cosmic musical influence of the stars, a similar idea to Plato's Harmony of the Spheres.

30

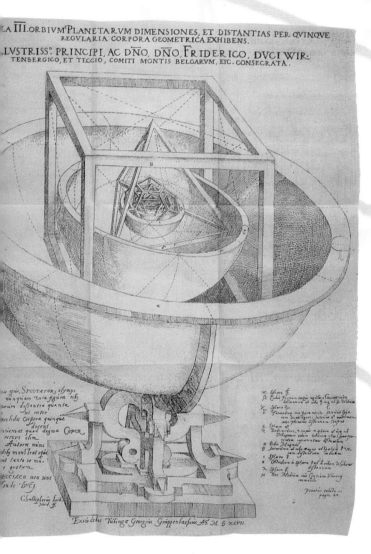

LA III.ORBIVM PLANETARVM DIMENSIONES, ET DISTANTIAS PER QVINQVE REGVLARIA CORPORA GEOMETRICA EXHIBENS.

ILVSTRISS: PRINCIPI, AC DÑO, DÑO, FRIDERICO, DVCI WIR-
TENBERGICO, ET TECCIO, COMITI MONTIS BELGARVM, ETC. CONSECRATA.

Excudebat Tübingæ Georgius Grüppenbachius Aõ M.D.XCVII.

Johannes Kepler (1571–1630), is one of the major figures of modern science because of his revolutionary theory of planetary orbits, but he was at the same time a mystical astrologer. His scientific work was simply one part of a mystical geometry of the cosmos. This illustration of 1597 shows his model for the Solar System as interlinking "Platonic" solids (the cube, tetrahedron, octahedron, dodecahedron, and icosahedron).

these two were bonded together to form an indissoluble unity by the mediation of water and air.

The Demiurge wrapped the spherical being in the World-Soul, the *anima mundi* as it was later termed. This soul is compounded from the three logical categories of Existence, Sameness and Difference – because existence is the condition for anything to be, and all things are distinguished and known as themselves on account of their similarity to, or their difference from, other existing things. Taking the compounded "soul-stuff", the Demiurge divided it into seven strata along a band in such a way as to produce the ratios of the musical intervals of the octave. At this point Plato's construction shows the influence of Pythagoras (late 6th century BC), who demonstrated the ratios of the musical scale from the tetractys, the natural numbers one to four. In the *Timaeus* Plato gives us a beautiful metaphor: the Harmony of the Spheres. As the planets move in their orbits, they sound the notes of the musical octave. The soul hears this harmony before incarnation, and the task of philosophy is to bring us back into attunement with the heavenly spheres as we were before birth.

The Demiurge created the equator and the ecliptic circles of the Celestial Sphere by splitting the fabric of the World-Soul into two strips which he curved into circular bands. He laid one across the other at a slant of 23°. One of these bands, the ecliptic circle, comprises the seven circuits of the planets which seem from our point of view to move around the Earth at their centre. The remnants of soul-stuff remaining once this work had been done became the souls of humankind, sown in the stars and planets before reincarnation into the brutal realm below. For Plato, the neo-Platonists and the Hermetic astrologers who came later, there was no higher purpose in our studies of the heavens than the recovery of our primal perception of the goodness and greatness of the universe, from which our substance and our intelligence are derived.

THE COSMOS, HUMAN AND DIVINE

The passage of ideas from Plato (428–348BC) to Aristotle (384–322BC) takes us from a system of thought that allies naturally with poetry and myth, into a realm of rationality, logic and science – for example, Aristotle was sceptical about the concept of the Harmony of the Spheres (see pp.30–31). However, despite the strongly contrasting orientations of these two fathers of philosophy, at root they share a common construction of the cosmos. This cosmological legacy binds together, into a relatively unified conception, many distinct and seemingly unrelated expressions of religion, magic, science, philosophy and astrology over nearly two millennia of development in the Greco-Roman, Persian, Islamic and European cultures.

Aristotle studied and then taught in Plato's Academy at Athens before tutoring the young Alexander the Great and founding his own school, the Lyceum. His treatises *On the Heavens* and *On Generation and Corruption* effectively translate the groundplan of Plato's cosmos into a scientific conception. Like his teacher, Aristotle saw the Celestial Sphere as the perfect creation of the creator-god, the Zeus of abstract philosophical principle rather than the temperamental god of the common man with his archaic myths. The sphere is incorruptible and eternal, and its stars are divine fire; its motion is the first of all movements, hence its Latin name, *primum mobile* ("first moving thing"). All other possible motions, whether in the heavens or on the Earth, are ultimately derived from the rotation of the Celestial Sphere around its own axis.

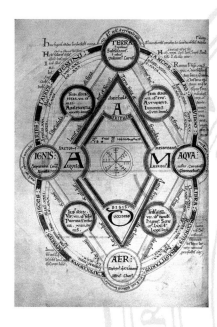

This cosmological diagram from the Book of Byrhtferth *(English, c.AD1110) shows the four elements at the top and bottom and at either side of the structure. The zodiacal constellations form the outer links between the elements.*

A single ceaseless motion, the rotation of the sphere along the plane of the equator, cannot account for both the coming-to-be and the passing-away of all things in creation. The primary cyclical change is produced by the great counterclockwise movement of the Sun, alternately retreating from and then advancing toward the Earth's equator in its annual path along the ecliptic. This formulation is similar to that of Plato, whereby distinctions between things are produced by the motion of the planets along the slanted circle of the ecliptic. Seasonal alternation in turn brings about changes in the four elements from which all creatures are compounded – fire, air, water and earth.

Aristotle held that time itself, and the life-cycles of living creatures, are functions of this seasonal rhythm of the Sun. But the intermingling of the creatures below produces a chaotic flux where contingency obscures the pattern, and our lives are shortened or lengthened by countless chance incidents as well as by our own conscious intervention.

In its final form, Aristotle's cosmology and physics, coupled with the sophisticated conception of the motions of the spheres of the Sun, Moon and planets developed by his contemporary, the astronomer Eudoxus (c.400–c.350BC), provided a complete basis for the physical universe. The culminating phase in the construction of this model came with the observations and theories of the Alexandrian astronomer, geographer and astrologer Claudius Ptolemy (who flourished in the 2nd century AD), and it is his name (Ptolemaic) that is

VIRTUES OF THE HEAVENS OF PARADISE, FROM DANTE

	Heaven	Souls Encountered	Discipline or Virtue
1st	Moon	inconstant in their vows	Fortitude required
2nd	Mercury	active and ambitious	Justice required
3rd	Venus	lovers	Temperance required
4th	Sun	theologians, teachers, historians	Prudence
5th	Mars	warriors	Fortitude
6th	Jupiter	the Just	Justice
7th	Saturn	contemplatives	Temperance
8th	Stars	Virgin Mary, Saints and Adam	Faith, Hope and Charity
9th	Primum Mobile		
10th	Empyrean	the Blessed; St Bernard	

The table shows Dante's divisions of the souls encountered in his Paradise.
Dante gives positive virtues to the Sun and the superior planets; and a discipline of the virtue where it is lacking, to the Moon and the inferior planets.
The Empyrean is literally the "sphere of fire", directly before the face of God.
St Bernard (1091–1153) was a famous Abbot of the Benedictine Order.

Right: This illustration shows the universe according to Dante. At the bottom, the four elements are shown with the Moon. The planets then come in Ptolemaic order (with the Sun after Venus). After Saturn, toward the top of the picture, the stars of the zodiac are represented. The last "band" is the Primum Mobile and beyond that the Empyrean. Each band is also assigned one of the Liberal Arts (subjects of secular education) and a divine governing body.

given to the long-enduring geocentric (Earth-centred) construction of the universe known to later Islamic culture and to Europe in the Middle Ages – incidentally, a system which lent itself neatly to Plato's theories on the Harmony of the Spheres.

The most sustained and beautiful expression of the medieval cosmos was that achieved by the Florentine poet Dante Alighieri (1265–1321). Written after experiencing a mystical vision at Easter, 1301, his great poem the *Divine Comedy* is a multi-levelled metaphor of the path of the soul through pagan and Christian mysteries, unfolded in the universe of Plato, Aristotle and Ptolemy. In the third book, *Paradise*, the ascent into Paradise occurs through the successive planetary spheres (see illustration, below). Dante's description of this ascent uses established astrological symbolism to catalogue its own hierarchic scheme – like a cosmic filing cabinet – accommodating the souls of the illustrious dead, angels, and events in history (see table, left).

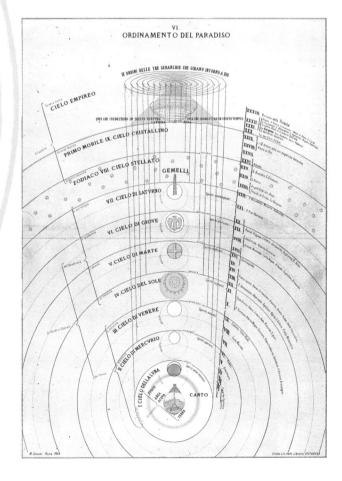

CELESTIAL METAPHORS

In attempting to give form to the cosmos, many cultures through history have drawn upon metaphors derived from terrestrial observation, in the process creating some profound and poetic conceptions of the cosmos.

A classic example is the widespread metaphor for the polar axis, the World Tree, variants of which are illustrated on these pages. Best known is the Judaic and Christian Tree of Paradise, which holds the heavens aloft in its branches. The pagan religion of northern Europe, preserved for us in the Scandinavian prose tales known as the *Eddas*, tells of a giant ash tree, Yggdrasil, which comprises the whole world. One of its three roots plunges into Niflhel, the underworld; beside the second root, in the icy land of the giants, rises the fountain of all wisdom, known as Mimar; and beside the third root, which some say reaches up to heaven, is the well from which the Norns, the three crones who control the fates of all beings, draw water with which to moisten the tree.

In the Mayan culture of Central America, whose mythology has only recently been revealed as deeply sky-oriented, the World Tree is a central conception, frequently depicted as a maize plant with the face of the maize god. The name of the Tree, *wakah-chan*, means "raised-up sky": First Father raised it at the beginning of creation in order to divide sky from earth. When the Christianity of the Spanish conquerors assimilated the old culture, the villagers took over the Cross as a representation of *wakah-chan* – a characteristic example of ancient beliefs adapting to the imposition of imported religions.

In this Egyptian coffin painting from the Ptolemaic or Roman period (after 200BC), the soul, represented by a Ba (a bird with a human body, at the right), receives rejuvenating water from the tree-goddess seated in the Tree of Life (left). The soul was believed to leave the body of the bird to be revived, and when it returned, the body would regain all its humours.

In some cultures the celestial metaphor that orientates the universe is more elaborate, though still based around the idea of a mysterious centre to creation. The Navajo people of Arizona tell the following story of creation. In the time of great darkness, Sky Father descended and Earth Mother rose to meet him, and on the top of the mountain where their union had occurred the ancestors of humankind found a little figurine of turquoise. This became the immortal goddess Estsatleh, meaning "she who rejuvenates herself": after passing through mature womanhood and becoming a crone, she rose again as a girl. Four daughters were born from parts of her body, and a fifth was born from her spirit. The Sun came out of the turquoise beads on her right breast and the Moon emerged from the white shells on her left breast. No image can be made of her, and even the gods are not permitted to contemplate her face.

In this story we see one of many variations on a recurring cosmological motif – a mysterious place where heaven and earth join and the lights of the sky are born. This is the place where the four directions and the four seasons are demarcated, with the centre as the quintessence, the mysterious "fifth place". Like the perfect god of Plato's *Timaeus* (see p.30), Estsatleh is complete unto herself, turning around her own centre in perpetual rejuvenation. For us the movement of this god is the rotation of the Celestial Sphere (see p.14), and the mysterious place where the Navajo ancestors found the turquoise stone represents the polar axis of the heavens, around

which the whole of creation revolves.

The mysterious place at the cosmic centre sometimes appears as a stone. The modern tourists at Delphi (near Corinth), one of the most sacred sites of ancient Greece, wend past the archaic rounded block known as the *omphalos*, "the navel", also referred to in classical times as the "middle of the mother". This is the navel of the world, and it harks back to a time long before the solar deity Apollo claimed the site for himself in the 8th century BC, when this most famous of oracles served the earth-goddess Gaea. Yet, etymologically, mother-navel also embraces *phallos*, and it has been speculated that the stone was originally a phallic symbol marking a shrine to the fertile earth-goddess or the tomb of the sacred snake, the Python. Whatever the historical reality of the *omphalos*, this sexual ambiguity passes down to us as a reflection of the ambivalence of cosmological metaphors concerning the polar axis: as the self-fertilizing creation point of earth and sky, as such it is both a womb and a phallus.

If we know where to look, the same symbolism springs to life with surprising consistency beneath traces of myth that on the surface appear to have little to connect them. The beliefs of the scattered Finno-Ugric tribes who once stretched from Finland and Lapland to western Siberia were organized around

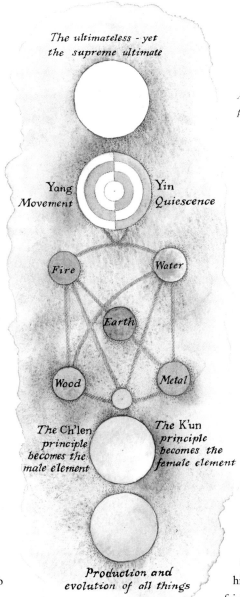

The ultimateless - yet the supreme ultimate

Yang
Movement

Yin
Quiescence

Fire

Water

Earth

Wood

Metal

The Ch'len principle becomes the male element

The K'un principle becomes the female element

Production and evolution of all things

A diagram of the Supreme Ultimate of Chinese philosophy. After the inexpressible ultimate of being and non-being, we move on to the Yin (originally meaning darkness) and Yang (originally, light) principles, two opposing but mutually dependent energies of creation. These came to be seen as the cosmic forces which interacted to produce all the phenomena in the universe. Hence, beneath them are the Five Elements or Five Agents (see pp.50–51), after which the female and male principles come together to produce all earthly things. The diagram is based on a conception by the neo-Confucian philosopher Chou Tun-yi (AD1017–73).

shamans (visionary healers), who had as a central symbol the mysterious talisman Sampo, forged by the smith Ilmarinen. However, could this character be another guise for Wayland the Smith and Plato's Demiurge, who were forgers of the heavens (see p.30)? The description of the talisman Sampo as "many-coloured" strikes a chord with an archaic motif that is manifested in the biblical Joseph with his coat of many colours, and it has been fairly conclusively established that Sampo is a representation of the star-spangled heavenly vault. More surprising still, the word Sampo can be traced back to the Sanskrit *skhamba*, which means pillar or pole – bringing us back, full circle, to the notion of the polar axis as key component in our metaphorical conception of the universe.

35

PRECESSION AND THE GREAT AGES

The stars we see in the night sky have all shifted against the framework of the celestial equator and the ecliptic since observations were made by the early Greek astronomers. This shift has been caused by a phenomenon termed *precession* – the wobble of the Earth's axis, in a movement akin to that of a gyroscope, forming a complete cycle over 25,800 years (see pp.22–3). The first scientific description of this cycle is credited to Hipparchus (2nd century BC), but earlier cultures incorporated aspects of the phenomenon into myth, especially the precession of the equinoctial and solsticial points, which appear to move backward against the fixed stars by about 1° every 72 years.

A representation of Aquarius pouring his water into the river of life. Owing to precession the spring (vernal) equinox point will pass into Aquarius during the next millennium.

This brings us to a knotty question: how far do the myths of various cultures reflect these long-term celestial changes? Even today, despite mounting evidence to the contrary, mainstream academic opinion resolutely averts its eyes from the sky, but against it stands a minority view which places the heavens as the significant determinant of both the form and substance of major myth-complexes. This is the bold claim of the most comprehensive study along these lines, by Giorgio de Santillana and Hertha von Drechend: *Hamlet's Mill: Myth and the Frame of Time* (1969). The basic thesis is that the geography told in myth is located in the heavens; it is the whole cosmos that forms the

The eucharistic bread and fish, from a painting in San Callisto, Rome. The fish represents Christ, whose coming was foretold by the spring (vernal) equinox point entering the first fish of Pisces.

"world" of archaic imagination. Roads, rivers and oceans in many myths often refer to parts of the sky, especially to the path of the Milky Way. Similarly, poles and trees refer to the celestial axis.

Perhaps the most challenging possibility of this interpretation is its claim that precession has been assimilated into myth. The movement of the polar axis becomes the fall of the World Tree or the descent from the Garden of Eden, bringing a cataclysm at the end of each age. These cataclysms reflect the displacement of successive constellations as they lose their hold on the equinoxes and solstices.

In recent decades precession has taken root in the popular imagination of the "New Age". However, the assumption that we are at the dawning of this Great Age owes very little to observation of the sky. Since around 100BC the equinox point has been slowly making its way through the constellation Pisces and is only now beginning its progress through the second fish of the Pisces pair: it will not reach the same degree of longitude as the star Beta Piscium at the head of this fish until AD2813; even stretching the case we barely brush the edge of Aquarius much before AD2300.

Precession in our era has been potently interpreted by the psychologist Carl Jung (1875–1961): "The course of our religious history as well as an essential part of our psychic

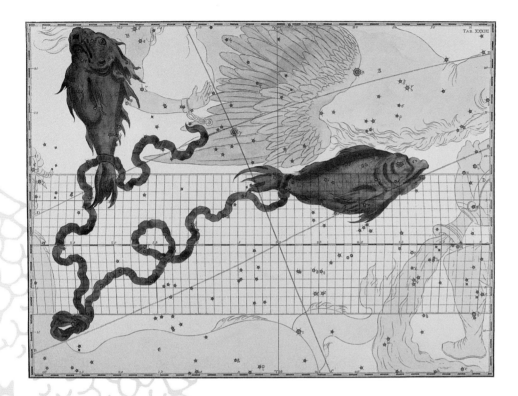

An 18th-century engraved plate of the constellation Pisces, from an English book of constellation maps. The first fish in the Age of Pisces is that on the left. The birth of Christ occurred at a point between the alpha star in the knot of the cords and omicron further up the cord attached to the first fish. Karl Marx was born near the omega star, which is just on the knot at the second fish's tail. On the very left edge of the illustration, the horns of Aries, the previous age, can just be seen, and to the right, the urn of Aquarius, the next age (which will dawn c.AD2813), is visible. At the present time the spring (vernal) equinox point lies very close to Iota Piscis, which is left of centre of the second fish.

development could have been predicted, both as regards time and content, from the precession of the equinoxes through the constellation of Pisces."

Christ, the "First Fish", was born on the crossover from Aries to Pisces. The rise of science and secular rationalism in our era is a reflection of the second fish. As if to confirm this last point, Karl Marx, the apostle of anti-religious materialism, was born in 1818 – within a year of the exact period (the ecliptic contact) when the spring (vernal) equinox point had the same degree of longitude as the first star in the second fish (Omega Piscium) in 1817.

The historical correspondences of the Age of Aries are no less remarkable. The constellation Aries bunches its three brightest stars together in the head of the ram. The equinox point passed through the ecliptic conjunction of this trio over a relatively short period, between 713BC (Beta Arietis) and 446BC (Alpha Arietis). This 276-year span was decisive for world history: the birth of Gautama Buddha during the 7th century BC, Confucius born in 551 or 552BC, and the rise of the Greek city states in this same brief period, transformed civilization, East and West. The next great phase of Buddhism came in the first century of our era with Mahayana (Greater Ferry) Buddhism. Bodhisattvas, who sacrifice their own enlightenment in order to bring salvation to others, are a central goal for the Mahayanists and present a striking parallel to the sacrifice of Christ the Redeemer in Pisces.

CORRESPONDENCES

For ancient cultures, the celestial cycles of the stars and planets provided a pattern for the world below. Even where the heavens might be denied a governing role, as in the monotheistic religions, the stars were nevertheless considered a supreme expression of divine will and order.

Greek and Roman Stoic philosophers described a common breathing of the universe, identifying the microcosm, the little world below, with the macrocosm, the greater world above. The Hermetic axiom, "As above, so below," attributed in the early Christian era to the mythical sage Hermes Trismegistos, expresses this conception – a notion of correspondences that retains its vitality, most notably in astrology, to the present day.

The mystical correspondence between heavenly and terrestrial realms is vividly embodied in Zodiacal Man – a recurrent theme in Western iconography. The idealized human form was seen as a microcosm of the heavens, and each sign of the zodiac was linked with a bodily function.

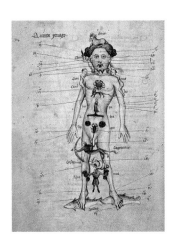

This Flemish tapestry, hanging in Toledo Cathedral, dates from the 15th century and shows zodiacal constellations alongside other star-groups pictorially represented. The floral background reinforces the idea of a heavenly realm that interpenetrates the terrestrial.

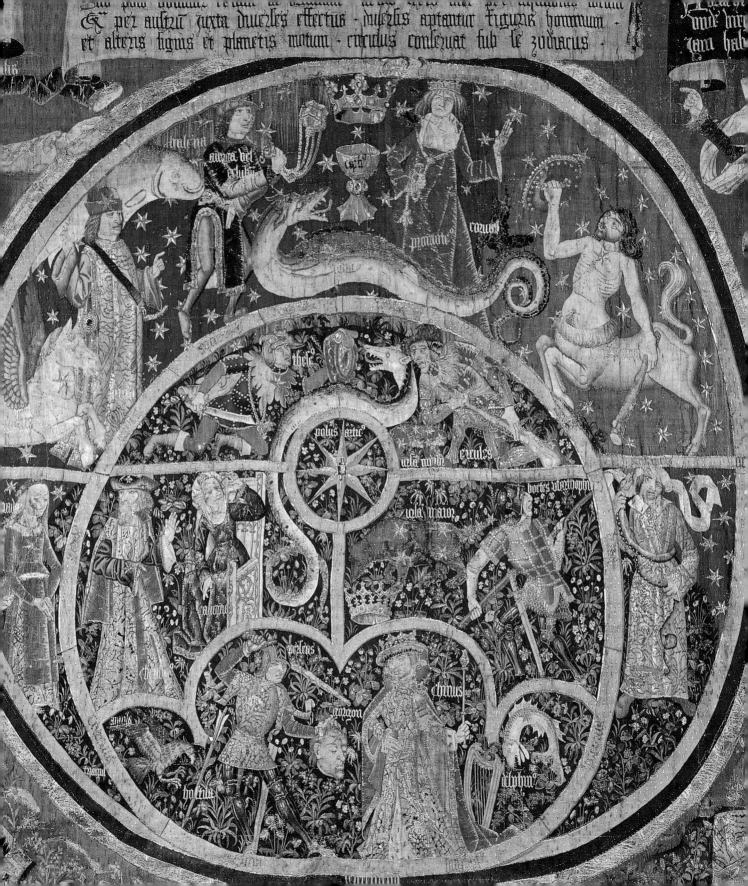

THE STARS, ORACLES AND FATE

In the most sophisticated astrologies, the relationship between character, fate and the heavens is both subtle and natural, reflecting not a disruptive interference from external forces but a complex and universal harmony within the universe. Something of this subtlety is expressed in the commentary on the hexagram *Ch'ien* (the Creative) in the *I Ching* ("Book of Changes"), the famous ancient oracle book of China: "The great man accords in his character with heaven and earth; in his light, with the Sun and Moon; in his consistency, with the four seasons; in the good and evil fortune he creates, with

gods and spirits. When he acts in advance of heaven, heaven does not contradict him. When he follows heaven, he adapts himself to the time of heaven. If heaven itself does not resist him, how much less do men, gods and spirits!"

Since the 18th-century Enlightenment, science has gained an ever-advancing dominion over the material universe. The scope of rationality has widened to the point where even our human nature has been laid upon the dissecting table. Yet many people today believe that the ancients, and the so-called "primitive" peoples, still have something astounding to show us: the primal recognition that the whole universe is animate, and that far from being gross matter the reality around us is "ensouled" – filled with volition and intelligence.

In this primordial way of knowing, there is not an absolute separation between subject and object, observer and observed, nor a logical and physical separation between the human soul and the animate intelligence of nature. "Mythopoeic" imagination – the faculty employed in myth-making – therefore joins us in a correspondence, a "co-response" of emotion and sympathy, with the universe around us. The recognition of this co-response is the foundation of the culturally universal phenomenon of omen-reading, and of systems of divination developed from signs and omens.

In all traditional societies seers, shamans and prophets interpret the omens, but it is in the ancient civilization of Mesopotamia, the region of modern-day Iraq, that we find the most sophisticated development of divination in an organized tradition of observation and learning. There is evidence from the 3rd millennium BC of the ritual examination of the entrails of an animal sacrificed to a god, in

Flocks of birds have been thought in many cultures to have had divinatory significance. In part this belief may be based on observation of the arrivals of migratory species, heralding a change of weather.

order to determine the god's answer to a question posed about the future. The liver, known to the doctors of Egypt and Greece as the seat of life, was *par excellence* the mirror of the gods, and from at least 1900BC liver divination became codified, with an extensive interpretive literature recorded on clay tablets. As well as extispicy (examination of the liver, lungs or colon spiral), the Mesopotamians used lecanomancy (oil patterns on water) and libanomancy (the configurations of smoke from the burning of incense) for divination.

Mesopotamian practices then came to Greece and eventually passed into the shadowy culture of the Etruscans of northern Italy, whose noble families held tenure of Rome's College of Augurs.

The English word "augury" has as its root the Latin *avis*, meaning "bird", indicating the central status of bird omens in early times. Creatures of the sky were messengers from the gods in their heavenly abode. Omens embodied by thunder and lightning, like those embodied by birds, were under the aegis of the great sky-god Zeus, the Greek equivalent of the Roman god Jupiter. Interestingly, different omens tended to carry different status, so that signs from the sky appear to have been elevated above those divined on earth, just as the portents of the supreme god Zeus held more significance than those of local or

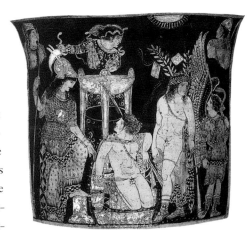

An ancient Greek vase painting showing the oracle at Delphi. In the foreground the tragic hero Orestes is shown sitting on the omphalos – the world's navel.

An illustration based on a bronze model of a sheep's liver, used for divining by the Etruscans. The face is divided into sectors of the heavens.

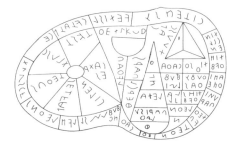

earth-bound divinities. This helps to explain the gradual enhancement of astral omens over all other forms in late-Mesopotamian culture, certainly by the 8th century BC. Increasingly accurate knowledge of the cyclical movements of stars and planets, which represented the gods of the sky, gave its priestly possessors the semblance of a mastery of fate itself. For example, the Mesopotamian Nabu, the equivalent of our planet and god Mercury, was the god of wisdom and patron of scribes. Every year at a special New Year ceremony, his father Marduk – our Jupiter – confided his decrees for the coming annual period and Nabu wrote them down on a Tablet of Fate. The priests who could predict with astronomical certainty the movements and showings of the planets of Marduk and Nabu were declared to be Nabu's privileged interpreters.

At its highest elevation, divination takes on the possibility of a transcendent self-knowledge. At Delphi, near Corinth in ancient Greece, where the Pythian priestess sat at the navel of the world to speak the oracle of the Sun-god Apollo, there was a famous inscription: "Know thyself." Self-knowledge is the navel of fate, the axis around which our conscious being turns. This wisdom of the Sun is the essence of divination, and is considered the highest knowledge of all oracles.

DIVINE MESSENGERS

The reading of omens and portents from the sky gradually evolved into the divinatory art of astrology, with its attendant science of astronomy, in the first millennium BC. However, long before then, the collating of observations of the sky, including meteorological phenomena and the appearances of the Sun, Moon and planets, had established the essential outlines of a symbolism that survived little changed for thousands of years. The Mesopotamian omen collection *Enuma Anu Enlil*, dating from *c*.1000BC but incorporating much older material, gives brief formulaic readings on a range of sky phenomena, including eclipses, lightning and cloud formations.

Centuries later, omens from the sky were still a popular source of divination. These lines from Shakespeare's *Julius Caesar* (*c*.1600) show a remarkably consistent theme of interpretation from the earliest records to relatively recent times, linking the most dramatic of the celestial phenomena with social disorder, particularly the downfall of kings:

"When beggars die there are no comets seen;
The heavens themselves blaze forth the death of princes."

Among the most striking of all the heavenly portents are comets, which were universally interpreted as associated with the fates of monarchs and leaders. From the standpoint of science, however, these are lesser members of the Solar System: huge snowballs of gas and dust moving on elongated orbits around the Sun, in cycles that can vary from a few years to many centuries. The brightest comets are an awesome sight, visible in the night sky for many months with a glowing head, a tail of gas and debris stretching away from the direction of the Sun for millions of miles. When cometary debris is scat-

tered across the Earth's orbital path, it will eventually be captured by the Earth's gravitational field and pulled into the upper atmosphere as meteors, or "shooting stars".

A distinctive tradition emerged concerning the shape of the comet. Pliny (AD23–79), in his *Natural History*, the great classical scientific compendium, lists the commonly recognized forms: javelin stars, which quiver like darts; dagger stars, shaped to a point; tub stars like a casket; torch stars; horn stars; and horse stars flowing like a horse's mane. If the comet resembles a pair of flutes, it is said to be a portent for the art of music; in

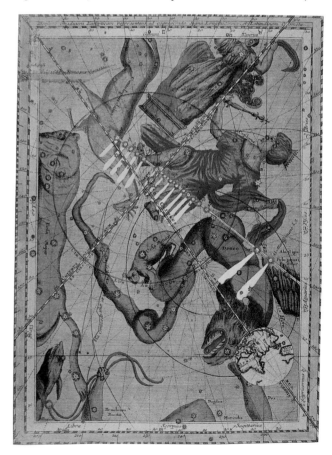

This perspective illustration shows the comet of 1742 in various stages across the Northern-hemisphere sky. The comet, with a small head and fiery tail, travels across the pictorially represented constellations Camelopardalis and Cepheus, and finally reaches into the wing of Pegasus. The Earth is shown at the bottom right, with a line passing through to Polaris and into the heavens.

42

This illustration of 1618–19 shows the movement of a comet over a period of 24 hours. The constellations across which it is travelling are Boötes and Ursa Major.

the genitals of a constellation figure a comet portends immortality.

Aristotle's view that comets were fiery disturbances in the upper atmosphere, below the level of the planetary spheres, made them meteorological rather than astrological. However, the symbolic framework of astrology offers a ready-made structure of correspondences for the specific interpretation of any celestial occurrence. According to Ptolemy in the 2nd century AD, "[comets] show, through the parts of the zodiac in which their heads appear and through the directions in which the shapes of their tails point, the regions upon which the misfortunes impend." Geographical regions have long been associated with zodiac signs: for example, "Italy, Apulia (Cisalpine), Gaul, and Sicily have their familiarity with Leo and the Sun."

Halley's Comet, with a period of 76 years, is the best-known comet in European history. In 1066 its appearance was taken by William of Normandy as a favourable portent for his intended conquest of the Saxons in England – an omen recorded in the Bayeux tapestry.

Perhaps the most exceptional celestial portent, which has never lost its potency, even in our secular era, is the Star of Bethlehem. Although the "magi" (from the Greek *magos*) have been described as "three wise men from the East" or three kings, Persian astrologer-priests is a more accurate translation of the original biblical text. Arabic and later European astrologers,

A stone relief at St Lazare cathedral in Autun, France. It shows the three Magi dreaming of the advent of Christ. They are thought to have predicted the event from planetary conjunctions at the time of Christ's birth.

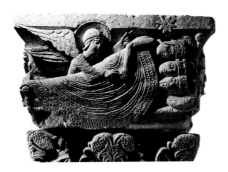

favouring a rational basis for their art, tended to accept the Christian interpretation that the star was a supernatural sign from God, and so outside the realm of conventional astrology. However, Johannes Kepler, in the early 17th century, established the likelihood that the "star" was the conjunction of Jupiter and Saturn at the end of Pisces, near the equinoctial point, in 7BC. Kepler felt that God might have also marked this conjunction with a *Nova*, a new star flaring in the sky. Recently the English astronomer David Hughes, incorporating the latest evidence from biblical dating, has supported the hypothesis that Christ was probably born in 7BC, and that the biblical reports are a layman's version of what the conjunction would have meant for astrologers. The Magi would have known of ancient Jewish predictions of a Messiah. Pisces is a sign of rulership for Jupiter, the planet of kings, and Saturn was the planet of the Jews. Hence, the conjunction in Pisces symbolically means "King of the Jews". The Jupiter-Saturn conjunction occurs every 20 years, but astrologers would have been impressed that this was an uncommon triple conjunction of these planets in that year, in which through retrograde motion (see p.21) Jupiter and Saturn produced not just one but three contacts – this is perhaps why there are three kings in the story. Interpretation aside, it is an impressive illustration of the ancient understanding that the heavens themselves give signs of great events in the world below.

THE STORY OF ASTROLOGY

"Mortal as I am, I know that I am born for a day, but when I follow the serried multitude of the stars in their circular course, my feet no longer touch the earth; I ascend to Zeus himself to feast me on ambrosia, the food of the gods." The poetic mysticism of the sky and stars, the impulse that has fascinated astrologers for centuries, is perfectly expressed in this comment made by Claudius Ptolemy, the famous geographer, astronomer and astrologer, in the 2nd century AD.

In his great cosmological work, the *Timaeus*, Plato teaches that the purpose of sight is not to find our dinner but to allow us to contemplate the order of the heavens. By this contemplation the soul is brought into harmony with its divine purpose. From mankind's earliest speculations, what we now understand as the objective science of astronomy was inextricably bound up with astrology – the search for a transcendent meaning to our subjective experience, interpreting our destinies from the stars and planets.

Astrology developed from a complex amalgam of Babylonian and Persian astral religion and augury, Egyptian cosmology and calendar construction, and Greek scientific and philosophical speculation. Its classical form, including basic doctrines such as the order and interpretation of the twelve signs of the zodiac, had for the most part been settled during the Hellenistic period, the fertile era when Greek civilization penetrated diverse cultures from the Mediter-

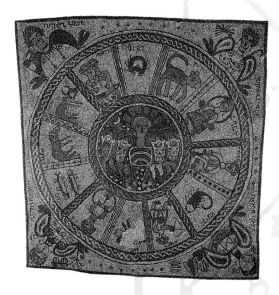

This mosaic in the Beth-Alpha synagogue in Israel is an ancient depiction of the signs of the zodiac surrounding the Sun-god Helios, who is accompanied by the stars and Moon.

ranean and Egypt through Persia to northern India, in the train of the conquests of Alexander the Great after 334BC.

Virtually all cultures have found revelation in the Sun, Moon and stars; and some cultures have further developed divination from units of time and the calendar. For example, the Aztecs and Maya of central America used a prophecy calendar derived from their system of counting in groups of 20 days, and the ancient Chinese developed a system of fate-calculation on a 60-day and 60-year cycle.

However, astrology as we know it depends on a further decisive step: linking the positions of the heavenly bodies, especially the planets, at a certain moment, with the circumstances of that moment. Like the science of calendar construction, divination by planetary movement requires an accurate knowledge of astronomy, together with an established canon of interpretation of individual planetary qualities.

In the 5th century BC these things combined to produce the first Babylonian horoscopes – maps of the heavens for an exact time and place on the Earth. From that time on began the development of judicial astrology, the practice of judgment on specifics of character and fate, especially from the horoscope cast for the moment of birth.

During its formative years, astrology seems to have become infused with a tendency to fatalism. The heavens had always

belonged to the great gods, and with the growing certainties of astronomical prediction it was possible, by anticipating the movements of the planets, to predict the omens of the gods in advance. The Greek and Roman Stoic philosophers treated the universe as an whole, with every part in correspondence and sympathy with every other part. This was a perfect complement for astrology, and with only a few exceptions the Stoics were significant allies. In his *Astronomica* (AD9–15) the Latin poet Manilius encapsulates the fusion of Stoic philosophy with astral divination: "Fate rules the world, all things stand fixed by its immutable laws ... it gives birth to men and at their birth determines the number of their years and the changes of their fortunes."

Astrology achieved political influence in Rome, to the extent that when Octavian became Emperor Augustus in 27BC he issued silver coins with the Capricorn glyph, believed to be his Moon sign, embossed on the reverse. Along with this status came a darker side connected with political intrigue. This comes through in an account by the historian Tacitus of the way in which the emperor Tiberius used astrology to identify potential rivals. Before his elevation to the imperial throne, Tiberius sought the help of astrologers on several occasions. However, dissatisfied with their advice, he had them hurled from the cliff-top path that led to his mansion. When it came to his turn, the astrologer Thrasyllus predicted the great man's future rise to power. Suspicious, Tiberius asked if Thrasyllus could foresee what might happen to him, Thrasyllus, that day. The astrologer studied the planetary positions and, shaken, declared that the day could be his last. Impressed by the astrologer's accuracy, Tiberius congratulated him, and from then on took the predictions of the astute Thrasyllus as oracles of truth. In AD14 Tiberius became emperor, and continued to use astrology as a tool of politics.

However, astrology has not always been so well received. Its

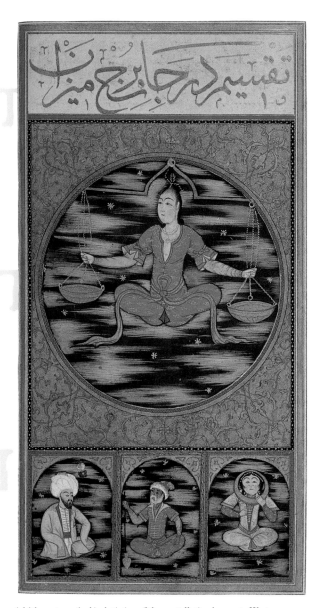

A 14th-century Arabic depiction of the constellation known to Western astrology as Libra. It comes from a copy of a manuscript by Al Sufi, who based his interpretations of the constellations on Ptolemy's version.

greatest early opponent was Christianity, because the practice of astrology maintained the survival of the old pagan gods. St Augustine (AD354–430), who had studied astrology in his youth, demonstrated that it was founded on irrational arguments. Furthermore, he claimed that the surprisingly true answers sometimes given by astrologers were prompted by demons, who aimed to tempt the souls of both astrologer and client into a belief in stellar determinism – thus taking away the free will of the soul – and, worse still, into the worship of planetary gods. This argument is still used by some Christians today.

Paganism was dying in the last days of the Roman Empire. There is a record of augury from the entrails of a sacrificial animal as late as the early 5th century AD, but nothing after that time. Astrology could similarly have slipped away at this time but for its capacity to disguise its religious origins and interweave its theory with the prevailing Greek-dominated science and philosophy. This was Ptolemy's achievement in his *Tetrabiblos* (the "Four Books"), which extended Aristotle's notion of change emanating from the rotation of the Celestial Sphere into a natural and easily comprehensible rationale of the subtle influence of the heavens – on the seed at the instant of conception, and by extension at the moment of birth.

Ptolemy's rationalization eventually brought about a limited concord with Christianity at the time of St Thomas Aquinas

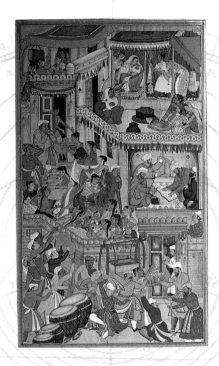

A late 16th-century Islamic view of astrologers, who can be see casting horoscopes using books and various devices during the celebrations of the birth of the Turkish leader Timur (1336–1445).

(*c*.1225–*c*.1274). Stellar influence was fundamental to the medieval conception of reality, and the Church declared that there need be no argument with astrologers provided that they limited that influence to the body, which might in turn influence the soul but could not ultimately dictate the soul's free choice. "The stars incline, they do not compel." "The wise man rules his stars, the fool obeys them." These maxims express an approach to astrology that could be tolerated by late-medieval Christianity.

The Renaissance, the fascination with classical learning and art that blossomed first in Italy in the 14th century and later spread throughout western Europe, gave renewed impetus to astrology, which made its appearance at the highest levels of society and political influence. However, the storm clouds were already gathering for the ancient art. The rise of a scientific, objective imagination by the end of the 17th century, coupled with the overthrow of the old geocentric cosmos of Ptolemy by the new Sun-centred system of Copernicus (1473–1543), made astrology an anachronism for the educated classes in Europe by the start of the 18th century. It has taken a new renaissance in the 20th century, and a scepticism about science as the answer to humanity's problems, to remind us that the core intuition of astrology, connecting us to an intelligent cosmos, may be just as relevant now as it was for the Mesopotamians, the ancient Egyptians and the early Greeks.

ALCHEMY

As in the heavens, so in the dense body of the earth itself: alchemy brings the stars and planets into the metals, minerals and crystals where their powers may be released and purified by the initiate who knows the secrets of the Hermetic Art.

The word "alchemy" is believed to derive from the Greek *chemeia*, from the earlier *chumeia*, meaning "mixing" or "mingling". From prehistoric times there was a developing technology of dye production, glass-making and the manufacture of metal alloys. However, it is not possible to separate the knowledge of ancient times into secular versus religious or magical forms, and an esoteric and cosmological interpretation of the operations of early chemistry and metal-working, the starting-point for alchemy, appears to date from ancient Egypt. The Greek, Islamic and European alchemists attributed their magical knowledge to the mythical Hermes Trismegistos, the divine master of magic. The god and planet Mercury (later identified with the Greek god Hermes) was said to be the living spirit of alchemy, with the power of transmutation.

From the 4th century BC, alchemists established the associations between the heavenly spheres and metals. Gold was associated with the Sun; silver with the Moon; quicksilver with Mercury; copper with Venus; iron with Mars; tin with Jupiter; and lead with Saturn. At any given time, the influential "strength" of a particular planet was said to affect the rate of "growth" of its associated metal, so that the interpretation of the movements of the planets was vital to the alchemist's work.

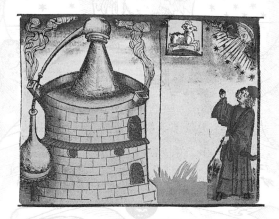

This German woodcut (1519) shows an alchemist at work. He looks to the sky to channel the energy of the stars into his furnace on the left of the picture. From its chimneys smoke rises, indicating that calcination is in progress. A powder is shown pouring from the upper funnel into the container at the side.

Furthermore, appropriate times for the alchemist to begin new stages in his work were marked out by astrology. For example, it was thought that the initiation of a new work was best around the spring (vernal) equinox.

A vast range of metals as well as other substances was used in the work, which usually began by purifying the materials, turning them to powder through intense heat, a process known as *calcination*. The goal, at the material level, was to transmute base metals – for example, lead – into silver and finally gold. Many alchemists were also seeking the secret of organic life, the reward for which would be the elixir of immortality. This is an especially marked theme in the distinct early tradition of Chinese alchemy as practised by the Taoist adepts. A curious by-product of the search for this elixir was the attempted creation of human life, the *homunculus*, by the initiate.

To state simply that the alchemists worked to produce gold loses sight of the work's spiritual dimension. In the earliest Greek writings, the account of material operations appeared alongside a description of a magical or spiritual reality attuned to the souls of the alchemists. The tradition as a whole insisted that the art could be attained by grace alone. In alchemy the stars and planets were a source of celestial energy that could be employed to materially "create". Hence, by purity of motive only, the natural energy of the heavens could be channelled to turn base metals into gold and, most spiritually, to find the secret of eternal life.

SACRED CALENDARS

From our perspective, day and night and the passage of the seasons occur "in" an abstract time, and it comes as a jolt to the imagination to realize that up until the very recent past humanity understood in a very practical sense that time comes from the sky. It is none other than the record of celestial motion: day and night and the seasons are time.

In almost all cultures the annual seasonal cycle of the Sun and the monthly phases of the Moon have been the foundation for the count of time beyond the day, but many different ways have been found to arrange these basic elements. Settled agrarian civilizations give emphasis to an orderly solar cycle, marking the Sun's annual passage on the ecliptic through the four great stations of the year, the equinoxes and the solstices.

Every calendar has to cope with awkward fractions: for example, there are approximately $29\frac{1}{2}$ days in a lunar month, and there are not 365 days in a year but just under $365\frac{1}{4}$. These fractions rapidly accumulate so that fixed festivals drift away from the phenomena they honour. The solution is *intercalation*, the periodic insertion of an additional unit of time, whether a leap-day or a lunar month, to bring time-keeping back into line with the heavens.

The earliest Hindu calendar described in the *Rigveda* (a book of sacred hymns composed *c.*1200BC) typifies the development of a combination of solar and lunar time-keeping. It runs in a cycle of twelve lunar months of thirty days each, with an additional lunar month intercalated every two or three

years after either the 4th or the 5th lunar month. The solar month varied between 27 and 32 days depending on the Sun's entry into each zodiac sign measured from the spring (vernal) equinox point. The corresponding lunar month started with the first Full Moon (North India) or New Moon (South India) after the Sun's entry into the sign. The great festivals were then placed in this temporal structure. For example, the date of Diwali, the Hindu Festival of Light, is established every year on the New Moon of the 8th month Kartikka (October–November). This celebrates the victory of Lord Rama over Ravana, king of the demons, and the annual visit of Lakshmi, goddess of prosperity; her way is lit by many candles so that good fortune is enticed into each house.

Mesoamerican civilization developed a system of time-keeping on a number-base of 20, superimposed on an early solar calendar of 365 days. With the help of the calendar, the Maya achieved accurate astronomical computations. They established the synodical period of Venus, when the Earth, Sun and Venus come into the same alignment, as just under 584 days. Thus five Venus synods (2,920 days) coincided with eight solar years of 365 days; the Maya held a ceremony every eight years, when they fine-tuned their Venus calendar to allow for the odd two-fifths of a day that it had fallen behind the true Venus cycle. Venus was the key planet for Mesoamerican culture; as the morning star it represented the Aztec god Quetzalcoatl, the Feathered Serpent.

This illustration from the Codex Féjérvàry-Mayer *shows the chief god Tezcatlipoca eating the palm of a sacrificial victim. Around him are the symbols of the twenty Aztec days.*

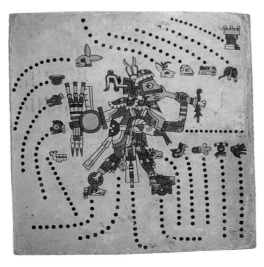

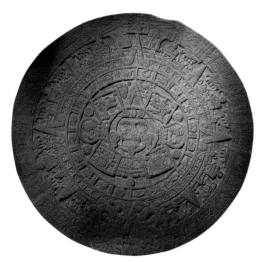

This 24-ton Aztec Sun Stone Calendar has the face of the Sun-god, Tonatiuh, in the centre, surrounded by the five ages of humanity. Then come the symbols of the days and stars, and finally the sky encircled by fiery serpents.

DAYS OF THE WEEK

French	Spanish	Italian	German	English
dimanche	domingo	domenica	sonntag	sunday
lundi	lunes	lunedì	montag	monday
mardi	martes	martedì	dienstag	tuesday
mercredi	miércoles	mercoledì	mittwoch	wednesday
jeudi	jueves	giovedì	donnerstag	thursday
vendredi	viernes	venerdì	freitag	friday
samedi	sábado	sabato	samstag	saturday

Planetary gods rule weekdays in an occult system established in the Roman Empire before AD100. Planets are laid in a circle in the ancient "Chaldean Order", reflecting relative planetary motion, from Saturn, slowest and outermost, to the Moon, swiftest and closest to the Earth. To define the week, begin at the Sun, then draw a straight line to the Moon. Continue to join the planets, without retracing your steps, until you have completed the seven-pointed star.

Modern time-keeping is deeply influenced by the stellar worship of ancient Babylon and Chaldea in ways that are now hardly recognizable, although they are still reflected in some European languages (see table, this page). The day of the Moon (Latin *Luna*) is immediately apparent; the Lord's day (Sunday) is solar in German and English. French, Spanish and Italian follow the Jewish Sabbath for Saturday, and show us the planets Mars, Mercury, Jupiter (Latin Jove, Greek Zeus) and Venus for Tuesday, Wednesday, Thursday and Friday. English explicitly gives Saturday to Saturn, while English and German borrow from Teutonic equivalents of the Latinized Greek gods for Tuesday (Tiw-Tir or Things, the German god Dien), Thursday (Donar-Thor, the thunder-god adopted in place of Jove), and Friday (Frija-Frigg, equivalent to the Latin Venus and the wife of Odin, the supreme Teutonic deity). The English Wednesday comes from Woden, the forerunner to Odin.

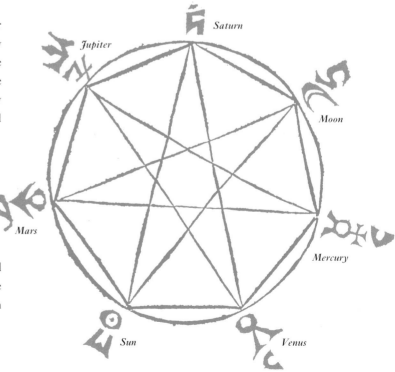

CHINESE ASTROLOGY

The enduring social coherence of Chinese culture over three millennia has ensured that it has assimilated expressions from other civilizations and made them uniquely Chinese, weaving them seamlessly into its own native tradition. This is certainly the case with the sciences of the heavens. There are parallels with Greek, Persian and Indian approaches, suggestive of borrowing in historical times, as well as common archaic origins, fused with distinctively Chinese developments.

The Western and Indian traditions are rooted in the ancient Mesopotamian and Egyptian observation of the horizon, through the heliacal (with-the-Sun) rising and setting of stars and planets, and the ecliptic, the Sun's annual path through the constellations. A metaphor from China's great sage Confucius (6th century BC) sums up the very different fundamental theme of Chinese astronomy: "He who exercises government by means of his virtue may be compared to the Pole Star, which keeps its place while all the stars turn around it." Chinese astrology and astronomy are both circumpolar and equatorial: they observe the northern circumpolar stars which never set at the latitudes of China, and pay attention in particular to their passage across the meridian (the great circle through the Pole and the observer's Zenith, the point directly overhead; see p.15).

The system of 28 lunar mansions, or *hsiu*, was established along the equator during the 1st millennium BC; they are in effect slices of the sky radiating out from the Pole. This

This image from a Chinese almanac shows the geomantic compass on the left. Geomancy (Earth omens), interwoven with astrology in the Chinese system, combined five cardinal directions (north, south, east, west and centre) with the five elements. On the right is the Spring Festival Cow.

approach based on equatorial moon stations has been found in Old Babylonian astronomy from before 1000BC, which suggests an early common origin for the system. The scholar Joseph Needham, in his monumental work *Science and Civilization in China* (1959), shows that the ancient forms of the ideograph of *hsiu*, showing a shed made of matting, offers a charming clue as to how the lunar mansions were conceived in early times: "these segments of the heavens must have been thought of as the temporary resting-places of the Sun, Moon, and planets, like the tea-houses scattered along the roads on Earth."

The *hsiu* marker stars were selected according to their approximation in RA (Right Ascension, the measure along the celestial equator) to the dividing lines radiating out from the Pole. Circumpolar stars, and especially the stars of the Plough (see pp.108–109), were then correlated with the equatorial moon stations; these stars were the abodes of the chief members of the heavenly bureaucracy, overseers of the earthly adminstration of the emperor, the "Son of Heaven".

The circumpolar conception also lends itself to a five-fold division of the sky. The 28 *hsiu* are grouped into four equatorial Palaces of seven *hsiu* each: these four are the Green Dragon, sometimes also called the Blue Dragon (east and spring), the Vermilion Bird (south and summer), the White Tiger (west and autumn), and the Black Tortoise (north and winter). The circumpolar sky forms the fifth region, the Central Palace.

THE FIVE AGENTS AND THEIR COSMOLOGICAL ASSOCIATIONS

	Wood	*Fire*	*Earth*	*Metal*	*Water*
palace	spring	summer	late summer	autumn	winter
planet	Jupiter	Mars	Saturn	Venus	Mercury
climate	wind	heat	humidity	dryness	cold
number	8	7	5	9	6
colour	green	red	yellow	white	black
flavour	sour	bitter	sweet	pungent	salt
odour	rank	scorched	fragrant	rotten	putrid
viscera	liver	heart	spleen	lungs	kidneys
animal	fowl	sheep	ox	horse	pig
emotion	anger	joy	sympathy	grief	fear

The associations in this table are found in the Nei Ching, the Yellow
Emperor's Classic of Internal Medicine, *which dates in its main outlines
from not later than the 4th century* BC.

This division brings astronomy into harmony with the ubiquitous symbolism of the "Five Elements" or "Five Agents", which emerges everywhere in Chinese occultism (see table, above). This cosmological theory is best known in modern times through Chinese medicine, especially acupuncture.

Horoscopes giving planetary positions as a means of reading character or fate are not characteristic of Chinese astrology until late in its history, reflecting an importation from the mature traditions of Indian and Islamic astrology; and where these horoscopes were used, there is evidence to suggest that their interpretation was overlaid by, or combined with, associations derived from the Five Agents.

The characteristic form of "Chinese astrology", known to the modern world, is a later development of an ancient method of fate-calculation derived from the symbolism of the calendar and a sexagenary (sixty-count) measure of the Four Pillars of Fate – the units of time comprising the year, month, day and hour of an individual's birth. The popular version of the "Chinese zodiac" takes one element of this count, the "twelve-branches" cycle, and applies it to years and occasionally to hours, symbolized through a cycle of twelve animals: rat, buffalo, tiger, hare, dragon, snake, horse, goat, monkey, cock, dog and pig. If a separate continuous count in fives for the Five Agents is introduced, we have a sixty-fold cycle. Hence, it will be sixty years before the wood-pig year is repeated.

The origins of the Chinese animal zodiac remain a mystery. Although attempts have been made to derive it from the zodiac of Western tradition, a common link has not yet been found.

*A polar star map from the Chinese Tun Tuang manuscript (c.AD940). Our
constellations of the Plough (Big Dipper) in Ursa Major (below) and
Cassiopeia (above) can be easily identified.*

MYTH AND THE SKIES

The constellations form a vivid panoply of mythical beings, all layered with narrative and symbolic significance. Helpless Andromeda lies chained to her rock with her tormentor the sea-monster Cetus nearby and the hero Perseus poised for her rescue. Gemini, the heavenly twins, are seated side by side, sharing a mother, but one with a mortal, one an immortal father.

The images that we ascribe to the constellations, well-known through the centuries to mariners, astronomers and farmers, took shape in the first civilizations of the Middle East with influences also from India and Egypt. Further adjustments to the *dramatis personae* were made by the ancient Greeks. However, the original Mesopotamian concept of the heavens can often be discerned behind the familiar Greek stories of heroes, heroines and monsters.

The projection of mythical figures onto the skies has a complex foundation, posing a problem of interpretation for modern scholarship. The perplexity emerges as soon as we look beyond practical elements, such as the needs of hunters or farmers to keep track of the Moon and the seasons. The mythical accretions imposed on these practicalities represent a complex mixture of human aspirations, intimately bound up with religion, myth and poetry. It seems easier to deal objectively with Egyptian calendar-construction than it is to be sure what the experience meant for the Egyptian who depicted the Sun as Ra, seated in his boat on the back of the sky-goddess Nut.

The attitude of the 18th-century Enlightenment, still flourishing in modern guises and hostile to all symbolism, might

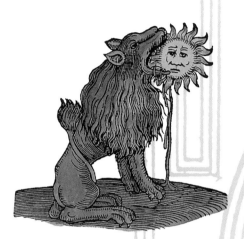

The Green Lion devouring the Sun, an alchemical symbol. The great psychologist Carl Jung saw the symbols of alchemy and astrology as part of the symbolic quest toward the whole self.

consider the worldview of an ancient Egyptian to be of purely antiquarian interest. The characteristic belief of an earlier age that myths were allegories of nature or the soul was shaken off. In place of interpretation, myths were classed as bizarre amplifications of spurious causal connections arising from poor observation or faulty data. Individual myths were sometimes explained as elaborations of historical events, an approach known as *euhemerism*, after Euhemerus of Messene (311–298BC), who taught that the Greek gods were in fact elevated human kings and heroes.

Interpretations of myth have taken a variety of routes beyond this rationalistic impasse. The Scottish scholar James Frazer (1854–1941) exemplifies the view that myths, especially fertility motifs, are survivals of an earlier phase of cultural evolution, reflecting humanity's struggle to master nature first through magic, then through the gods and religion. The "historicist" interpretation, on the other hand, relates myth to real processes of history – such as the replacement of one theological system by another through invasion or cultural assimilation. An illustration of this is when, in ancient Greece, the monstrous female serpent Python, protector of the Delphic oracle, was defeated by the Sun-god Apollo, to whom the site was later dedicted: this marks the overthrow of the old, possibly matriarchal cult by a new, patriarchal order. The astronomical interpretation of myth (see p.36) parallels the view that myths reflect humanity's repsonse to nature by locating a primary theme of myth in the dislocation of calendars and cosmologies resulting from celestial changes, especially precession (see pp.36–7).

Distinct from both the naturalistic and historicist trends stands the Romantic interpretation of the 19th century, which sees myth as an imaginative vehicle by which humankind gives symbolic expression to spiritual ideals. This kind of "mythopoeic" creativity is not confined to advanced civilizations like those of ancient Egypt and classical Greece. The French anthropologist Lucien Lévy-Bruhl (1857–1939) suggested that "primitive mentality" is characterized by a mythmaking capacity: the "primitive" mind is capable of understanding ordinary logical categories such as causation in

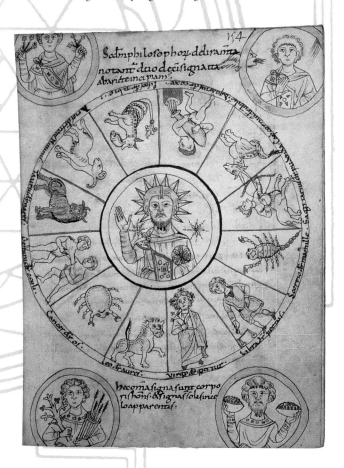

our terms, but has not lost the capacity to directly perceive and respond to a supernatural realm all around us. Omens, gods and spirits are real, and their world is the world recorded in myth. The mythopeic approach was overshadowed by the "structuralism" of Claude Lévi-Strauss (born 1908), who showed how myths reflect underlying patterns of social and cultural organization. However, Lévy-Bruhl's concept of mythopeic thought, coupled with the Romantic attitude to myth as spiritual revelation, sets the scene for the contribution of psychology, especially the work of Carl Jung (1875–1961).

Jung's thinking complements the astronomical interpretation by fleshing it out with a subjective dimension, related to the workings of the unconscious, as illustrated by his study on precession (see pp.36–7). He interprets the symbolism assigned to stars and planets as a residue of the collective unconscious, a part of the mind that responds to certain in-built universal symbols, or archetypes. Symbol systems such as astrology and alchemy enable us to create a language of the soul's journey toward its mystical fulfilment in the path of "individuation" – the process of forging the self. The single most important process or function on this path is the mind's creation of the "self archetype": this is most often shown as the Sun, but also as the mandala (an Eastern meditation symbol), which Jung interpreted as a symbol of balance and wholeness. The circle of the twelvefold zodiac constitutes such a mandala, and Jung believed that the twelve character types depicted in the signs, together with the dynamic attributes of the seven traditional planets bringing movement and change into the picture, made astrology "the psychology of antiquity".

Historic depictions of skylore abound in archetypal imagery, in the Jungian sense. This detail from a 9th-century manuscript shows Christ in the guise of the Sun surrounded by the signs of the zodiac. The Sun in turn was viewed as an archetype of the self.

53

SUN, MOON AND PLANETS

The ancient Greeks knew of only five planets – Mercury, Venus, Mars, Jupiter and Saturn, which together with the Sun and Moon, were "wandering stars" (the Greek word *planetes* means wanderers), moving against the background of apparently "fixed" stars. European and Indian astrology have sustained a rich planetary symbolism into modern times, and we even see traces of the mythological process at work in the newly discovered planets, Uranus, Neptune and Pluto (see pp.20–21). The following chapter shows how the Sun, Moon and planets, all rich with associations, have exerted a hold over the imagination since ancient times.

Right: *This illustration showing the Sun held aloft in the heavens is taken from a 14th-century treatise on astronomy. The symbolism surrounding the Sun extends across all cultures and is remarkably consistent, suggesting life, fertility and creation. In astrology the Sun and the Moon are numbered among the "planets".*

Right: *An illustration from the Dijon Bible, showing the planets and their spheres according to the Ptolemaic view of the cosmos: in Ptolemy's system the Earth, not the Sun, was at the centre. Here the order, radiating outward, is the Moon, Mercury, Venus, the Sun, Mars, Jupiter and Saturn. Personifications of the planets sit across the top, with Saturn (centre), flanked by the Sun and Moon; Mercury has a winged helmet, while Mars is characteristically shown with weapons.*

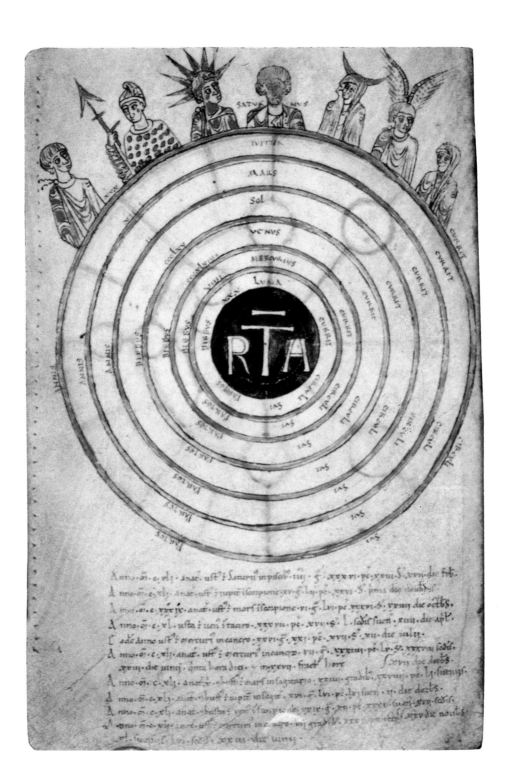

THE SUN

Nowhere else in the heavens is the contrast between science and myth more marked than in our conceptions of our greatest heavenly body, the Sun. This one phenomenon has produced two distinct truths through time.

In scientific understanding the Sun is an unexceptional star, just one out of thousands of millions of stars tenanting the inconceivable vastness of our patch of the universe. This incandescent sphere of mainly hydrogen gas, in permanent nuclear fusion at its core at temperatures in the region of 73 million degrees Farenheit (20 million degrees Celcius), is source and sustainer to a system of planets orbiting around it. The planets, together with asteroids and various comets, are the coalesced remnants of material spun off at the time of the Sun's own formation from an enormous supernova explosion in our galaxy around 4,000 million years ago. Everything else in the Solar System is a fragment by comparison – the Sun is 1.3 million times the volume of the Earth, and a third of a million times its mass.

A spiral Sun-symbol from an engraved stone found in Gotland, Sweden (5th century AD). Motifs such as these were common in northern Europe during the Bronze and Iron Ages.

The dependence of Earth-life on the Sun is total. Apart from meteoric material or interstellar dust straying into our planetary system from remote space, everything lives by the same source: earth, air and sea, minerals, plants, animals and the mystery of human life itself. Science becomes infused with poetry when we consider the perfect balance of life on Earth, delicately attuned to the light and heat of the Sun.

Although the Sun must have impressed itself on human imagination from the dawn of consciousness, there appears to be a distinct evolution in its symbolic or mythic treatment. Symbolic suns have occasionally been found in prehistoric sites, such as the Matopo Hills in Zimbabwe, but this is not generally a striking feature. Most cave paintings of Upper Paleolithic times (*c*.40,000 years ago) do not offer any representations of the Sun: their art is focused on the fertility of the female, and on animals of the hunt. However, we should not oversimplify our conclusions concerning the earliest hunters. The German anthropologist Leo Frobenius (1873–1938) travelled through the Congo jungle with several natives as his guides. One evening, he suggested to his companions that they should hunt an antelope to augment the food rations. The guides were astonished at the white man's request, as correct "preparations" had not been made, and these would have to wait until the next day. At dawn the natives cleared a patch of sand and drew the outline of an antelope on it, then waited for sunrise. As the Sun rose, a sunbeam struck the image. At once one of the natives fired an arrow into the neck of the image in the sand, while a woman raised her arms to the Sun and cried out. The hunters then ran into the forest. Soon they returned with a fine antelope shot through the neck. The ritual was completed by placing hair and blood from the animal onto the sand figure, before erasing the image.

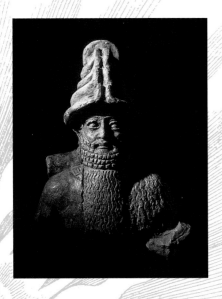

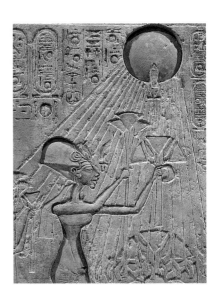

Right: *The Egyptian queen Nefertiti making an offering to the Sun god, as the solar disk Aten, from which hangs the "ankh", symbol of the rising Sun. The images appear on a freestanding limestone tablet (stele) of the 18th Dynasty.*

Left: *A Babylonian terracotta statuette (2000–1750BC) thought to represent the Sun-god Shamash, the son of the Moon-god Sin and brother of the love-goddess Ishtar. The three represent the divine Babylonian triad.*

From its association with the great hunter – clear sight, the arrow (like the sunbeam) that goes straight to its prey – there is a distinct evolution in the symbolic meaning of the Sun, which seems to arise with an advance in settled civilization.

This change can be traced in the myths of several cultures in which the Sun begins simply as one minor mythic character among many. For example, in Greek myth Helius, the Sun, the offspring of the Titans Hyperion and Theia, was given inferior status. We know that he was thought to travel westward across the sky, heralded by Eos, the dawn, but there are few myths about Helius himself. Only later did mighty Apollo strip Helius of his attributes to become himself the glorious Olympian Sun-god.

In one story about Helius and his son Phaethon, every day Helius drove his four-horse chariot across the heavens. One morning he gave way to Phaethon's insistent demands to drive the chariot, but the youth could not control the horses. First they raced far above their usual course and the whole Earth shivered; then they careered so close that the fields became parched. Annoyed at this disorder, Zeus struck Phaethon dead with a thunderbolt. This myth contains a calendar reference, attributable to the Hittites and then to the Mesopotamians, of renewing the year at the midwinter solstice. In an ancient

Mesopotamian ritual, the old king "died" at the solstice, and for a day a boy took his place as king. At the end of the day the boy was sacrificed. At Corinth, in Greece, a similar ritual took the form of dragging him from a Sun-chariot pulled by bolting horses. Then the old king, who represented the Sun, emerged, reborn from hiding to renew his yearly round.

One of the earliest civilizations to establish an enhanced status for the Sun was ancient Egypt, from the 3rd millennium BC. The Sun, in his aspect as the solar disk, was termed Aten; but depending on whether he rose, culminated or set, he was given successively the names Khephri, Ra or Atum. He was also Horus, the falcon-headed god later identified by the Greeks with their Sun-god Apollo.

A particularly evocative symbolism evolved around Khephri, the sunrise god. He was represented as a scarab-beetle, who rolled the ball of the Sun over the horizon. The hieroglyph for the scarab eventually evolved into the astrological glyph for Cancer, the sign associated with the midsummer solstice. The glyph symbolizes for later times, as it did for the ancient Egyptians, the perpetual fertility and renewal of life.

The culmination of the Sun's status in ancient Egypt was reached in the brief religious revolution of Pharaoh Akhenaton (meaning "glory of Aten") in the 14th century BC. He exalted

the Sun as the creator of mankind, proscribed all other gods, and declared himself sole intermediary between the Sun and the Earth. This idea was to recur in later centuries, most impressively with the solar cults of Helius and Apollo, which developed around the figure of the Roman emperor.

The story of Sun-worship in Rome interweaves different strands of celestial symbolism, often serving the purposes of political propaganda. The first strand was the cult of Mithras, imported into Rome from Persia. Mithras was a bull-god, linked with the constellation Taurus (see pp.106–7); he was often shown banqueting with the Sun. Yet in a paradoxical inversion so characteristic of mythology, he was also depicted as a solar god who slew the bull. In this form he was known as Helius, the Sun-god, and also as *Sol Invictus*, the invincible Sun.

The second strand derived from the cult of the Phoenician Sun-god Baal, who was worshipped in the form of a black stone. Baal became popular in the Roman Empire in the 2nd century AD. In 218AD, when Elegabalus became emperor as *Sol Invictus Elegabalus*, the cult of the Sun was founded as an official religion. Aurelian (reigned AD270–275) adapted the solar cult to accord better with traditional Roman religion under the title *Deus Sol Invictus* – god, the invincible Sun. This lasted until the reign of Constantine (4th century AD), when Christianity took root, banishing (and at the same time assimilating) its solar rival. The festival of *Sol Invictus* was later celebrated on December 25, the date adopted by the Christians for their own invincible king.

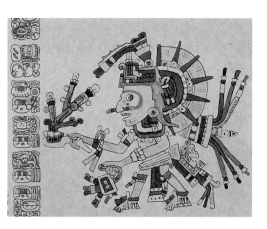

The Aztec deity Quezalcoatl, with whom the emergence of the Fifth Sun is associated. It was Quetzalcoatl's task in the era of the Fifth Sun to create humankind. He also represented Venus.

Sun-worship reached its most dramatic status in early Central American civilization. The Aztec epic of creation ends with the generation of the Fifth Sun, following the four previous eons, the Suns of earth, wind, fire and water. In this culture the gods themselves must be sacrificed to make the Sun move. One by one, the feathered-serpent god Quetzalcoatl cuts out their living hearts with a sacrificial knife, and by this act the moving Sun, Nahui Ollin, is created. This is the basis for the terrifying human sacrifices to the Sun carried out by the Aztecs.

The Sun symbolizes truth and integrity: "know thyself" runs the motto at the Delphic oracle, sacred to the god Apollo at Corinth in Greece. But the apparent brightness of the Sun conceals a mystery. The great neo-Platonic philosopher of the Italian Renaissance, Marsilio Ficino (1433–1499), taught that we "see" with two faculties, one of the concrete mind of ordinary thought, and one of the higher intellect. In his poem *De Sole*, his last major work, Ficino shows that the Sun has not one but two lights: the ordinary light of earthly senses, and a hidden, occult light – the inspiration of astrology.

This idea of the "hidden light" of the Sun is found among the Pueblo peoples of North America who teach that Oshatsh, the physical Sun, despite his blinding brilliance, is a shield to protect humankind from the light of the one Great Spirit. Such profound intuitions, which are consistent with our own Western preoccupations, remind us of the relevance and subtlety of thought found in innumerable myths of many ancient non-Western cultures.

THE MOON

Having a diameter of 2,160 miles (3,476km) compared with the Earth's 7,927 miles (12,714km), the Moon is larger than any other satellite in the Solar System. In some respects it is like a twin planet to the Earth. The two bodies are gravitationally yoked to each other so that the Moon's rotational period around its axis exactly matches its orbital period around the Earth (27⅓ days): this means that we always see the same face of the Moon, and that its far side is hidden from an Earth-bound gaze. There is, however, an essential difference between our planet and our satellite: the Moon is a dead world, with virtually no atmosphere, no surface water, and no chance of life as we know it.

As with the planets, we are able to see the Moon only by reflected light. The crescent of the New or Old Moon, or the complete disk of the Full Moon, is illuminated directly by the Sun, giving a cycle of phases lasting 29½ days, waxing from New through first quarter to Full, then waning through third quarter to its disappearance at the "Old Moon", ready for the next New Moon. We sometimes see a beautiful phenomenon in the evening sky known as "Earthlight", or the "Old Moon in the New Moon's arms"; that is the shadowy effect produced when light reflected from the Earth falls upon the dark part of the lunar disk, hidden from the Sun's light.

As the satellite of a middle-sized planet, the Moon is of a quite different order to the Sun in the astronomical scheme. However, from our Earth-centred human perspective, the Sun and Moon are a heavenly duo. They are the two great lights of

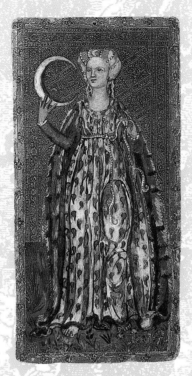

A Tarot card representing the Moon. In Tarot divination the Moon is said to foretell hidden perils, illusion and deception.

the sky, almost universally seen as the twin rulers of day and night. There is, in addition, the extraordinary circumstance, almost belonging more to myth and poetry than to astronomy, that despite their vastly different distances they both appear to be approximately the same size.

The symbolism associated with the Moon across different cultures and epochs initially seems bewildering in its diversity, and is often complex and paradoxical when compared with the relative consistency of meanings usually given to the Sun. Yet this elusiveness is in its own way a true expression of the ever-changing and inconstant night luminary. The Moon appears to have had greater eminence than the Sun in prehistoric times, and it is believed that in most cultures the calendar started as a count of the "lunar months", rather than the solar seasons. In a similar vein, many megalithic sites with astronomical associations are dedicated to tracking the orbit of the Moon. The name of the Japanese Moon-god, Tsuki-Yomi, is derived from the Japanese words meaning "moon" and "counter".

The ancient Egyptian Moon-god Thoth, sometimes shown with the head of a dog, or as a baboon wearing the Crescent Moon on his head, shows an ancient priestly interpretation of the fact that as the Sun and Moon rise and set, they replace one another in the sky. As the Sun-god Ra made his underworld journey in the hours of darkness, Thoth was required to take his place in the upper world. In some accounts Ra actually created the Moon to illuminate the night sky and put Thoth in

charge of it. Thoth was also responsible for regulating the calendar. He taught humanity the arts and sciences, and was interpreted by the Greeks as the god Hermes. In a later epoch, the Moon-god Thoth became the inspiration for the "hermetic" tradition of Greek, Islamic and European occultism.

The Moon's function as regulator over the menstrual cycle (from the Greek word *menses* meaning "moon") gave it an association with fertility in ancient times, and as patriarchal societies took over from matriarchies the Moon appears to have been allotted an increasingly feminine role, with the Sun taking the masculine part. A characteristic illustration of the feminine Moon in her most benign aspect is provided by the Moon-goddess Ch'ang-o, or Heng-o, one of the most popular figures in Chinese folk belief. The Festival of the Moon, held on the Full Moon following the autumn equinox, is one of the three great annual feasts. It is dedicated solely to women and children, and men do not take part. Figurines are prepared in the form of a rabbit, or a soldier with the face of a hare, both lunar animals, and children make offerings directly to the rising Moon. In Chinese myth Ch'ang-o was the wife of the archer I, who was granted the elixir of immortality for saving humanity by shooting down nine of the ten suns when they rose together and threatened to shrivel the world. One day, I returned home to find that his wife had drunk the elixir, and he chased her to the Moon. The lunar hare offered protection to the woman, and forced I to desist from his pursuit. To this day Ch'ang-o is said

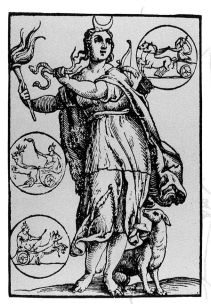

The Roman goddess Luna, from Mythologiae *by Natalis Comitis (1616), shown with her attributes: the crescent Moon on her head, the torch in her right hand, a bow and arrows on her back, and a dog at her feet.*

to live on the Moon, a model of beauty and modesty.

Today we perhaps tend to take for granted the feminine symbolism of the Moon, yet it has also notably been treated as masculine – as in its embodiment as Thoth in ancient Egypt. The Japanese lunar Tsuki-Yomi is a male god, and in early Mesopotamian mythology Sin the Moon-god was an old man with a beard, the most important deity of the triad Sin, Shamash the Sun-god, and Ishtar, who was a representation of Venus.

In the mythology of Brahmic India, the Moon is said to be where the departed souls go. The notion of the Moon as a realm of the dead brings us to a further tension in its symbolism. Its phases can suggest an analogy with organic cycles and the realm of nature, as in the mythology of parts of South America, where the Moon is thought to be the mother of grasses. In ancient Mesopotamia some people considered the heat of the Moon, rather than the more likely Sun, to be the energy force by which plants grew. At the same time, however, the phases of the Moon have implied to some peoples decay and death. This life-death paradox is contained in the Moon as Triple Goddess, a myth-motif that appears in many guises, especially where we find a female trinity, as in the three Fates, or the three witches. In the world of ancient Greece, poets saw the virgin huntress Artemis (known to the Romans as Diana) as "the goddess with three forms", her other two aspects being Selene, the Moon in the sky, and Hecate, a mysterious goddess of the lower world. The

Triple Goddess can be interpreted as three phases of the lunar cycle: the silver bow carried by Artemis represents the crescent New Moon, Selene is the mature Full Moon, and Hecate is the dark of the Moon. Hecate herself carries the same three-fold symbolism, and is often described as having three bodies or three heads. She wanders among the souls of the dead, and her approach is announced by the howling of dogs. She dwells on tombs and lonely places where two roads cross, and teaches the arts of sorcery and witchcraft. Sometimes she was depicted as an old crone, showing the last moments of the Moon's cycle, and libations were offered to her at the end of every month.

The Moon's influence on the Earth's tides is reflected in its mythological association with water. For example, in the Brahmic myths of India, the god Soma (a named derived from its link with the hallucinogenic substance *soma*, said to have been the food of the gods, contained in the mythical elixir of immortality) was associated with Candra, the deity of the Moon, and concurrently represented the waters of life. Germanic folk-tale links the Moon with water and trickery. One of the most popular tales is that of the fox who convinces a wolf that the reflection of the Moon in a pool of water is a girl bathing. The wolf dives into the water in an attempt to claim the "girl", and drowns as a result.

The phases of the Moon are also accounted for in mythology around the world. In Maori myth the (male) Moon kidnapped the wife

The Moon, like the Sun, has often been depicted as a figure borne by a chariot across the sky – as in this roundel from a 13th-century stained-glass window. Luna *is Latin for "moon".*

A painting on the inside of a Greek bowl dating from c.490BC, showing the Greek Moon-goddess Selene in her chariot, pulled by two horses. In Greek myth Selene was the daughter of the Titans Hyperion and Thea. She became the lover of Endymion, the king of Elis in the Peloponnese, by whom she had fifty sons. Selene wanted Endymion to live for ever, and so put him into a magic sleep in which he remained eternally young.

of the god Rona. Enraged by the abduction, Rona is said to have confronted the Moon, and now they are for ever locked in battle in the sky. As the Moon wanes it is said to have become weary of fighting and needs to rest, which it does during the waxing period of the cycle; when the Full Moon reappears, the fighting commences once more.

In psychological and astrological symbolism, the Moon stands for the subliminal realm, the subdued light of the unconscious as opposed to the brighter illumination of the conscious mind, and it carries the soul-image as compensation for the bright ego-consciousness represented by the Sun.

MERCURY

Mercury, which is less than half the diameter of the Earth, is the smallest of all the planets. It is also the closest to the Sun, at 36 million miles (58 million km). Viewed from the Earth, Mercury never appears to be at a distance farther than 28° from the Sun, and over its 88-day orbit it seems to shuttle back and forth (through retrograde motion; see pp.20–21) in attendance upon the great luminary, as befits its ancient mythological interpretation as herald or messenger. However, its closeness to the Sun obscures it from casual naked-eye observation, and it can only be satisfactorily seen, briefly, under ideal conditions at sunrise or sunset in early spring or autumn.

From 1924 to 1929 the astronomer Eugene Antoniadi made detailed observations of Mercury. Through his giant telescope, he saw dark patches on the planet's surface, to which he gave names from Greek and Egyptian myth, such as Apollonia, Horarum and Aurora. He believed that he had seen a planet with vast dusky areas as mysterious and engaging as the characters after which he had named them. However, later space-probe observation showed that none of these patches was real.

For the astrologer-priests of ancient Mesopotamia, Mercury was the god Nabu, and in honour of him a cult was established with its principal centre at Borsippa, a city a few miles to the south of Babylon. There are now only sparse accounts of this cult, but it is known that *c*.1000BC Nabu replaced an early Sumerian goddess Nisaba (or Nidaba) as the patron of scribes. Nabu was the son of royal Marduk (equivalent to the Roman god Jupiter), and any variation in the condition of the planet Mercury presaged change for the son of the king, the crown prince. However, Nabu's most important function was to be the scribe of the gods. On the seventh day of the spring festival marking the Mesopotamian New Year, he rescued Marduk from captivity, symbolizing a restoration of authority and order for the year to come; and on the eleventh day the gods gathered to decide the destiny of the world, while Nabu recorded their judgments.

As Nabu, Mercury was known to the Sumerians as a rain-maker, which possibly derived from his link with good harvests. This in turn may be the origin of Mercury's association with trade in the time of the ancient Greeks and Romans.

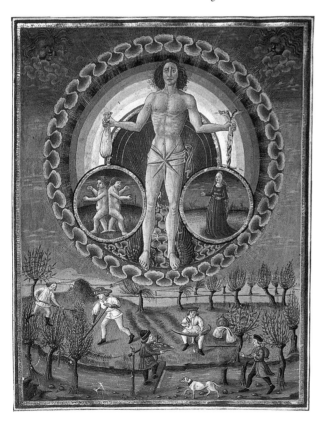

The planet Mercury from the book De Sphaera *(15th century). In his right hand the figure holds a bag of coins indicating his role in commerce, and in his left he holds the caduceus (a magical wand entwined with two snakes, said to be a symbol of peace and to have healing powers). Contained within the circle are the zodiacal signs over which the planet is believed to have influence: Gemini on the left and Virgo on the right. On the ground are the people who are guided by Mercury – a traveller, harvesters and a merchant.*

Several European languages have kept the Latin root of *mercurius* in words such as *merch*ant and com*merce*.

The god Mercury is the Roman equivalent of the Greek god Hermes. Originally he was a phallic fertility-god and the god of travellers. The literal translation of the name Hermes is "he of the stone heap"; the god was honoured by a pile of stones at the wayside, to which each traveller would make an addition – a tradition followed by climbers and walkers today. He also guided the souls of the dead to the underworld, wore a cap of invisibility and was a messenger to the gods.

Mercury's divine nature was established from the day of his birth. Before noon on that day he had invented the

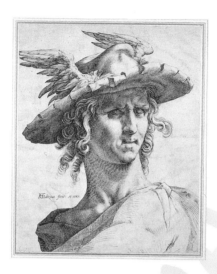

This drawing of 1587 by Henrik Goltzius shows Mercury as a youthful boy in a winged cap (an alternative to his winged sandals). According to Julius Caesar, Mercury was the most widely worshipped god of the Gauls and Britons.

lyre, and before the day was out, as if to show his trickster qualities, he had stolen the cattle of his brother Apollo. He separated fifty heifers from the herd, and at night drove them down from the mountain. To disguise their tracks he made them walk backward, and he disguised his own footsteps by wearing enormous sandals. Apollo was furious, but Zeus was charmed by the clever child and made him his cup-bearer. Some of the oldest depictions of Hermes show him as an old man with a long beard, but the classical Greek Hermes was a beautiful youth. In astrology he is often conceived as being an embodiment of both sexes – the "hermaphrodite".

An important strand in the story of Mercury comes from Egypt. In the Hellenized (Greek-dominated) world of the late centuries BC, we find the widely accepted attribution of Mercury as the Egyptian god Thoth. However, in the early

Dynastic period of the 3rd millennium BC, Thoth had been a Moon-god, albeit with many of the characteristics attributed to Mercury. He was the patron of science and literature and the god of medicine. Like Hermes, he was also the messenger and scribe of the gods. This shift in attribution from the Moon to Mercury is a clear example of cultural assimilation under strengthening Greek influence during the 4th century BC.

This same period saw the distinctive naming of Mercury as Hermes Trismegistos, an aspect of the god's symbolism in later magic and alchemy. The Egyptian Greeks frequently called their gods *megistos*, meaning "greatest". Reflecting the Egyptian practice of intensifying an adjective by repetition, the god Thoth-Hermes seems to have had his epithet *megistos* stated three times – that is, greatest-greatest-greatest Hermes, which was abbreviated to *trismegistos* or "thrice greatest". Before long the name Hermes Trismegistos had become established in its own right. This god was credited with passing on to humankind medicine, magic, astrology and alchemy. In European alchemy we find him in his Latin form, Mercurius – the goal of the alchemical work and the secret guide to the adept, sometimes a Christ-figure and sometimes a trickster or a dragon, guarding the secret of the Philosopher's Stone.

In astrology it is believed that those people who are born under the influence of the planet Mercury are quick-witted, crafty and alert, and are able to think and talk lucidly and fluently. However, they are also believed to have a tendency to fickleness.

VENUS

Venus is sometimes referred to as a twin sister of the Earth, and there is a kinship in the purely physical dimensions of both planets. Venus is close in diameter to the Earth, at 7,600 miles (12,231km) compared with the Earth's 7,927 miles (12,757km), although it is lighter, having seventeen percent less mass. Venus revolves around the Sun in 225 days at a distance of 67 million miles (108 million km), which places it inside the Earth's orbit, as an inferior planet. The effect of this from the Earth is that Venus, like Mercury, appears to travel through the sky close to the Sun, its maximum elongation never exceeding 48°. One day on Venus is equivalent to 243 days on Earth, which means that Venus takes longer to revolve on its own axis than it does to orbit the Sun. Furthermore, Venus revolves in the opposite direction (east to west) to that of most of the other planets in the Solar System, setting itself apart not only by virtue of its exceptional beauty, but also by its physical characteristics.

A planet's visibility depends on its ability to reflect light from the Sun. The dense cloud atmosphere surrounding Venus permits a large proportion of the light falling on the planet to be reflected, and as a result at certain phases Venus will outshine any object in the sky apart from the Sun and Moon. On a moonless night with good weather, it is possible to observe the shadows cast by the blue-white Venus-light.

Cross-cultural comparisons of the symbolism of Venus reveal as many differences as similarities. The light of Venus, which to most Europeans seems so beautiful, is viewed with caution in traditional Chinese astrology. Venus was called

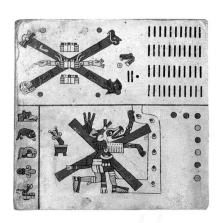

Venus is alternatively seen as the morning or the evening star. This illustration from the Codex Féjérváry-Mayer shows the Aztec god Xolotl, Venus as the evening star, at the crossroads of fate. The god later became the mythological twin of the supreme god Quetzalcoatl, the morning star.

"Grand White" on account of its colour, but in China white is often considered unlucky, ominous and ghostly. Wherever Grand White appeared in the sky, it was taken to signify arms and punishment. This association stems from its belonging to the negative, dark, yin principle (as distinct from the positive, light yang). The appearance of Grand White in daylight (which may happen after just sunrise or sometime before dusk when Venus is near to maximum elongation) implied the yin overcoming the yang, and therefore trouble for the sovereign from the lower orders. Such reactions, of course, depend upon the persuasion of the participants; for example, just six days after Li Yuan formally took the throne from the disintegrating house of Sui to found the illustrious T'ang dynasty (which lasted for three centuries), Grand White appeared in the blue daylight sky (June 24 AD618) and was interpreted as a celestial blessing. Grand White's secondary name "Metal Fire" connects the planet with metal, one of the five elements of Chinese metaphysics, and suggests the association of the bright flash of Venus with light reflected from weapons.

The warlike aspect of Venus is particularly evident in Mayan myth, for example, in its association with the daylight and rain-god Chac, who was identified with Tlaloc, the Aztec god of rain and disaster. The Maya established in the 4th century AD a ritualistic institution, termed "Tlaloc-Venus warfare", involving the conquest of territory and the taking of sacrificial victims. Furthermore, decisions on when and where to do battle were timed to the cycles of Venus and Jupiter.

However, this is only one facet of the leading role played by Venus in Mesoamerican culture. The most important of all the gods, the plumed serpent Quetzalcoatl, was identified with Venus as a morning star, rising in the east just before dawn. The evidence of the Venus table of the *Dresden Codex*, which dates from around the 12th century, gives a clear picture of the Mayan ritual calendar-system, integrally linked with observation of the planet. Mesoamerican sky-watchers had at an early period gained an exact understanding of the 584-day synodic cycle of Venus as the planet goes through its phases of morning and evening star. The "Venus table" records 65 of these 584-day cycles: in all, 37,960 days. This coincides with 146 of the 260-day counts of the Mayan calendar, and 104 365-day solar years of the Maya people. These exact multiples within the Venus cycle elevated the planet's standing among the Mayans above that of any other. At his heliacal rising (when he is first observed rising just before the Sun), the planet-god Quetzalcoatl is shown throwing the spears of his dazzling rays and impaling his enemies.

In some parts of ancient Mexico, Venus was regarded with fear. The indigenous peoples would lock their windows and doors before sunrise to protect themselves from Venus' harm-

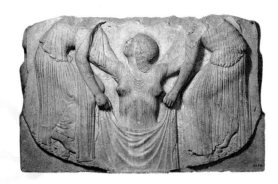

An ancient Roman stone relief depicting the birth of the goddess Venus (equivalent to the Greek goddess Aphrodite). Venus was born, fully formed, from the castrated genitals of the god Uranus as they fell into the sea.

A medieval depiction of the planet Venus. The figure is seen with the zodiacal constellations over which she rules: Libra on the left and Taurus on the right. The planet's glyph is shown beneath the morning star emblem on the right of the picture.

ful rays, which they believed would bring disease and death, as it rose alongside the Sun.

The Mesopotamian interpretation of the heavens gives us glimpses of a Venus different from the planet of love in our usual, Western understanding. The original Sumerian deity associated with Venus was Inanna, but the influence of this goddess was overlaid and then compounded with Attar, a Semitic male deity, who was adopted into Mesopotamian myth. The god Attar then developed into the the goddess Ishtar, the result being a bi-sexual Venus: Ishtar the morning star is male, while Ishtar the evening star is female. As an example of the transcendent nature of these interpretations, Ashtar was also identified with Astarte, who became one of the origins of our celebration of the festival of Easter (see p.88).

In her feminine aspect, Ishtar was part of the great Mesopotamian triad of the Sun, Moon and Venus. She was the daughter of Sin the Moon and the sister of Shamash the Sun. Two groups of women were engaged at her temple: sacred prostitutes and commercial whores (one of Ishtar's epithets is "she who loiters"). This sexual image of Ishtar provided the foundations for the identification of the Greek goddess Aphrodite as the ruler of erotic love.

MARS

At 142 million miles (229 million km) from the Sun, and with an orbit of 688 days, Mars is the first of the planets beyond our own. It is relatively small, a little over half the diameter of the Earth, but its closeness to us ensures that it appears quite bright. It has two moons, Deimos and Phobos, the latter being so close to Mars' surface that it orbits the planet in seven and a half hours. The atmosphere of Mars is similar to that of the Earth. It seems to have water and oxygen and a surface temperature which can reach 77°F (25°C). Hence, some form of life as we know it is a possibility.

For several centuries Martian features observed through a telescope have excited hopes of an extraterrestrial civilization. The most important of these features are the "canals", curious lines which appear too regular to be natural phenomena. Recent satellite probes have established that, apart from a huge canyon, known as Agathodaemon or Valles Marineris, these are, disappointingly, products of an optical illusion. More recent speculation has surrounded unexplained pyramid-like formations clearly visible from satellite pictures.

Symbolically, Mars shows more cross-cultural consistency than the other planets, perhaps as a consequence of the distinctive red hue, produced by the concentration of iron oxide on its surface. Red has been universally associated with fire and blood. Furthermore, Mars rules iron, a metal which rusts red during oxidization, is used for weapons, and is smelted in fire.

The planet Mars from an English "shepherd's calendar" (1497). He is seen with fire and the zodiacal signs Aries and Scorpio over which he rules.

In China, the red planet was associated with the element fire, the heat of summer and the heart. The Taoist alchemists saw it as Cinnabar, red mercuric sulphite. The origin of Mars' common name "Sparkling Deluder" remains unaccounted for, but its secondary titles, "Star of Punishment" and "Holder to the Law", are understood through the connection of Mars with the maintenance of civic ritual, a vital element in China's Confucian culture. Its heat was thought capable of producing drought. A typical application of the law of correspondences held that when Mars was in the "Well" star-field – the 22nd lunar mansion *Ching*, around western Gemini – it portended the drying up of wells; and since this star-group also stood for the capital city, wells there would be especially affected.

From the time of the first civilizations of Mesopotamia, Mars has taken on a malevolent identity as lord of the dead, bringer of pestilence and war. His earliest known form was the Sumerian Lugalmeslam, ruling the lower world to which the Sun travels every night. Early on, this deity seems to have become assimilated to Nergal, the main representative of Mars for the Mesopotamians. Called to account for insulting the emissary of the goddess of the underworld, Ereshkigal, Nergal was ordered to descend into her realm; but he was forewarned by the god of wisdom, Ea, to accept nothing from the goddess. Ereshkigal's attendants brought a chair, but he would not sit; they brought him bread

and beer, but he would not eat or drink; they brought him a footbath, but he would not wash. Ereshkigal then went to bathe, and allowed Nergal to get a glimpse of her body; at first he resisted, but when the beautiful goddess repeated the performance Nergal gave in. They made love for six days and on the seventh day Nergal went back to the upper world. Erishkigal threatened to raise the dead until there were more dead abroad than living unless her lover was returned. The not-unwilling god was then pulled back to share rulership of the underworld with Ereshkigal.

This tale has a number of significant parallels. Firstly, there is a related Mesopotamian tale of Ishtar (Venus to the Romans) descending into the underworld, and the two stories are clearly intended to be understood together. Further, the pairing of Nergal and Ishtar is a theme that recurs throughout the later symbolism of Mars and Venus.

In classical myth Nergal was readily assimilated to the Greek god Ares, who for the Romans was Mars, the god of war. The Greeks held Ares in low account, but the Romans exalted Mars as a military god. Ares/Mars loved war for its own sake, and like a mercenary was indifferent to the rights and wrongs of the parties for whom he fought. Most of the other gods despised him, except for Eris, the goddess of strife, and Aphrodite (Venus), over whom he exercised a perverse and rather disreputable

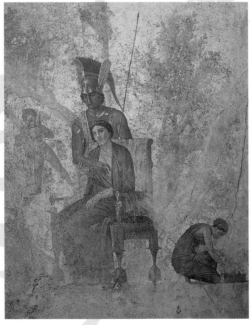

A fresco, found in Pompeii and dating from the 1st century AD, showing the war-god Mars in his battle robes embracing Venus, the goddess of love. Mars represents the male principle and Venus the female. Together they represent sexuality.

fascination. The relationship between these two was unashamedly erotic. The pairing of Mars and Venus has come to personify sexuality and sexual difference. Even in modern science the planetary glyphs for these two planets are those for male and female (see p.5).

Mars is at the heart of the most significant modern scientific research undertaken in astrology, by the French statistician and psychologist Michel Gauquelin (1928–1991). His first breakthrough concerned the "Mars effect" in the early 1950s. In carefully controlled experiments he has drawn data from thousands of French birth certificates, on which the time as well as the place of birth is recorded, and established, with high levels of statistical evidence, that French solo athletes have tended to be born with Mars in four significant horoscope positions – just past rising or culminating, and to a lesser extent, just after setting and on a lower meridian passage. The presence of Mars in these birth charts reflects the tough-minded will required to conquer at a high level in competitive sport. Hostile scientists in both Europe and the USA unsurprisingly dismissed the effect as a "fluke", although Gauquelin's method has never been faulted. Perhaps, just when scientific rationalism seemed to have the final victory over astrology within its reach, Mars intervened in Gauquelin's discoveries in order, characteristically, to prolong the war.

JUPITER

Jupiter is the giant of the planets, eleven times the diameter of the Earth and more than three hundred times its mass, with tremendous gravitational and rotational pressures creating in its dense atmosphere a maelstrom of methane and ammonia. With an orbital radius of 483 million miles (777 million km), Jupiter is scarcely touched by the distant Sun's light and heat, and life as we know it is unimaginable. This planet's identity as the King of the Gods fits its heroic stature in the Solar System, as does its attendant retinue of twelve moons; four of these were discovered by Galileo in 1610, and may be observed from the Earth with good binoculars.

Jupiter's period of revolution around the Sun is 11.86 years. The approximation of this cycle to twelve years means that Jupiter marks out one sign of the zodiac every year, just as the Sun marks out one sign every month. This correspondence of motions led the early Chinese astrologers to term Jupiter the "Year Star". In China the planet was understood to generate power in each of the star-groups

A medieval drawing of Jupiter. The zodiac signs that he governs, Pisces and Sagittarius, are indicated. Pisces, the fish, rules the feet, while Sagittarius, the archer, rules the thighs – one of which is pierced by an arrow.

through which it passed and, as in European astrology, it was deemed a divine law-maker, attuned to the human administration of authority in the world below. In traditional Chinese illustration, Jupiter appears as the "noble official" or magistrate, the local representative of imperial authority for each town in China. The twelve-year cycle was closely linked with the twelve branches of the sexagenary system (worked out on a base number of sixty) of the ancient Chinese calendar, and as early as the 4th century BC we find the following observations on this key rhythm in the *Chi Ni Tzu* text: "Deciding

wisely and with judgment and helped by the Tao, one may draw on surpluses to mend shortages ... during floods chariots should be built, during droughts boats should be prepared. Bumper harvests come every six years, and famines every twelve. Thus the sage, predicting the recurrences of Nature, prepares for future adversity."

In Mesopotamian myth Jupiter was the planet of Marduk, the patron god of Babylon. Marduk appears to have started life as an agricultural deity, who was associated with the fertilizing power of water. This idea can be traced forward to the Romans, who honoured their god Jupiter as *Jupiter Pluvius*, the bringer of rain, which is among the greatest blessings that a sky-god can bestow on humanity.

The Mesopotamian epic of creation, which is believed to date from the 2nd millennium BC, gives the fullest picture of the status given to Marduk. The first four generations of gods were created from the primeval pair, the god Apsu and the goddess Tiamat, but their offspring were so infuriatingly noisy that Apsu wanted to destroy them so that he could go back to sleep. Ea, one of the troublesome brood, gained knowledge of this and slew Apsu. However, Tiamat, stirred to vengeance, marshalled a battle troop of hideous monsters. The gods appeared to be doomed until Marduk, the son of Ea, answered his father's appeal for help against these formidable foes. However, Marduk agreed to save the gods from Tiamat only if they promised him supreme authority: "My own utterance shall fix fate instead of you. Whatever I create shall never be altered. The decree of my lips shall never be revoked, never changed!"

The assembled gods required the successful completion of a test before they agreed to his condition. They set up a constellation in their midst and asked Marduk to destroy and recreate it at will: "He spoke, and at his word the constellation vanished. He spoke to it again and the constellation was recreated." At this the gods rejoiced and called him king, and from then on Marduk was known as "Herder of Stars". He captured the monsters of Tiamat and then murdered the primordial goddess herself. Marduk sliced her corpse into halves "like a fish for drying" and made them into the sky and the earth, and from her spittle he made the clouds, wind and rain.

One of the first steps in Marduk's creation was the attribution of three regions for the gods Anu, Enlil and his father Ea: together these constituted the great trinity. From planispheres and omen-texts in the series known as *Ea Anu Enlil*, we know that the Babylonians divided the heavens into three roads: the way of Anu was the equatorial belt, the way of Ea was the outer road south of the equator, and the way of Enlil was the inner road of the Northern circumpolar stars. Twelve stars lay along each road showing the months of the year, and each month is marked by a star's heliacal rising. Enlil, or Bel ("Lord"), was originally a Sumerian sky deity, but he was frequently assimilated to Marduk in a single compound figure. The three gods together form a complete cosmology.

As with the other planets, our naming of Jupiter is from the

This boundary stone, from the 12th-century BC, shows the gods of ancient Mesopotamia. The eight-pointed star (top left) represents Ishtar, the crescent moon is Sin, and the Sun disk (top right) is Shamash. The symbols immediately below represent Anu, Enlil and Ea. Beneath these are the dragons of Marduk and his son Nabu.

Roman version of a Greek deity, in this case Zeus, chief of the twelve Olympian gods. Early myths about Zeus run in striking parallel with aspects of the Mesopotamian Marduk, but in later Greek philosophical thought Zeus ultimately achieved the status of being the abstracted essence of divine law. This philosophical elevation was already mythologically in place when Zeus became the law-giver of the gods themselves, and the unrivalled father of the Olympians. The individual gods are like separate personalities in a royal family, unified in the person of Zeus, who not only stands above the pantheon as supreme power, but appears as exponent of divine sway in general, so that it is to him that all prayers rise.

Astrology has consistently borrowed mythic interpretations of the planetary gods for its interpretation of the planets themselves, but it has always remoulded the subject matter to its own ends. This is clear from the astrological interpretation of Jupiter. In traditional Western astrology, Jupiter is seen as one planet among a group of relative equals, although even then he never loses his imperial sway; he is known as the "greater benefic", for ever seeking progress and expansion. He is broad-minded, exuberant, proud and imperious, and a generally honourable planet – in a way that recalls the mythological characteristics of the Roman god. Jupiter inclines to religion and philosophy, and is a wise counsellor and teacher: the Indian name for the planet, *Guru*, emphasizes this role.

SATURN

Among the planets Saturn is second only to Jupiter in size. It is 318 times the volume of the Earth, with a diameter of more than 75,000 miles (120,700km). At 886 million miles (1,426 million km) from the Sun, it is the farthest of the planets observed since ancient times, and fainter than Jupiter, Venus or Mars.

Since the first telescopic observations, this planet has impressed the popular imagination with its beautiful system of rings, composed of a myriad tiny fragments orbiting like little moons along Saturn's equatorial plane. The system reaches an outer diameter of 170,000 miles (273,588km), but it is less than ten miles (16km) thick when seen edge on, and cannot be seen by the naked eye. Titan, the name given to Saturn's principal moon, which was discovered in 1665, is larger than Mercury and may be observed with binoculars; its chemically rich composition has excited scientific speculation that early conditions on the Earth may be replicated at the molecular level in this unlikely corner of the Solar System.

With an orbital period of 29½ years, Saturn is the slowest of the ancient planets, and this seems to have led to two alternative strands of symbolic association, exemplified by the European and Chinese approaches to the planet's meaning. In the medieval European vision of the universe, founded on the cosmology of Ptolemy, Saturn occupies the outermost planetary circuit, lying on the band beneath the sphere comprising the signs of the zodiac. Saturn was thought to be solitary, slow, cold and melancholy, and the ruler of time itself. In keeping with the sluggish nature assigned to the planet, it was identified with the metal lead. This is Saturn as marker of the outer limit, the boundary of our reality. A related strand of symbolism sees Saturn as the enemy of life, opposing the Sun as the "greater

This Arabic illustration, from an 18th-century manuscript, shows different agricultural activities under the stewardship of Saturn.

malefic". In this role it could show itself as ignobility against the Sun's nobility – dirt, stagnant water, vermin and lice all fall within its aegis.

The Chinese interpretation inverts the European approach: Saturn is seen as representing Earth, the element at the centre of the Five Agents. The Chinese name for Saturn, "Quelling Star", has the connotation of exorcism, suggesting that its aid may be sought in driving out demons. On one point both traditions converge: the slow motion of Saturn gives it the character of age, and in Chinese astrology, as in Europe and Greek-influenced Asia, it is personified as an old man.

The origins behind the Saturn of modern Western astrology present a complex picture. We have to go back to Mesopotamian mythology to pick up some of its more significant origins, and even there the picture is a confused one. In the Mesopotamians' myths, the planet belongs to the god Ninurta, the brother of Nergal (their Mars). However, the similarities between these warrior-gods were such that the two brothers were sometimes fused into one entity. Ninurta became a god with extraordinary powers after he rescued the tablets of fate stolen from Enlil (see p.69) by the wind dragon Zu, who was in league with the powers of chaos. In gratitude for his courage and success, the gods granted Ninurta stewardship of the tablets, so that he became the overseer of fate itself, prefiguring a significant thread in the later astrological Saturn.

Other aspects of Ninurta are less easily assimilated to our conventional symbol of Saturn. He was associated with weapons and frequently depicted as an eagle, sometimes a two-headed eagle facing both ways, an image still found in heraldry. Equally difficult to square with later tradition is his solar association:

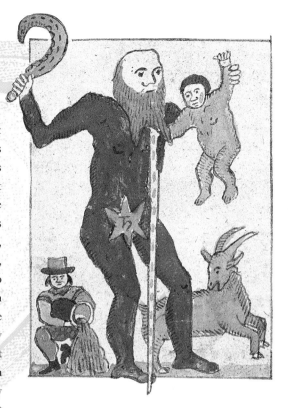

several Roman writers record that the Mesopotamian astrologers called Saturn "the star of Helius [the Sun]". This reflects an ancient and obscure practice of giving the name Shamash to Saturn, as well as to the Sun. Epigenes of Byzantium, a Greek astronomer of *c*.200BC, may give us the clue. He claimed to have studied in Chaldea, the state in southern Babylonia that became famous as the home of early astrology. Epigenes taught that Saturn has the greatest influence on the movements of other heavenly bodies, and we may speculate that this is why Ninurta/Saturn is known as a "second Sun".

The story of Cronus, the Greek Saturn, and his castration of his father Uranus, is one of the best known myths in the classical canon (see pp.28–9). This tale locates Saturn/Cronus first in the sequence of the traditional planetary gods. In the next phase of the myth the narrative repeats itself to produce the second – and greatest – planetary god. Gaea and Uranus, as the latter lay dying as a result of his castration, prophesied that Cronus would be dethroned by one of his own sons, just as he had usurped his father. In order to prevent this fate, Cronus swallowed his children as soon as Rhea bore them. The furious Rhea bore her third son, Zeus, in the dead of night and handed him into the care of Gaea; Rhea then gave Cronus a stone to swallow, which he thought was the infant. It was Zeus (Jupiter to the Romans) who fulfilled the prophecy, overthrew his father and established

This medieval illustration shows Saturn in the traditional guise of an old man. On the left of the picture is the figure of Aquarius and on the right, Capricorn: the zodiacal signs that Saturn is said to influence. He holds high the sickle with which his Greek counterpart, Cronus, castrated his father. Saturn was also thought to govern agriculture.

his supreme rule. In this way two successive ages of Saturn/Cronus and Jupiter/Zeus arise after the primordial reign of Gaea/Earth and Uranus/Heaven, in which there was no time.

The developement of Greek Cronus into Roman Saturn is at first puzzling, and introduces mythological elements that do not fit easily with the later, purely astrological Saturn. Saturn was an Italian god of agriculture, identified with a legendary early king of Rome; his reign was so mild and civilized that it was later thought of as the Golden Age. The festival of the Saturnalia marked the winter solstice, when the Sun enters Saturn's sign of Capricorn. For the three days of the festival, public business was suspended, criminals were not punished, and slaves were allowed extraordinary licence; the world was for this short time turned upside down. This popular event was extended to seven days under the later Empire; with its customs of lighting candles and the exchange of presents, it is the pagan origin of our Christmas festivities.

The modern statistical research of Michel Gauquelin, in addition to his experiments on Mars (see p.67), established an illuminating correspondence for Saturn. His research showed a significant occurence of Saturn in the birthcharts of successful doctors and scientists. In astrology it is suggested that slow Saturn well reflects the disciplined, patient and cautious attitude required for success in the world of science.

THE MODERN PLANETS

The five planets from the Sun out to and including Saturn have been observed and interpreted since the dawn of history. The epithet "modern" refers to planets that were unknown in antiquity, their invisibility to the naked eye ensuring that they went unobserved before the era of modern technology. Astronomy underwent a great technological advance in the early years of the 17th century with the invention in the Netherlands of the telescope. This was first seized upon for its military and naval significance, but there soon followed a wave of scientific applications, in a spirit of experiment and inquiry. The heavens began to reveal wonders that had never before been seen. By 1610 the Italian astronomer Galileo (1564–1642) was observing the moons of Jupiter, using lenses that he had ground and polished himself, and which were capable of magnifications of up to thirty times.

It still took more than 170 years before the first of the modern planets, Uranus, yielded to the telescope of British astronomer William Herschel (1738–1822) in 1781, although over the previous century several observers had mistaken it for a star. In fact Uranus can just be detected by the naked eye; but at twice the distance from the Sun as Saturn, it is faint and insignificant in the company of many barely visible stars. Satellite probes have shown that Uranus is a surprising planet: it has a system of rings and fifteen moons. Most strange is the 98° tilt on its axis of spin, giving it a quite different motion to that experienced by any other planet.

Neptune was discovered in 1846. Its existence was first inferred from mathematical studies of unexplained perturbations on the orbits of Uranus and comets, indicating the presence of a gravitational field as yet scientifically unaccounted for. Neptune has approximately the same diameter as Uranus (33,000 miles/52,930km), but it is a massive 2,793 million miles (4,495 million km) from the Sun. It can be seen with binoculars, but only very faintly.

Pluto, the most recent planet to be discovered, is at a distance of 3,670 million miles (5,906 million km) from the Sun. It was detected by photographic searches in 1930. Tiny, with a diameter only a little greater than that of Mercury, it can be observed with only the most powerful telescopes.

The modern planets raise intriguing issues, and serve as a microcosm of how astrological and symbolic interpretations arise. How does a consistent and agreed symbolism emerge for these totally new celestial bodies, given the absence of an ancient tradition as a foundation? For the astrologer, operations such as naming a new planet are symbolically charged: contemporary events on the Earth must be mirrored in the "nature" of the new planet and vice versa. Its name, therefore, must reflect this nature. When Uranus was discovered, Herschel wanted to name it "Georgium Sidus" after the Hanoverian king of England, but this held little appeal for non-English astronomers. "Neptune" was proposed, along with unworkable monsters such as "Neptune de George III". Eventually the Berlin astronomer Johann Bode suggested "Uranus", the father of

This silver plate of the 4th century AD shows the Roman god of the Sea, Neptune, surrounded by dolphins. The planet Neptune was discovered in 1846 by the German astronomer Johann Galle. It is said to rule the zodiacal sign Pisces.

Saturn and grandfather of Jupiter. Most astronomers agreed that this was appropriate, although "Herschel" and "Herschellium" survived for many years, which is the origin of the "H" design of the planetary glyph (see p.5).

The symbolism of Uranus adopted in modern astrology is largely independent of the myths and deeds of that god. However, in the case of both Neptune and Pluto, the Greek and Roman myths colour the astrological interpretation. The connection is most obvious with Pluto, the Roman version of the Greek lord of the underworld, Hades. Astrological texts take the planet to symbolize "the underworld" of crime and depravity, the realm of a being capable of rape and other harms, like the feared Hades of Greek myth. Modern psychological astrology adds to Pluto's list of associations the deep unconscious, a meaning obviously rooted in its mythological manifestation.

This ancient Roman stone relief shows Pluto, the god of the underworld, with the maiden Proserpina (Persephone to the Greeks), whom he abducted from the earth to become his bride. The traits of rape, abduction and darkness attributed to the god have been projected onto the meaning of the planet.

ogy and numerology, because instead of the sacred seven planets there were now an unholy eight. This revolutionary quality is at work at all levels of culture. Around the same time of the discovery of Uranus raged the political revolutions in France (the French Revolution of 1789) and in North America (the War of Independence, beginning in 1781).

Neptune's historical associations are more complex. The 1840s, an era of Romantic reaction to the previous Age of Enlightenment, saw the origins of modern spiritualism in 1848, after supernatural occurrences at the home of the Fox sisters in New York State. The Communist Manifesto was published in 1848, indicative of Neptune's affinity with socialism, springing from compassion for the under-class. These years saw the development of photography and

Although astrologers place a great deal of importance on the name given to a new planet, the historical association of the planet for the time of its discovery is a more enduring source of astrological interest. The discovery of Uranus brought about the final upheaval of the secure medieval cosmos in which everything had its place. Locating this new planet threatened to sweep away the traditional symbolism of astrol-

the petro-chemical and pharmaceutical industries – film and drugs are characteristic associations for Neptune.

Pluto's discovery is inevitably seen by astrologers as a herald of the cataclysmic events of the 1930s, including the rise of a terrifying new breed of absolute dictator, from Hitler to Stalin and Mao. It also shows the release of potentially annihilating new powers, through the splitting of the atom.

To the astrologer, the ancient hermetic axiom, "As above, so below," remains as vital now as it has ever been.

CONSTELLATIONS

The stars we see are a myriad suns, but their remoteness reduces them to twinkling points of light which all appear equally far away. They are in fact at vastly different distances from us, and the constellations into which we group them depend solely upon our own vantage-point in the universe. The modern constellations are mostly derived from Greek reinterpretations of the more ancient Mesopotamian and Egyptian figures; but many cultures have projected their own myths into the stars.

The same figures we see in the vast dome of the night sky have inspired the mythopoeic imaginings of generations before us. This chapter highlights the main stories and interpretations of some of the most important constellations in the heavens.

This print dating from c.1510 shows the constellation Draco, the dragon, intertwined with Ursa Major and Ursa Minor (the Greater and Lesser Bears). Draco was identified by the ancient Greeks as Ladon, a monster slain by Heracles during his eleventh laour so that he could obtain the golden apples from the garden of the Hesperides, the seven nymphs who lived on Mount Atlas in the far west.

A 16th-century star map of the Northern hemisphere sky. The position of constellations with regard to one another often reflects an aspect of myth. For example, Ophiuchus (top right quadrant) represented Asclepius, the Greek god of healing, who killed the scorpion that had stung Orion in the heel. In the skies his foot rests on the constellation Scorpio, as if to grind the creature into the ground as the two star-groups set.

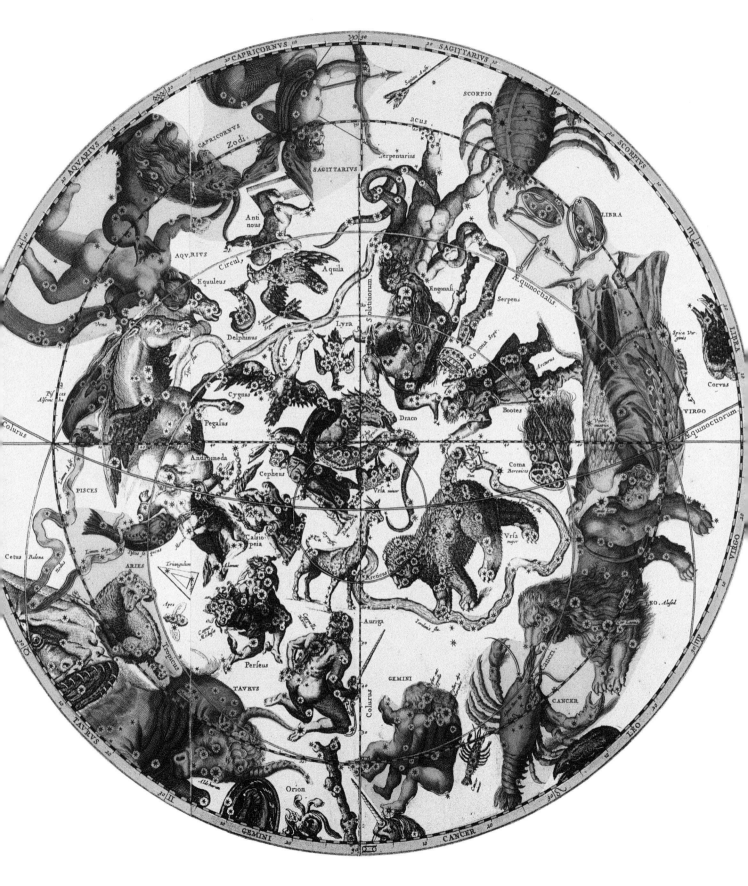

ORION

Mighty Orion the Hunter lays claim to being the most impressive of all the constellations, dominating winter nights in the Northern hemisphere and the summer skies of the South. This figure, perhaps more than any other constellation, gives a sense of the connection with humanity that comes from contemplating the night sky. Orion was a formidable man for many cultures: for the Jews he was the biblical Samson, and for the Arabs he was Al Jabbar, the Giant. Countless others have imaginatively shaped the contours of this same figure – the colossus striding high above the travails of human history.

Orion stands to the southeast of Taurus, with his belt of three stars slanted across the celestial equator. The second-magnitude star Mintaka (Delta Orionis), meaning "belt", falls almost exactly on this great circle. A dagger hangs from his belt, its tip shown by Na'ir al Saif (Iota Orionis), the "bright one in the sword". With his right hand, on the eastern side of the figure, Orion brandishes a club. His right shoulder is marked by the pale orange first-magnitude star Betelgeuse (Alpha Orionis); the left shoulder contains Bellatrix (Gamma Orionis), the "female warrior", a pale second-magnitude star; and the giant's left leg is marked by Rigel (Beta Orionis), a blue-white star of the first magnitude. To the west of the figure a string of faint stars embodies a lion's skin trophy held aloft by the hunter. A line through the three stars of the belt gives a useful orientation to other stars: extending the line to the southeast brings us to Sirius in Canis Major; and to the northwest the same line leads to the star Aldebaran in Taurus.

As Orion sets, so Scorpio rises. This is reflected in the Greek myth that the hunter was fatally wounded by a scorpion. Orion, a son of Poseidon, was a giant of great beauty and prowess. He lay with Eos (in Roman myth, Aurora), the maiden of Dawn, and to this day dawn blushes rosy pink in memory of the coupling. She lingers in his presence, the bright stars of Orion fading slowly in the west as dawn breaks.

Orion, brandishing his club in his right hand and holding a lion's skin in his left. The illustration shows how the three stars of Orion's belt (Zeta, Eta and Delta Orionis) form a useful guide to neighbouring constellations. To his northwest lies Taurus, with Sirius in Canis Major precisely to the southeast.

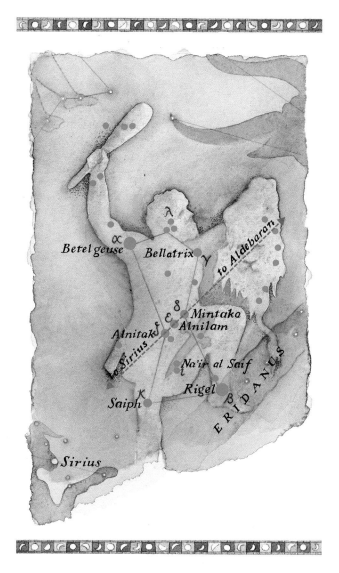

Orion, from a set of German playing cards (1719). The figure is shown in reverse, as if seen from outside the Celestial Sphere.

The constellation was revered by the earliest civilizations of the Euphrates valley, but among ancient cultures of the East it is the Egyptians who have left us the clearest clues about the mystery of the stars of Orion, for them a representation of Osiris, the god of the dead. Modern research on the Great Pyramid has demonstrated that its perfectly engineered southern shaft, running from the King's Chamber at the core of the pyramid, was aligned to the belt-stars in 2700–2600BC. At the same time the northern shaft was aligned to the Pole Star of that period, Thuban (Alpha Draconis). Even more extraordinary is the finding that five of the Fourth Dynasty pyramids on the Giza plateau repeat in their groundplan the pattern of the Orion constellation (see pp.136–7).

Many fragments of this story have been recovered from hieroglyphic texts, but the main account comes from the Greek historian Plutarch (1st century AD). Osiris was the son of the earth-god Geb and the sky-goddess Nut. He became the king of Egypt and took Isis, his sister, as queen. A gentle, humane ruler, Osiris taught the people the arts of civilization and built the first temples. However, his brother Set, jealous of his power, murdered him, cutting the body into fourteen pieces, which were scattered far and wide. The faithful Isis began a painstaking search for the body-parts, recovering all except the phallus, which had been devoured by a crab. Isis magically reconstituted Osiris and brought him back to

The Egyptians equated Orion with their god Osiris, shown here enthroned, with the four gods of the cardinal points before him.

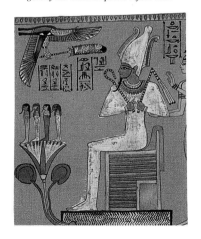

eternal life. She performed the first embalming, and impregnated herself from him to produce the infant Sun-god Horus.

It is now thought that the function of the Great Pyramid was to assimilate the pharaoh to the heavens as an earthly counterpart to Osiris. After death, the pharaoh's embalmed body was placed in the King's Chamber, its phallus oriented along the sighting tube to the belt-stars of Orion. As the light of these stars flashed down the narrow shaft, the pharaoh inseminated the constellation, ensuring that his successor would be Horus – the reborn Osiris.

In China, Orion was known as the hunter and warrior Tsan. The belt-stars identified the 21st lunar mansion *Shen*, "Three-Stars", the deadly rival of *Shang*, the lunar mansion centred on Antares in Scorpio (see p.92).

The primary status of Orion for the ancient Egyptians is paralleled in the Mayan culture of Central America. The creation myth of the *Popol Vuh* (texts collated in the 16th century) tells us that after being killed by the Lords of Death, First Father was reborn as the Maize God through the cracked shell of a turtle. Recent research has shown that in the classic period of Mayan civilization, before 900AD, the turtle was represented by three stars in Orion: Alnitak in the belt, Saiph and Rigel (Zeta, Kappa and Beta Orionis). The ancient tradition of three hearthstones marking the centre of the home for Central American peoples has its origins in these three stars.

CANIS MAJOR AND MINOR

In Greek myth no giant would be complete without faithful hounds with which to hunt, and the powerful Orion is no exception. South of Gemini and east of Orion we see the giant's two hunting dogs, Sirius and Procyon. Sirius (Alpha Canis Majoris, magnitude -1.6) is the brightest star in our skies, far outshining a group of second- and third-magnitude stars which, with it, comprise the constellation Canis Major (the Greater Dog). Seen from the Northern hemisphere, this dog sits low in the sky behind Orion, keeping a watchful eye on the hare Lepus, a minor constellation at Orion's feet.

Procyon, a yellow-white star of the first magnitude, is roughly level with Orion's shoulders. It shares its small constellation, Canis Minor (the Lesser Dog), with just one other star of any significance, the third-magnitude Gomeisa.

The two dogs have a dramatic visual relationship with Orion in the Northern hemisphere's "Winter Triangle", a huge configuration straddling the Milky Way, formed by Sirius, Procyon and Betelgeuse (Alpha Orionis).

The name Procyon in the Greek means literally the "dog who rises before", because this star announces the coming of Sirius, the more magnificent star, to which Procyon plays second string.

Sirius, or Sothis, defined the ancient Egyptian calendar through its heliacal rising – the day of its first appearance as a morning star each year, when it would first flash for a moment in the eastern sky just before the rising of the Sun. This occurence in mid-July coincided with the Nile floods, on which the fertility of the land depended, and a Sothic calendar was established by the middle of the 3rd millennium BC.

In ancient Egypt Sirius was identified with the goddess Isis,

A pictorial star map showing the relative positions of Canis Major and Canis Minor. Like Sirius, Procyon is a binary (a double star); its companion-star is a white dwarf, first seen in 1896, known as Procyon B.

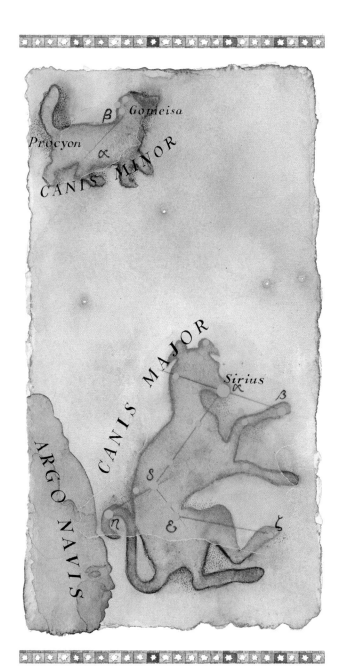

78

The ancient Egyptian goddess Isis, wife of Osiris (see pp.76–7), was associated with Sirius, the Dog-Star. In this illustration, after a mural in Set I's temple at Abydos, she is shown with horns – she later became the cow-goddess Hathor.

a supreme healing deity and protector of the dead (see p.77). Later, Isis' head was cut off by Set, and the Moon-god Thoth replaced it with that of a cow; from then on she became the cow-goddess Hathor. Sirius became associated with the widespread cult of this deity. Isis had marvellous powers of magic: using earth fashioned from the spittle of the aged Sun-god Ra, she formed a snake which bit him. Ra could not comprehend the source of this potent venom and sought the healing power of Isis. Before she would use her sorcery to lift the ailing god's affliction she made him reveal his true name to her, thus passing his power into her bosom.

The naming of Sirius as the Dog-Star originates from ancient Egypt. The "Dog Days" of folklore refer to the forty days of July and August, following the beginning of the Sothic year, when the summer is at its most intense. It was believed that Sirius itself produced this heat, either as a direct effect of its own rays, or indirectly by its influence on the Sun.

In the Dog Days, it was believed that vigorous creatures gained strength, but weak plants and animals withered and died. Humans could become sick with a deadly fever, called *seiriasis*, from *seirios* ("scorching"), the Greek name for Sirius.

Ancient traditions centred around Sirius sometimes emphasize this scorching quality, while at other times they bring out the star's tendency to extremes. The Latin grammarian Servius (4th century AD) illustrates the concept of sympa-

thies and antipathies by showing the affinity of the star Sirius with earthly dogs, heat and rabies. He explains that dogs, having the power of fire, are by nature antipathetic to moisture: "for whatever has moisture as its enemy ... has difficulty consuming water to slake its thirst. Now it is for this reason that those who are affected by the bite of a rabid dog recoil from water ... because the poison of this animal, since it is opposed to moisture, rages in a similar way within the human body."

Sirius was known to the Chinese as Thien Lang, the "Celestial Wolf". Associated with ill omens, it was thought when showing brightly to portend attacks by thieves. Thien Lang was also the governing star of Tibet, the settled agrarian civilization on the borders of China.

In the 1940s it was discovered, amid controversy, that the Dogon peoples of Mali in West Africa have traditionally referred to a companion-star to Sirius, called Po. They call this the "heaviest star", with an elliptical 50-year orbit, used as the basis for computing ritual time-periods. Yet not until 1862 was it established that Sirius is truly a binary (double star), with the

tiny Sirius B (magnitude 8.5) orbiting it once every 50 years. It is difficult to explain how the Dogon could possibly have been aware of this: their knowledge of the Dog-Star Sirius and his mysterious dwarf companion presents an unresolved enigma to us all.

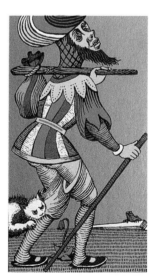

The Fool, from a Tarot pack. Some authorities believe it shows the dog Sirius at the heels of Orion, the "universal man".

GEMINI AND AURIGA

Culminating high overhead at midnight during January in the Northern hemisphere, a set of twins, represented by the first-magnitude stars Castor and Pollux (Alpha and Beta Geminorum), can be seen sitting close together. This is the zodiacal constellation Gemini. Castor, the more northerly of the pair, is white, while Pollux is orange. The constellation lies to the north of Procyon (Alpha Canis Minoris) and to the northeast of Orion. The feet of the Twins are marked by Alhena (Gamma Geminorum), which lies a little over halfway between Al Nath (Beta Tauri) and Procyon.

In Greek myth these twins were called the Dioscuri, "sons of god". In some accounts they were half-brothers, the children of Leda, who bore Castor by a mortal and Polydeuces (Pollux in Roman myth) by Zeus. Polydeuces excelled in boxing and Castor was skilled with horses. Such was their mutual devotion that Polydeuces refused the immortality granted him as a son of Zeus, unless his brother could share it. Zeus allowed them to stay together, but they had to alternate their days between the realm of the gods and the underworld, Hades. In reward for their love, Zeus set their image among the stars. When Castor sets in the west, descending to Hades, Pollux follows him; when Castor rises, his brother is soon at his side.

The ocean-god Poseidon gave the Twins the power to safeguard those at sea. In the Southern hemisphere they can be seen high above the mast of the *Argo*, the ship in which Jason sailed to find the Golden Fleece (see p.105). When the Twins stepped aboard, two flames

A 16th-century Turkish illustration of the astrological sign Gemini. Through its planetary ruler Mercury, Gemini has an association with clerks and scholars.

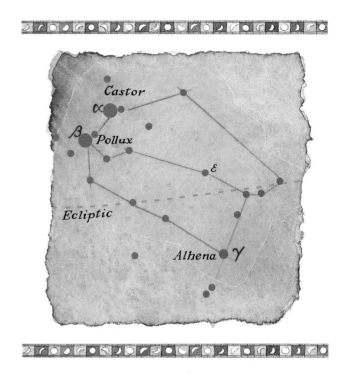

A star map showing Gemini. Johann Bayer, when allotting Greek letters in 1601, caused confusion by awarding beta to the brighter star, Pollux.

sprang from the mast the electrical phenomenon described by sailors as St Elmo's fire.

The twins theme takes different forms across cultures. The Romans associated this constellation with Romulus and Remus, the descendants of Aeneas and the legendary founders of Rome in 753BC. In the Mayan creation myth, they were a pair of peccaries copulating. The Arabs saw them as peacocks, a designation which survived into late-medieval European usage. In early Phoenician and Chaldean tradition, they were thought to be a Pair of Kids, following the shepherd who was represented by Auriga, which lies to the west of Gemini and to the north of Orion.

Auriga the Charioteer carries two kids in his hand and cradles a goat in his left arm, marked by the magnificent yellow-white star Capella, the "Little She-Goat" (Alpha Aurigae, magnitude 0.2). The right foot of the charioteer passes into the constellation Taurus, and is shown by the tip of the Bull's horn, Al Nath (Beta Tauri), lying just above the ecliptic. As our gaze sweeps across the sky we pass through a spiral of stars, which crosses through Theta Aurigae to the second-magnitude Menkalinam (Beta Aurigae) near the right shoulder, and then across to Capella. Close to Capella the spiral turns through Epsilon Aurigae to mark the kids – the Hoedi, two minor stars (Nu and Zeta Aurigae). The figure has been perceived in its present form since the earliest records on the Euphrates.

In Greek myth the goat Capella was associated with the goat-nymph Amalthea. When the goddess Rhea hid her infant Zeus from his father Cronus, who devoured all his children, Amalthea (meaning "tender") suckled the god. In reward Zeus turned one of her horns into the Cornucopia, the horn of plenty, which forever brims with food and drink.

Curiously, the charioteer has no chariot. Greek myth explains this by identifying him as Myrtilus, a son of Hermes. Myrtilus was the servant of Oenomaus, who tried to prevent his daughter Hippodameia from marrying. The possessive father challenged her suitors to a chariot race, first ensuring his own victory by harnessing his chariot to the wind-borne mares of Ares. When Pelops, who was Hippodameia's own choice, took his turn, Myrtilus replaced the lynch-pins of his master's chariot with wax, so that the wheels flew off and Oenomaus was dragged to his death. Fate punished Myrtilus fittingly. He desired Hippodameia for himself, and so, while out driving

The charioteer Auriga, shown holding the goat in his left arm, marked by the Alpha star Capella, and the kids in his left hand (the Hoedi: Nu and Zeta Aurigae). His foot is marked by Al Nath (Beta Tauri) and to his right lies the constellation Perseus.

one evening with the girl and Pelops, he tried to ravish her. After an angry exchange the trio drove on, until Pelops struck Myrtilus and threw him to his death in the sea.

There is an apparently independent reflection of the Greek theme of this constellation's association with a chariot in the Chinese star group of the "Five Carriages", located wholly in Auriga with Capella as its principal star.

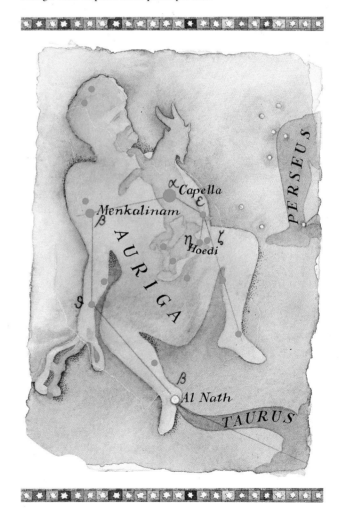

THE SOUTHERN SKIES

Once a magnificent vessel occupying an enormous span of the Southern skies, the constellation Argo is now split into three portions: Carina the Keel, Puppis the Stern and Vela the Sail. Only the flag on the poop, the top of the stern, is faintly visible from the Northern hemisphere when it culminates in mid-January below Procyon. In the South, however, Argo forms a significant figure. The keel can be located from the brilliant-white first-magnitude Canopus (Alpha Carinae), a beautiful star, lying south of Sirius.

In Greek myth the *Argo* was the ship in which Jason and the Argonauts sailed to find the Golden Fleece (represented by the constellation Aries; see p.82). To reclaim the throne of Iolcus, Jason had to bring back the Golden Fleece for his uncle, the usurper. He drew volunteers from all over Greece to become his Argonauts. The goddess Athene put an oracular beam in the ship's prow, made from the sacred oak of Zeus at Dodona.

Stories of the celestial ship date from ancient

Egypt and Mesopotamia. The Greek historian Plutarch (*c*.AD46–*c*.AD119) claimed that it was the ship of the dead under the command of Osiris. Late Christian interpretations took it to be Noah's Ark.

Some say that Canopus takes its name from the helmsman of King Menelaus who destroyed Troy in 1183BC; but it is possible that the name goes back to the Coptic or Egyptian Kahi Nub, "Golden Earth". For the Arabs, its title Suhail was a syn-

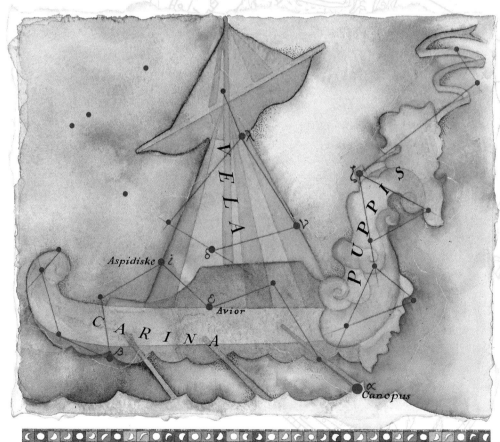

The three constellations comprising Argo Navis: Vela the Sail, Puppis the Stern, and Carina the Keel. Here Canopus marks the oar to the rear of the ship.

A star map of the Southern Cross whose long axis points toward the South Celestial Pole. It lies in a dense part of the Milky Way.

onym for wisdom, while in China the star was venerated in Taoist alchemy and known as the Old Man Star, or "Supreme Verity of Cinnabar Tumulus".

Another superb constellation in the Southern hemisphere is Centaurus, culminating at midnight in April. The alpha star, Toliman (meaning "Shoot of the Grape-vine"), also called Rigel ("Foot of the Centaur"), is the closest star to our Sun, lying only 4.5 light years away. Because they are within 9° of each other, Toliman and the beta star Agena have been treated as a pair. According to the Victorian scholar R.H. Allen, they were "Two Brothers" in aboriginal Australia, and "Two Men who were Lions" in South Africa.

The centaur association originates in classical times. There are several variants, but the context of each is the accidental wounding of a centaur by Heracles. In one version several hostile centaurs attacked the hero and, as he fought them off, one of his arrows accidentally struck the gentle centaur Chiron in the knee. Chiron had learned from Apollo and Artemis the arts of music, astrology, medicine and divination, and was even credited with the design of the constellations.

Crux, the Southern Cross, once formed the belly of Centaurus. Now it is a distinct Southern circumpolar constellation, comprising four main stars in a compact formation. The vertical axis of the cross points through the alpha star Acrux

toward the South Celestial Pole. The whole figure straddles the Milky Way, 4° wide at this point. Dante, in his great poem *Purgatory*, the second part of the *Divine Comedy*, draws upon his sophisticated knowledge of astronomy, including the phenomenon of precession, to create a profound symbol from this constellation. Passing through the Inferno and into Purgatory at the gateway of the Southern hemisphere, he observes the South Celestial Pole: "... I turned, and, setting me to spy/That alien pole, beheld four stars, the same/The first men saw, and since, no living eye." The Southern Cross was just visible on the horizon at Jerusalem at the time of Christ, but since then had slipped from view, leaving the Northern hemisphere, in Dante's words, "famished and widowed".

An ancient constellation map showing Centaurus. He appears holding the small constellation Bestia or Lupus in his right hand; the two constellations were often depicted together.

83

CANCER

An inconspicuous zodiacal constellation, Cancer the Crab lies to the east of Gemini. To find the constellation, one begins at Castor, the more northerly of the Gemini Twins, and constructs an equilateral triangle with a base line to Procyon – the apex of the triangle falls on the ecliptic at the Crab's centre on the fourth-magnitude South Asellus (Delta Cancri). Its fainter companion North Asellus (Gamma Cancri) lies 4° to the north. Between the two and slightly to the west is Cancer's distinctive feature, the star-cluster Praesape, which to the naked eye appears as a cloudy spot. There are more than 500 stars in this cluster, around eighty of which may be distinguished with good binoculars. To the south, two stars mark the Crab's legs: Acubens and, to its west, Al Tarf (Alpha and Beta Cancri).

Praesape, meaning "swarm of bees", seems an apt name for the star cluster, but it was also imagined as a manger, surrounded by asses – this is the literal meaning of Aselli.

The Greek myth of the Crab is as low-key as the constellation itself. It was crushed underfoot when it tried to nip the toes of Heracles as he fought the Hydra, a monster with a dog's body and eight or nine serpent-heads.

In early Mesopotamian culture, however, Cancer was not so insignificant. It was the gateway through which souls passed from their sojourn in the stars down to their birth as human beings.

The zodiacal sign Cancer has a resonance beyond the faintness of the stars in its namesake constellation, because the Sun's passage into the sign marks the northern midsummer solstice, when the Sun reaches its maximum height above the horizon and "stands still" (in Latin this is the etymology of "solstice"). This key moment in the solar calendar is marked by sight-lines at numerous Stone Age sites, such as that through the Heel Stone at Stonehenge (see pp.116–20). From the Earth, the latitude where the Sun is overhead at midsummer noon defines the Tropic of Cancer. The word "tropic" comes from the Greek *tropos*, to turn, and the solstices are, therefore, great turning points in the calendar, and in all human affairs.

The symbolism of the Tropic of Cancer provides the basis for a well-known story told by the psychologist Carl Jung that demonstrates his concept of *synchronicity* – a non-causal connecting principle, more mysterious than cause and effect – that underlies all divination, including astrology. An intellectual but neurotic patient recounted to Jung a dream in which she saw a golden scarab. As she spoke, Jung heard a tapping on his study window. He opened the window and in flew a beetle, which Jung caught in one hand. He stretched out his palm and said, "There is your beetle" – it was a rose-chafer beetle, a northern-climate relative of the Egyptian scarab. The woman was astounded by this irruption from her dream world into reality, and the shock of this "coincidence" became the turning-point in her treatment.

This illustration is a 10th-century view of Cancer. Surrounding constellations are (clockwise from bottom left): Hydra, Ursa Major, Leo, Lynx, Gemini, Pegasus and Canis Minor.

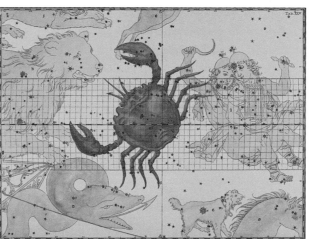

LEO

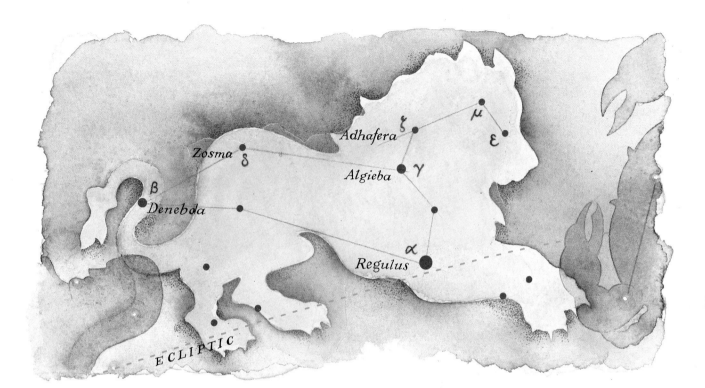

The impressive zodiacal constellation of Leo dominates spring nights in the Northern hemisphere and autumn nights in the Southern hemisphere. The regal lion pacing westward across the sky is easily identified, because Leo forms the first striking star-group east of Gemini and the star Procyon in Canis Minor. As our gaze passes over the inconspicuous Crab of Cancer we come to Regulus, the star at the heart of the lion, exactly on the ecliptic (Alpha Leonis: first magnitude, flashing white and ultramarine).

A distinct group known as the Sickle defines the lion's head: these are the stars Algieba or "Lion's Mane" (Gamma Leonis), Adhafera (Zeta Leonis), with Eta and Kappa Leonis bringing us round to the nose. Regalus, now at the heart, was formerly part of the sickle. Due west of the Lion's Mane,

A star map of Leo. Cancer is to the right of the figure and Virgo lies to the left. Regulus (Alpha Leonis) lies just off the ecliptic. The stars of the Sickle are Regulus, Algieba (Gamma Leonis), Adhafera (Zeta Leonis) and Eta Leonis marking the lion's nose. There is one further star of the Sickle, Kappa Leonis, northeast of the Eta star, but it is too small to warrant inclusion here.

Zosma (Delta Leonis) marks the back and haunches, and Denebola is the "Lion's Tail" (Beta Leonis, second magnitude, blue).

Leo has held a position of eminence, and has been interpreted with a fair degree of consistency, from the earliest times for which we have firm records, through all those cultures that can be seen as heirs to both Mesopotamian and Egyptian civilizations. This influence includes the Jewish, Greek, Latin, Indian, Persian and Arabic cultures, as well as later European

astrology and mythology. There are several interwoven threads that have contributed to the status of Leo as the King of Signs, and Sign of Kings. One is undoubtedly the solar connection, making Leo a representative of the Sun itself. In the formative period of settled civilizations in Mesopotamia and Egypt, some five millennia ago, the Sun's passage at midday through this area of the sky coincided with the midsummer solstice. Leo was therefore the constellation of high summer, which is manifestly the realm of the Sun. Pliny (1st century AD) records in his *Natural History* that the Egyptians worshipped Leo because the rise of the Nile coincided with the Sun's path through its stars. We have already seen the close association established by the Egyptians between Sirius (Sothis) and the Sun, because this star's heliacal rising occurred in mid-July with the Nile floods (p.78). The gates of the canals irrigating the Nile valley were often decorated with a lion's head, a possible origin of the motif of a fountain springing from the head of a lion, widely found in Greek and Roman architecture. It is unknown why a lion was chosen; but it is difficult to imagine an animal more noble and, once the connection of Sun and lion had been made, it seems to have become steadfast.

Regulus, sometimes called Cor Leonis, "heart of the lion", has come to take on all the magnificent associations of its constellation. However, this probably reflects a later tradition rather than the original Egyptian conception, since Leo was once a smaller constellation than our present figure, the stars of the Sickle, or Knife, being treated as a separate group. It appears that Mesopotamian astrology established Regulus as one of the four Royal Stars, guardians of the affairs of the heavens. These four stars are all of first magnitude and lie on or close by the ecliptic in a great cross: a line from Regulus in Leo to Fomalhaut in the opposite constellation of Aquarius forms one arm of the cross, while Aldebaran in Taurus and Antares

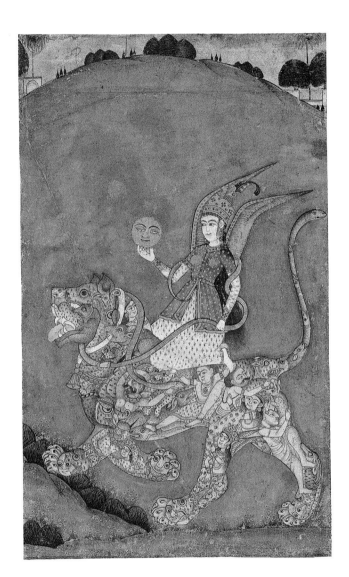

This Indian miniature, dating from the 17th–18th centuries, shows an Indian deity holding in her hand a representation of the Sun-god Sol, riding on the back of the constellation Leo. The lion itself is fantastically constructed as a composite of people and animals; for example, its tail alone is made up of five snake-like creatures and its lower jaw is formed by a bear.

in Scorpio complete the figure. In the first formative period of the major astral myths, these four watchers of the heavens, and their home constellations, marked the four stations of the solar year; the equinoxes and the solstices.

In Greek myth the constellation Leo was identified as the Nemean Lion, which Heracles skinned as the first of his twelve labours. The lion was an enormous beast whose pelt was impervious to stone or metal; it was created by the Moon-goddess Selene. As the lion could not be defeated by weapons of any sort, Heracles had no choice but to wrestle with it. Although he lost a finger, he managed to hold the creature's neck in a lock until it choked to death. He skinned the lion by cutting the magical pelt with the beast's own claws. From then on, Heracles wore the pelt as invulnerable armour and the lion's head as a helmet.

To the northeast of Denebola, the "Lion's Tail", above the figure of Virgo, lies a small cloud of minor stars which forms the main group of the constellation Coma Berenices, or "Berenice's Hair". This group closely marks the north pole of our galaxy, the axis around which our whole vast system of myriad stars turns, over a period of around 225 million years.

There is a sad tale, related by the poet Ovid (43BC–AD17), that connects this constellation with Leo. There were once two young lovers, Pyramus and Thisbe, who lived in neighbouring houses. Their parents, however, were against the match, and so they had to meet in secret or whisper to each other through cracks in the walls. One evening they arranged a clandestine meeting at the edge of the woods. While Thisbe waited, a lion

An 1870 book-illustration of the Leonids as observed by two balloonists, Giffard and Fonvielle, while flying in their balloon "L'Hirondelle". The next Leonid shower is scheduled for 1999.

came near, carrying its prey. Although it showed no interest in the girl, she was frightened and ran to warn Pyramus. As she ran her veil fell from her shoulders and fluttered past the lion. The animal, disturbed in its feast, snatched at the cloth with its bloody paw. In her fearful panic, Thisbe missed Pyramus, and when the boy came to look for her, he saw no sign of Thisbe apart from the veil stained with blood. At once he assumed that the lion nearby had eaten his beloved, and in a wild passion he leaped at the creature, but was killed by a single blow from its great claws. Thisbe returned and, seeing Pyramus lying dead, fell weeping on the corpse. The lion, still angry from Pyramus' attack, struck Thisbe as well, uniting the couple in death. Thisbe's blood spurted up to a mulberry tree, which is why to this day the tree bears blood-red berries. As a reminder to parents not to stand selfishly in the way of their children's feelings, Zeus placed Thisbe's veil in the sky as Coma Berenices.

In the early-morning hours around November 16 in the Northern skies, an occasionally impressive meteor shower, the Leonids, can be seen streaming from a point west of Adhafera in Leo. The phenomenon occurs as the Earth crosses the debris-strewn path of what is held to be a disintegrated comet.

The mythic understanding of the Leonids comes from its scientific description as a meteoric fireball, or "bolide" (from the Greek for "thrown spear"), which hisses as it crosses the sky. Bolides were often thought of as flying dragons, and in classical Mediterranean cultures as well as in China they were regarded as messengers or angels sent from the heavens.

87

VIRGO

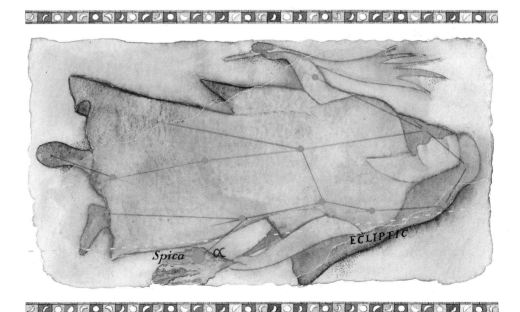

Virgo the Maiden is a zodiacal constellation of great antiquity. In area it is the second largest star-group, although apart from its great star Spica (Alpha Virginis, magnitude 1.2, brilliant white) the figure is not immediately obvious. Spica lies just south of the circle of the ecliptic.

It is most easily located by referring to the surrounding constellations – for example, if we continue from the slight curve in the handle of the Plough slightly east of south to Arcturus (Alpha Bootis), and then follow the curve around roughly the same distance again, we head south to Spica, the only other bright star in this region of the sky.

Virgo is shown as a maiden, frequently winged, lying along the ecliptic. In her right hand she holds a palm frond, and in her left a sheaf of corn: the "Virgin's spike" of Spica.

From the periods of early Mesopotamian and Egyptian cul-

tures, Virgo has been portrayed as a female figure associated with fertility. In Babylonian myth she represented Ishtar, Queen of the Stars, also known as Ashtoreth. In his chronicles of Anglo-Saxon England written in the 8th century AD, the Venerable Bede links the goddess Astarte, related to Ashtoreth, with the Saxon fertility goddess Eostre, who gives us the term "Easter". This was a matter of simple observation. In Bede's time, the stars of Virgo shone brightly in the night skies of March and April, as the fertile growing season of the Northern hemisphere commenced, and they remained visible until late summer to guarantee the arrival of the harvest: twelve centuries on the pattern remains much the same.

Early Greek authors identified Virgo with the ancient Egyptian goddess Isis, but principally the Greeks identified her as Persephone, daughter of the mother-earth goddess Demeter. In time, Ceres (the Roman equivalent of Demeter)

A pictorial representation of the star-group Virgo. In her right hand she holds a palm frond. In her left hand she holds sheaves of corn marked by Spica. This star is one of only two bright stars in this area of the sky, the other being Arcturus in the constellation Boötes.

Spica α

ECLIPTIC

became directly identified with the constellation, rather than indirectly through her daughter. The connotations of fertility and harvest are represented in the well-known myth of Persephone's abduction. She was spied among the springtime buds by the Lord of the Underworld, Hades, who made one of his rare excursions into the upper world to seize this beautiful maiden and take her down into his realm to become his queen. Demeter spent many days wandering over the land in search of Persephone, until finally, in rage, she threatened to withdraw her power of fertility and lay waste the Earth unless the gods restored her daughter to her. Zeus arranged for his brother Hades to return Persephone, on condition that the girl had not tasted the food of the underworld. In fact, Persephone had already eaten some pomegranate seeds. Filled with compassion for Demeter and her daughter, Zeus decreed that henceforth Persephone must spend half the year below the earth with Hades (autumn and winter), and half the year above with Demeter (spring and summer). When Persephone returns to her mother we see the revival of spring, and the celebration of the Easter-goddess.

The Demeter-Ceres myth has become the primary way in which we now imagine this constellation, but there is a second major strand alluded to by classical authors, which holds Virgo to be a representation of Astraea ("Star-maiden"),

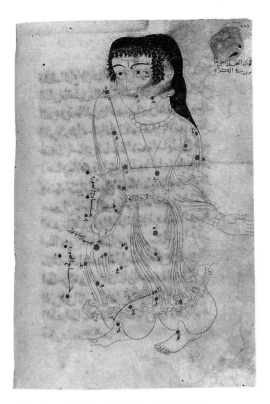

Virgo, from the Book of Fixed Stars *by the Arab astronomer Al Sufi (10th century AD), who was greatly influenced by Ptolemy. Virgo is seen as she would appear on the* outside *of the Celestial Sphere. In classical representations she is usually winged. Here she has one shoulder raised to accomodate the star which according to Ptolemy is located at the tip of one wing.*

the goddess of justice, daughter of Zeus and Themis; her scales of justice are the constellation of Libra. According to the Greek poet Aratus (who flourished *c.*315 –245BC), "of old she dwelled on earth and met men face to face ... ever urging on them judgments kinder to the people". This was in the Golden Age, and as humanity passed from grace to degradation through the Silver and the Bronze Ages, "verily did Justice loathe that race of men and fly heavenward and took up that abode, where even now in the night time the Maiden is seen of men."

A third classical theme relates Virgo to Erigone, the daughter of Icarius (see pp.90–91).

In India, Virgo was known as Kanya, mother of the god Krishna, and was shown as a goddess seated in front of a fire. Since the period of early Christianity in Europe, Virgo has been identified with the Virgin Mary. It has been thought that the brightest star, Spica, represents the Divine Child cradled in his mother's arms.

European influence on China since the 17th century has shown in the Chinese name for Virgo: "Cold Maiden". However, ancient China gave it a different connotation, focusing on Spica as the determinative star of the first lunar mansion *Chio*, the "Horn". It was this star that marked the boundary between the sky palaces of the south and east, respectively known as the Vermilion Bird and the Blue Dragon (see p.50).

BOÖTES AND CORONA BOREALIS

High in the Northern hemisphere and a prominent constellation of the Northern spring and early summer, Boötes is easily identified by Arcturus, its principal star (Alpha Bootis, magnitude 0.2, golden yellow). This star is found by continuing the gentle southeastern curve of the handle of the Plough (Big Dipper), the Bear's tail of Ursa Major. Continuing the same arc around to the south brings us to the star Spica on the ecliptic in the constellation of Virgo, the only other very bright star in this region of the sky.

Arcturus marks the knee of the figure of Boötes, shown as a great hunter or herdsman with his head to the north and his feet bordering on the constellation Virgo. He is sometimes pictured holding a pair of hunting dogs on a leash to his west, represented by the small constellation of Canes Venatici.

Since Homeric times (*c.*8th century BC), Boötes has been designated as an ox-herder, and yet the name of his principal star Arcturus derives from the Greek word for "bear-keeper". Like other prominent stars, Arcturus has often interchanged its name with that of its constellation, and this reflects an alternative interpretation of Boötes in which he eternally drives the Greater and Lesser Bears around the Pole. The broad theme of hunter or herder has been the primary mythological motif throughout Greek-influenced cultures.

Related roles for Boötes are the waggoner, pulling the "waggon" of the Plough, and of course, the Ploughman. A distinct, but secondary, theme connected with the hunter-herder image may be traced through an early Greek

The constellation Boötes, the Hunter, from the Book of Fixed Stars (10th century AD), a superb manuscript by the Arab astronomer Al Sufi, based largely on the work of Ptolemy.

name for Boötes, Lycaon, meaning "wolf". In Hebrew tradition Boötes is termed Caleb Anubach, the "barking dog".

In contrast to the herder-hunter designation, another myth-complex about Boötes identifies him with the Greek figure Icarius who, in return for hospitality, was taught by Dionysus the secrets of the grape. However, when Icarius gave wine to local shepherds they mistook their intoxication for poisoning, and murdered him. His daughter Erigone was led to her father's body at the foot of a tree by his faithful dogs, represented by the constellation Canes Venatici or by Procyon in Canis Minor. There she hanged herself in grief. In memory of this tragedy, Icarius was placed in the stars as Boötes, and his daughter became the constellation Virgo (see opposite page).

Curiously echoing the classical interpretation, the Shawnee people of North America also associate Arcturus with hunting. The star represents the hunter White Hawk, while his wife is identified by Al Phecca (Arabic for the "Bright One of the Dish"), the brightest star of a group they call the "Celestial Sisters". This group is the small but distinctively beautiful constellation known to us as Corona Borealis (the "Northern Crown"). Al Phecca is also known as Gemma, the Latin word meaning "gemstone".

In Greek mythology the crown is the headband of the Princess Ariadne, who gave a beautiful thread to her lover Theseus to guide him out of the labyrinth of the monstrous Minotaur, on the island of Crete. The lovers married, and the god Dionysus gave the headband as a wedding present.

1

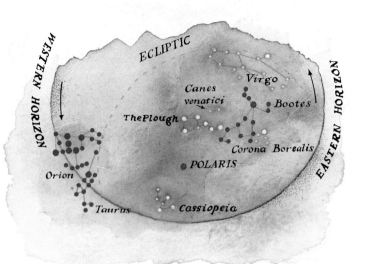

2

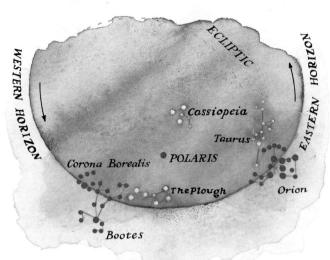

3

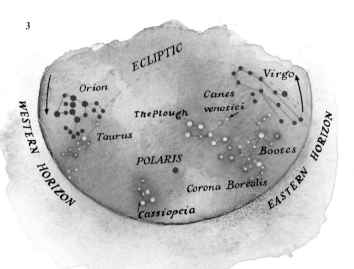

4

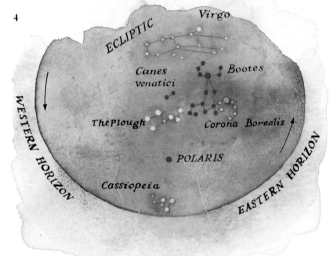

The story of Icarius (Boötes) unfolds if we watch the passage of the constellations in the night sky in the Northern hemisphere over two nights.

1 *When Boötes culminates, Taurus sets. As Taurus is sacred to Dionysus, we see that the god is departing, having passed on his knowledge to Icarius. Orion setting at the same time represents*

the local shepherds falling asleep, intoxicated under the influence of Icarius' wine.

2 *When the shepherds wake the next day, they are furious. Orion strides up over the eastern horizon brandishing his club, just as Boötes (Icarius) sets to the far northwest, consigned to his grave by the angry locals.*

3 *As the shepherds once more go down in the west, Icarius' daughter Erigone comes seeking her father (represented by Virgo rising).*

4 *Finally, as Boötes culminates again, the body of Icarius is found by his faithful dogs. When Virgo sets, the tragedy is completed with the passing away of the heartbroken Erigone.*

SCORPIO, OPHIUCHUS AND LIBRA

In the Mediterranean skies the distinctive hook of a scorpion's sting is clearly visible. This belongs to Scorpio, the eighth zodiacal constellation, on the portion of the ecliptic that lies to the south. Part of the tail is obscured at northern latitudes above 47°N and lost completely above 52°N; in Southern skies the whole constellation is visible. At the heart of the Scorpion is the ruddy-coloured Antares, the brightest star in this area of the sky and an ecliptic marker, lying less than 5° south of this

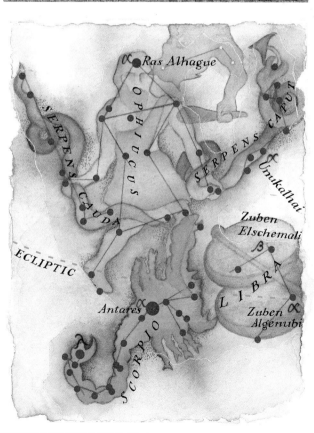

circle. To the west of Antares, a fan of three stars forms the claws of the present figure, although in early times these extended to the faint stars that now form the scales of Libra. The constellation can be found from Sagittarius, whose arrow points westward directly at Antares, just over 20° away.

About 5,000 years ago, in the fertile crescent of the Tigris and the Euphrates rivers, the Sun's passage through Scorpio brought the autumn equinox. Hence Antares was one of four Royal Stars marking the equinoctial and solsticial points of the ecliptic circle, forming a great cross in the sky with Aldebaran in Taurus, Regulus in Leo and Fomalhaut in Aquarius.

There is a malevolent, "death-bringing" theme associated with Scorpio, perhaps owing to the redness of Antares, which means "Rival of Ares". This link is amplified by the symbolism of the red planet Mars (Roman equivalent to Ares), known in astrology as a planet of slaughter, and the ruler of Scorpio.

In Greek myth the stories of the scorpion, the hunter Orion and the healer Asclepius (identified with the constellation Ophiuchus) belong together. Orion once stupidly boasted that he would be able to kill all wild beasts. Hearing this, the earth-goddess Gaea punished him for his arrogance, sending the scorpion to sting him on the heel. This is shown in the motions of the constellations. As Scorpio ascends on the eastern horizon, Orion dies and sets in the west. However, Asclepius healed Orion and crushed the scorpion underfoot – reflected by Orion rising again in the east, restored to vigour, as Asclepius (Ophiuchus) grinds Scorpio into the earth in the west.

The name Ophiuchus derives from the Greek for "Serpent-handler". Although there was no hero or god of this name, the

A constellation map showing the relative positions of Scorpio, Ophiuchus and Libra. The brightest star in the group is Antares in Scorpio. The illustration shows how the heads of Ophiuchus and Hercules almost touch, while Ophiuchus splits Serpens into two halves.

figure is associated with the healer Asclepius, son of Apollo, whose emblem of entwined serpents has long been a symbol of the medical profession. Asclepius learned the arts of medicine from Apollo and the centaur Chiron. Ophiuchus stands over the scorpion with his head to the north, beneath the inverted figure of Hercules, so that the heads of these heroes almost touch. In his hands he grasps a serpent, the constellation Serpens, whose head and tail are the two portions of one original constellation, now separated by Ophiuchus: to the west is Serpens Caput ("Serpent's Head") and to the east Serpens Cauda ("Serpent's Tail"). There is no bright star in the group. The main star, in the head of Ophiuchus, is Ras Alhague (second magnitude), Arabic for "Head of the Serpent-Charmer".

Ophiuchus is central to a controversial claim by anti-astrologers that it is the thirteenth sign of the zodiac, and that people born between November 30 and December 17 or 18 each year are not Sagittarians, but Ophiuchians! The astrological argument is based upon precession. The zodiacal signs

The Gorgon Medusa's head, severed from her body by Perseus: the picture shows an acroterion (roof ornament) from the temple of Apollo, Delphi. From the wound two phials of blood were collected by the goddess Athene and given to Asclepius (Ophiuchus). With blood from the left side Asclepius raised the dead; with blood from the right he could instantly kill.

consist of twelve 30° segments around the ecliptic measured from the spring (vernal) equinox point (see pp.24–5). The path of the Sun through these divisions over a year is the source of their meanings, but their names and some symbolism originally derive from twelve irregularly sized star-groups along the ecliptic. Owing to precession (see pp.36–7), the twelve signs long ago departed from alignment with their constellations, a fact accounted for by astrologers. Ophiuchus projects down across the ecliptic between the constellations Sagittarius and Capricorn, hence the idea of a thirteenth zodiacal constellation: but that has no bearing on the symbolic construction of the twelve-sign zodiac. As propaganda, however, the thirteenth sign is an easy stick with which to beat astrologers.

To the east of Ophiuchus is the small and visually insignificant zodiacal constellation of Libra. It can be located by looking on the ecliptic roughly midway between Spica in Virgo and Antares in Scorpio. Near the mid-point is the fulcrum of the scales, the star Zuben Algenubi (Beta Librae), almost exactly on the ecliptic. Around 8° northeast is the slightly brighter Zuben Elschemali. The ancient Greeks combined this constellation with Scorpio, but it was separated off into its own star-group by the Romans under the influence of Julius Caesar (100–44BC), who was placed in the heavens as a figure holding the scales, symbols of justice.

93

A star map showing the constellation Libra, from an 18th-century constellation book. The Sun passes through this star-group during November.

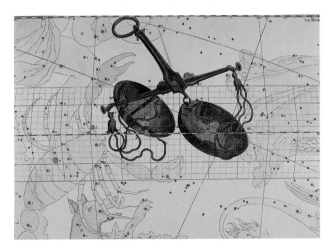

THE HERCULES GROUP

Hercules is a large and somewhat indistinct constellation rising high in the Northern midsummer sky. The shape of the kneeling figure, brandishing a club in one hand, with the other hand outstretched, bears a resemblance to Orion, although its stars are less impressive, none being much above the third magnitude in brightness. For the Northern hemisphere observer, the figure appears inverted, with his feet toward the North Pole. He is located to the west of the star Vega (Alpha Lyrae), and above Ophiuchus. The brightest star, which marks Hercules' head (Ras Algethi, "The Kneeling Man's Head"), is only a few degrees to the west and a little north of the more noticeable Ras Alhague, in the head of Ophiuchus. Hercules rests his foot on the head of the dragon Draco, which coils round the North Celestial Pole.

94

An obscure early Greek foundation of this constellation and its undramatic appearance hardly seem to do justice to the heroic stature of the most famous of all classical heroes, Heracles (Hercules to the Romans). Most Greek authors knew the figure under the name of "The Kneeling One", without understanding its derivation. In his *Phaenomena* the poet Aratus termed it " ... a Phantom form, like to a man that strives at a task. That sign no man knows how to read clearly, nor on what task he is bent, but men simply call him On His Knees."

Despite its pale appearance, there is evidence to suggest that the figure was of great significance from

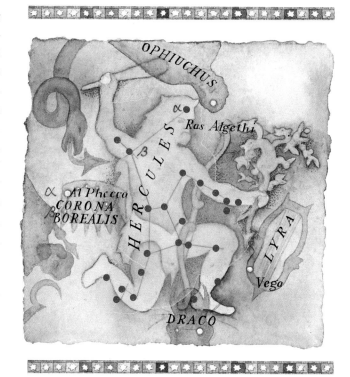

A star map showing Hercules and neighbouring constellations. He appears holding the Nemean Lion's skin. Boötes is by his right foot and Serpens Caput by his right arm. In the Northern hemisphere this configuration is inverted.

The constellation Aquila, from a late-14th century copy of Al Sufi's Book of Fixed Stars. *To the Arabic astrologers it was known as Al Okab, the Black Eagle, or as the Crow or Raven.*

the earliest times. Heracles is a close equivalent to the Babylonian hero Gilgamesh. Among a number of parallels, both defeat a monstrous lion, overcome a divine bull, and have to kill a dragon coiled around a sacred tree, the final labour of Heracles. From late in the 4th millennium BC there is a Mesopotamian description of a hero, who was later identified with Gilgamesh, kneeling with one foot on the head of a dragon – an apparent prototype of the Greek "Kneeling Man".

The Romans were impressed with the constellation, and finally established the tradition of identifying it with Hercules.

Although the sources vary about the details of the story, they agree on its broad outline: that he was required to undertake twelve seemingly impossible tasks, on completion of which he would become immortal. In the night sky he is imagined wearing the indestructible pelt of the Nemean Lion (associated with the constellation Leo), which Heracles killed as the first of his twelve labours (see p.86).

One labour in particular, the cleaning of the Augean stables, has become a well-known literary metaphor, used to express the idea of a formidable challenge. King Augeas was the owner of a herd of 3,000 oxen, but their stalls had not been cleaned for thirty years. Heracles had the filthy task of clearing them out in one day. To do this he diverted two rivers, the Alpheus and the Pineus, toward the farm; then he breached the walls of the farmyard so that the rushing waters cleaned the stables right through.

The Latin writer Servius (who flourished *c.*AD300) commented on the tradition of attempting to interpret the twelve labours of Heracles as the twelve signs of the zodiac, with the hero as a Sun-god passing on his journey through the solar year. One piece of evidence for this approach is the story of the Augean stables mentioned above. The name of the king, "Augeas", comes from the Greek for "Bright Ray"; furthermore, he was a son of Helius, the Sun-god, and Nuctea, the longest night. In symbolic terms, this combination may indicate the Sun at the darkest part of the Northern hemisphere's year, the midwinter sol-

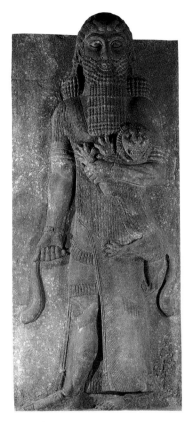

An 8th-century BC relief of Gilgamesh, whom the Babylonians associated with Hercules. He is shown here with a captured lion.

stice, which, in the millennium during which the myth matured, fell in the constellation Capricorn. However, the interpretation has a serious flaw: the early Greeks gave fewer than twelve labours, and the labours as they later became identified are not ordered in the sequence of the zodiacal signs.

To the east of Hercules and lying on the Milky Way is a group of relatively small constellations of which three, Lyra, Aquila and Cygnus, are visually striking by virtue of their bright stars. Lyra, the Lyre, close by Hercules, is marked out by the beautiful pale sapphire Vega. With a magnitude of 0.14, it is the fourth brightest star in the heavens. The Greek name for this constellation was *chelys*, the "tortoise-shell", said to be the shell that Hermes used to make a marvellous lyre for Orpheus, who charmed even the lord of the underworld with his music.

Passing southeast from Vega and across the eastern edge of the Milky Way brings us to another brilliant star, Altair (magnitude 0.9, pale yellow), in the constellation of Aquila the Eagle. This royal bird loyally served Zeus. Its final mission was to punish the Titan Prometheus for stealing fire from the gods and giving it to mankind, which in some accounts he is said to have created out of clay. Zeus ordered that Prometheus be chained to a mountain peak, and every day the hero had to suffer the eagle consuming his liver, which each night was miraculously restored. Heracles eventually slew the eagle, and Zeus placed it among the constellations.

SAGITTARIUS AND CAPRICORN

Lying well south of the equator, Sagittarius is not a prominent constellation for Northern hemisphere viewing, and at middle latitudes it clings just above the horizon, in the light summer nights in June to early August, never completely revealed. However, for Southern latitudes during these months it can be seen prominently, high in the sky.

The ninth zodiacal constellation, Sagittarius is represented as a centaur – a creature half-man, half-horse. He is armed with a bow and arrow, forming the western part of the figure, which falls on the Milky Way – a wide band at this point. The archer's bow is seen in a curve of three stars, Kaus Borealis, Kaus Medius and the more prominent Kaus Australis (respectively the northern, middle and southern parts of the bow: Lambda, Delta and Epsilon Sagittarii). The archer's hand, drawing back the arrow, is the second-magnitude star Nunki (Sigma Sagittarii), and the line of the arrow stretches from

Kaus Medius to Al Nasl (Gamma Sagittarii), which marks its point. The arrow gives a useful orientation, because the archer appears to be taking aim at Antares in Scorpio, some 20° westward on the farther edge of the Milky Way, and just a little above the line of fire. But perhaps the archer seeks a still greater target – among the clouds of stars into the depths of the Milky Way, the very centre of our vast galaxy.

Historically, the representation of Sagittarius as a centaur has led to confusion with the Southern constellation Centaurus. However, each of these mythical characters has a distinctive personality; unlike the mild Southern centaur, Sagittarius is wild and warlike. Appropriately, therefore, Sagittarius can be traced to Mesopotamian mythology as the archer-god Nergal, who ruled over the war-planet Mars.

In Greek mythology, however, Sagittarius was identified with the wise centaur Chiron. The association comes from a myth surrounding the action of Artemis, the goddess of hunting. Some say that Artemis manufactured the death of Orion, by arranging for a scorpion to sting him on the heel. To avenge this death, Chiron killed the scorpion with an arrow. The episode is shown in the skies by the centaur taking aim at the scorpion's heart, Antares. This story overlaps that of the crushing of the scorpion by Asclepius (the constellation Ophiuchus; see pp.92–3), and reminds us that, like Asclepius, Chiron was said to have healing powers.

The tenth zodiacal constellation, Capricorn the Goat, is an obscure figure for Northern hemisphere observation, lying well south of the equator and with no bright stars. It is best observed when it culminates around midnight during August, and may be found by drawing a line from Vega in Lyra

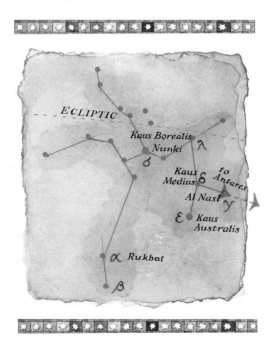

A star map of the constellation Sagittarius, showing the major stars and, particularly, the formation of the arrow which points toward Antares at the heart of the scorpion, Scorpio.

96

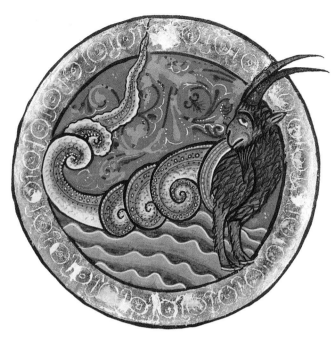

The zodiacal sign Capricorn, shown as an amphibious creature with the head of a goat and the tail of a fish, from an English Psalter of c.1170.

Capricorn develops the goat motif through the story of the satyr Pan, who had a goat's hindquarters. In revenge against the Olympian gods for toppling the Titans, the Titaness Rhea conceived a terrifying sea-monster, the Typhon. When this creature rushed toward Olympus, Pan dived into a river and tried to disguise himself as a fish, but managed only an incomplete transformation. By the time he returned to land in his new dual form, the Typhon had wrenched Zeus' sinews from his body. Pan used his gift of sound to utter a penetrating shriek to frighten the monster, while Hermes deftly gathered the remnants of Zeus' limbs. Restored, the great god hurled his largest thunderbolt at the monster, permanently disabling it. Zeus rewarded Pan by placing him in the heavens as Capricorn. The poet and mythologist Robert Graves describes Pan as a descendant of the devil-figure worshipped by a primitive Arcadian fertility-cult, which survived in the witch-cults of Northern Europe.

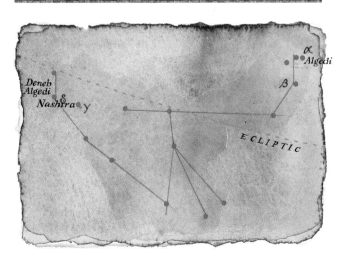

through Altair in Aquila; this runs on to define the horns and the head of the goat through the figure's alpha and beta stars, Giedi (Arabic for "ibex", a horned mountain goat) and Dabih ("Lucky One of the Slaughterers"). The fish-tail of the creature is marked by the gamma and delta stars Nashira ("Bringer of Good Tidings") and Deneb Algedi ("Goat's Tail").

Although classical authors often treat Capricorn as a goat alone, the goat-fish image can be traced to Mesopotamian origins. There is evidence to connect the figure with the Chaldean god Oannes, the god of wisdom, who was half-man, half-fish. In India, Capricorn was variously shown as an antelope or a crocodile, and occasionally as a hippopotamus with a goat's head – associations that repeat the theme of a creature that moves between water and land.

Another major thread of Greek myth associated with

A star map of Capricorn. The alpha star marks the horns and the delta star marks the tail. Capricorn is the smallest of the twelve zodiacal constellations.

AQUARIUS AND PISCES

The eleventh zodiacal constellation, Aquarius the Water Carrier, culminates at midnight in the period from August to September. The main part of the figure lies southwest of the great Square of Pegasus. He is shown as a man pouring a pitcher of water, from which flows a gushing stream known as *Fluvius Aquarii*, the River of Aquarius. The river splashes southward across the ecliptic in a great curve that brings it around by the waterman's feet, where the Southern Fish, Piscis Australis, swims upstream, marked by the reddish first-magnitude star Fomalhaut. Apart from this star, Aquarius is not an easily discernible figure, being comprised of stars of the third magnitude or fainter. As a result Aquarius requires some effort of the imagination to trace, but this constellation nevertheless has a fascinating and consistent history.

Our modern version of the constellation is almost identical to a waterman figure found in early Babylonian carvings, then as now awkwardly and unaccountably reaching back with his free arm toward Capricorn. There is a strong likelihood that the waterman is associated with the great Deluge, recorded in the Bible and in sources from the Old Babylonian period (2nd millennium BC). Furthermore, in this

era, the 11th month, corresponding to the Aquarius period of January-February, was termed the "curse of rain".

The Greek poet Pindar (*c*.522–*c*.422BC) recorded the ancient belief that the constellation symbolized the spirit of the source of the Nile, which gives life to the Earth as a whole. The ancient Egyptians deified the river as Hapi, and depicted this god residing close by the primordial spring, from which

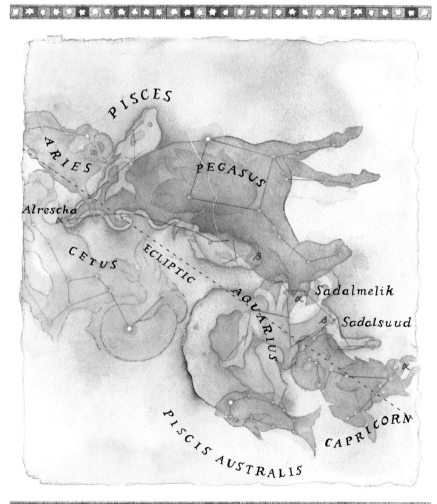

A star map showing Aquarius, Piscis Australis and the far-spanning Pisces in their positions in the heavens, among the winged horse Pegasus, the sea-monster Cetus and Capricorn the Goat-fish.

A 16th-century Turkish painting of Pisces, depicted as a single fish in this example. From right to left are images of the decans of Pisces, three 10° subdivisions of the sign.

he distributed water to heaven and the Earth from his urns.

In Greek myth Aquarius represents Ganymede, the beautiful Phrygian boy ravished by Zeus in the form of an eagle. He became the cup-bearer of the gods.

The humane symbolism of Aquarius has come into the forefront of the modern imagination owing to the widespread "New Age" culture for which it stands – an idea that has become inextricably bound up with the turn of a new millennium. The slow movement of precession (see pp.36–7) means that another three centuries will pass before the spring (vernal) equinox comes into alignment with the easternmost part of Aquarius. Whatever significance we give to this, it has come to represent hope for better things, and for a renewal of the waters of life.

The neighbour of Aquarius, also requires imagination to determine its shape, is Pisces the Fishes, the twelfth zodiacal constellation. It is a diffuse spread of faint stars covering a large span of sky between Pegasus, which it borders to the south, and Aries. The fishes are joined at their tails by a cord, knotted at their main star, Al Rischa (Alpha Piscium). The eastern of the two fishes appears to be striving vertically northward, whereas the other stretches along the ecliptic toward the west, below the square of Pegasus. Pisces culminates at midnight during the period from September to October. This constellation has been shown as fishes since Babylonian times, although its form has varied.

The 11th-century Arab astronomer and astrologer Al

Biruni was almost certainly correct in asserting that the original star-group consisted of one fish, not two. This accords with the Greek scientist Eratosthenes (born 276BC), who traced the constellation to the Syrian goddess Derke (to the Greeks, Atargatis), a huge fish with a woman's head.

The Greeks enriched the story of these stars by compounding Atargatis with the Syrian deity associated with Aphrodite (Astarte), and this is the origin of the Piscean association with the tale of Astarte-Aphrodite and her son Eros (to the Romans, Venus and Cupid). The monster Typhon, created by the vengeful goddess Rhea, one day startled Aphrodite and her son. Knowing that they could escape by water, Aphrodite and Eros turned into fishes and leaped into the sea. To avoid losing each other they tied their tails together with a long cord. In the Roman version Pisces represents the fishes that carry Venus and Cupid to safety.

The astronomer Julius Stahl cites the often-found connection between fish and treasure, and relates it to a German folk tale. A poor couple lived in a cabin by the sea, and their sole possession was a tub. One day the man, Antenteh, caught an enchanted fish, which offered anything they wished in return for freedom. Antenteh wanted nothing, but his wife asked for a home with furniture, which was granted. Then she asked to be a queen and the fish obliged. Finally the woman asked to be a goddess. Furious, the fish returned Antenteh and his wife to their cabin with its single tub. The empty tub is represented by the Square of Pegasus, and the enchanted fish is Pisces.

99

THE ANDROMEDA GROUP

The story of Andromeda, and her rescue from the sea-monster by Perseus mounted on the winged horse Pegasus, is one of the best known of all the Greek myth-complexes, and every autumn a striking, and easily located, group of constellations unfolds the drama across a large sweep of the Northern sky.

The starting point for observation is the circumpolar constellation Cassiopeia, immediately identifiable as a letter W, or M when inverted. The shape is formed from an arrangement of five stars of the second and third magnitudes. It is a signpost to the Celestial Pole, as the W is cupped toward Polaris, the star that stands within a degree of the Pole; furthermore, the configuration lies the same distance (30° of declination) on one side of the Pole as the Plough on the other side. By locating either or both of these figures, therefore, the whole Northern sky can be oriented at a glance.

Moreover, in our epoch these constellations allow a ready identification of the equinoctial colure, the meridian line running through the Poles to the spring (vernal) and autumn equinox points. The colure skirts the edge of the W at Caph (Beta Cassiopeiae) and runs on down to the Northern spring point. In the other direction the colure passes through the Pole and then down through the Plough between Phecda and Megrez (Gamma and Delta Ursae Majoris), which mark the "handle" side of the Plough's "saucepan".

The next stage of the visual journey is the "Square of Pegasus", a beautiful group of four stars culminating at midnight during the month of September. The brightest of the four lies just 2° east of the equinoctial colure and therefore due south of Caph. This is the second-magnitude Sirrah ("The Navel of the Horse") or Alpheratz; it has in modern times become the alpha star of constellation Andromeda, and marks the head of the chained princess close by the winged horse.

The northern edge of the Square of Pegasus extends into a gentle east-to-northeast curve of four stars describing the

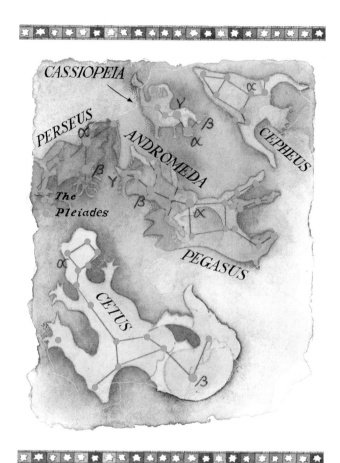

A star map showing the relative positions of Perseus, Andromeda, Cassiopeia, and Pegasus, along with Cassiopeia's father Cepheus, and the terrible sea-monster Cetus, which threatened the life of Andromeda.

figure of Andromeda, from Sirrah at the head through Mirach at her waist to Alamak marking her feet. At her feet and to her east is her saviour and suitor Perseus, located above the Pleiades in Taurus. His head is marked by the second-magnitude lilac-coloured Mirfak or Algenib (Alpha Persei). In his left hand Perseus holds the Medusa's severed head, shown

A star map of Cassiopeia, defining the distinctive "W" shape of the main stars and the equinoctial colure. This constellation can be used to orientate the directions of the equinox point and Polaris, the Northern Pole star.

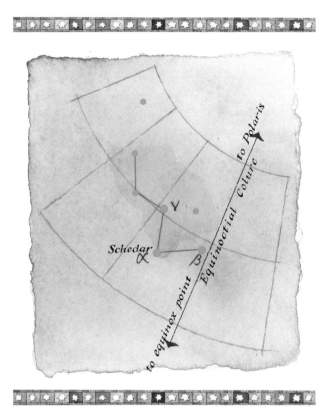

by ill-omened Algol (Beta Persei), the demon star; this is a white eclipsing binary (double-star) system which "blinks" by varying its brightness between the second and third magnitudes in a cycle of two days and 21 hours.

Two other characters in the drama remain to be located. Taking a westward line from Mirfak in the head of Perseus and back through Cassiopeia, we come to her circumpolar husband, Cepheus; and far away to the south, beneath Perseus and Aries, lies the sea-monster Cetus, his snout marked by the third-magnitude, orange star Menkar (Alpha Ceti), lying just above the equator of the heavens.

The story of Perseus repeats a recurring motif in Greek myth, that of the son who is prophesied to kill one of his progenitors, in this case his grandfather. An oracle foretold that King Acrisius would have no male heirs, but that his grandson would kill him. To circumvent this doom the king had his daughter Danaë imprisoned in a tower of brass so that she

A view of the constellation Cassiopeia, showing the Nova (to the right), a faint star, which explodes and shines brightly before decreasing to its normal luminosity again over a period of time, of 1572. This detail is taken from Tycho Brahe's Astronomiae Instauratae Progymnasmata *(Preparatory Study for Renewed Astronomy) of 1672.*

might never bear any children. However, the mighty Zeus mocked such precautions, and entered the maiden's chamber disguised as a shower of gold, carried on a shaft of light, and in this form he impregnated her. Danaë managed to conceal her baby Perseus for four years, but when Acrisius finally discovered his grandson, he had mother and child locked in a trunk and cast out to sea to perish. However, the trunk was carried by the ocean currents to the island of Seriphos, where Danaë and Perseus were rescued by the fisherman Dictys, brother of King Polydectes of Seriphos.

The heroic exploits of Perseus began when, as a young man, he defended his mother against the advances of Polydectes. To

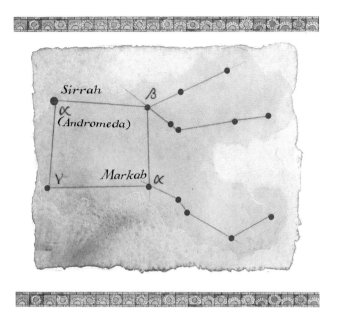

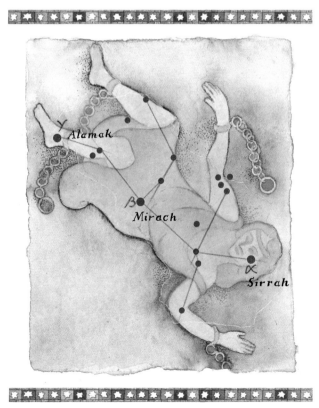

ensure that the king would choose another bride, Perseus agreed to bring him the head of the Gorgon Medusa, a rash and perilous promise. All knew that around the head of this terrifying creature coiled venomous snakes, and that her gaze turned living beings into stone. However, the goddess Athene heard the young man's vow and chose to guide him. She gave him a polished shield in which he would be able see to Medusa's reflection without looking directly at the monster, and the god Hermes provided a sickle with which to kill her. Athene led Perseus to the Graeae, monstrous hags and sisters of the Gorgons. Perseus grabbed the single tooth and eye that they shared and refused to return them until the hags showed him the way to the Stygian nymphs, who held for him winged sandals for flight, a helmet of invisibility from Hades, and a wallet in which to carry Medusa's head.

Once the Stygian nymphs had given Perseus these items, he flew to the land of the Hyperboreans, the people who live beyond the North Wind. There he stole upon the Gorgons, asleep among the petrified stone shapes of beasts and men. Using the reflection in his shield he struck off Medusa's head with a single blow. From the body of the Gorgon, a warrior and the winged horse Pegasus sprang fully formed: they had been begotten by Poseidon when he ravished Medusa in the temple of Athene. It was for this sacrilege that Athene had originally condemned Medusa to her hideous punishment. Perseus did not wait for further trouble, but rode invisibly

Above left: *A star map of Pegasus, the mythological winged horse. Highlighted in red is the "Square of Pegasus", in the top left hand corner of which sits Sirrah (Alpha Andromeda or Delta Pegasus), the brightest star in both its constellations.*

Left: *A pictorial representation of Andromeda, oriented as she would appear in the Northern hemisphere. The gamma star Alamak is a triple star, whose two brightest stars vary greatly in colour: one is blue, the other orange.*

102

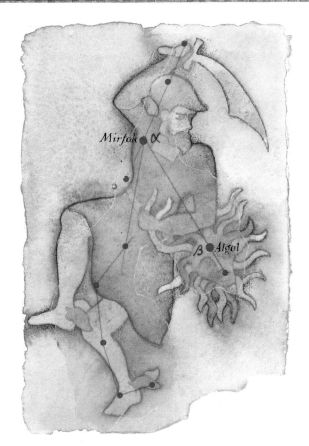

A pictorial representation of the constellation Perseus. In his right hand he holds the sickle given to him by the god Hermes, while Mirfak marks his head and Algol denotes the head of the Gorgon Medusa in his left hand. His winged sandals are marked by the gamma star at his feet.

away, with the seething head in his pouch. It was on this return journey that he came upon Andromeda chained to the rock, and this is where the destinies of these lovers intertwine.

Andromeda was the daughter of Cassiopeia and Cepheus, queen and king of Ethiopia. Cassiopeia once foolishly compared her own beauty, and that of Andromeda, to the beauty of the Nereids, the mermaid-daughters of the wise old man of the sea, Nereus. They complained to their guardian Poseidon, who

responded by summoning a flood and creating Cetus, the sea-monster, to ravage the people. The oracle of Ammon instructed Cepheus that his kingdom could be saved only by the sacrifice of his daughter. Accordingly, Cepheus had Andromeda chained naked to a rock at the sea's edge, as an offering to the monster.

Perseus, chancing on the scene, was entranced by the beauty of the young girl. Cepheus and Cassiopeia agreed to let him take their daughter back to Greece as his wife if he could save her. The young hero, dressed in his cloak of invisibility and in some accounts riding the winged horse Pegasus, drew the Gorgon Medusa's head from the wallet and, holding it aloft in case the monster looked up, swept down from the air, confusing the beast with the play of his shadow on the sea, before beheading it with the murderous sickle.

The joyful Andromeda wanted the wedding to follow immediately, but the celebrations were interrupted by another suitor Agenor (summoned by the treacherous Cassiopeia), who wished Andromeda for himself. He was escorted by an armed band and so, greatly outnumbered, Perseus drew out the Gorgon's head and turned two hundred of his foes into stone.

Perseus hurried back to Seriphos, but Polydectes had reneged on his undertaking not to pursue Danaë, who had fled to a temple. Perseus stormed into a banquet held by Polydectes and, to a clatter of insults and abuse, declared that he had with him the promised gift. Averting his eyes, Perseus pulled the Gorgon's head from the wallet, instantly turning Polydectes and his minions into a circle of boulders.

Perseus gave the head of Medusa to Athene, and ever since the goddess has displayed it on her shield. In punishment for her treachery, Cassiopeia was set in the heavens by Poseidon, placed in a market basket so that she looks ridiculous when her circumpolar movement tips her upside down.

However, Perseus had still not fulfilled the original

prophecy and he returned to Argos with his mother and his bride. Acrisius, remembering the oracle, fled to Larissa in Thessaly. One day Perseus was invited to take part in funeral games at Larissa – an occasion that Acrisius attended. When Perseus threw the discus, a chance wind sent by the gods carried the discus far from its path, so that it struck Acrisius and killed him.

Pegasus, the winged horse, presents an intriguing set of mythological motifs. The Greeks did not originally represent Pegasus as winged, but we have abundant evidence from Etruscan as well as from Mesopotamian sources that the horse with wings was known in pre-classical times.

Pegasus was commonly depicted as the steed of a great hero or a god. In ancient Jewish legend he was the horse of the legendary warrior Nimrod, "the mighty hunter before the Lord" (Genesis 10:9). In the earliest stratum of Greek myth, Pegasus is the equine carrier of Zeus' thunder and lightning. By stamping his moon-shaped hoof on Mount Helicon Pegasus created the Hippocrene, the "fountain of the horse" – a fountain of poetic inspiration sacred to the Muses, the nine goddesses of the arts and sciences.

The principal Greek myth relating to Pegasus is the story of Bellerophon, the "dart-bearer", son of the king of Corinth. Having killed another man (in some accounts his own brother), he was forced to flee from his home city and sought sanctuary with Proetus, king of Tiryns. Proetus' wife Anteia desired Bellerophon, but when he rejected her attentions the spurn ed woman told Proetus that the young warrior had tried to seduce her. Proetus was furious, but did not dare to murder a suppliant to his court. Accordingly he sent Bellerophon to

The constellation Cetus, as depicted in a Sanskrit star map (see p.103).

King Iobates, Anteia's father, carrying a sealed message with the words, "Pray remove the bearer from this world; he has tried to violate my wife, your daughter." This is the origin of the literary phrase "Bellerophontic letters", which is used to describe any communication designed to bring harm to the unwitting bearer of the message.

King Iobates was equally unwilling to murder his guest, yet he felt honour-bound to accede to his son-in-law's request. He resolved the dilemma by demanding the fulfilment of a seemingly impossible feat – to slay the Chimera, a she-monster belonging to one of his enemies. This creature had the fire-belching head of a lion, a goat's body and a serpent's tail.

Bellerophon was advised by a seer to catch and tame the winged horse Pegasus. One night while Bellerophon slept in the temple of Athene, this goddess brought him a golden bridle, and showed him where to find Pegasus. At the sight of the bridle the horse came willingly and allowed Bellerophon to mount him. Then Bellerophon, carried airborne by Pegasus, rained a hail of darts down on the Chimera and thrust between her jaws a lump of lead attached to the end of his spear. The monster's breath melted the lead, which ran down her throat and destroyed her inner organs.

One version recounts that, at the height of his fame, Bellerophon presumed to ride to Mount Olympus itself, the home of the gods. Zeus sent a gadfly to sting Pegasus under the tail, so that the horse reared, flinging Bellerophon to Earth where he landed in a thorn-bush. From that day on, he wandered blind and lame, shunning contact with men, and noble Pegasus became a lowly pack-horse.

ARIES

Aries the Ram culminates at midnight during the month of October. It is located to the west of the Pleiades and Taurus and to the southwest of Perseus. Its designation as the Ram goes back to the Mesopotamian heavens of the 3rd millennium BC. However, the shape of the ram in repose on the line of the ecliptic is difficult to distinguish apart from the dominant feature of the clump of three main stars that defines the head. The alpha star Hamal (magnitude 2.2, yellow), is the "Horn Star" or "Ram's Eye".

The first zodiacal constellation, Aries marked the spring (vernal) equinox (the crossing of the First Point of Aries with the celestial equator; see p.25) for two millennia before our era. Various temples dating from the middle of the 2nd millennium BC have been found oriented to Hamal.

In Greek myth this constellation represented the Golden Fleece shorn from a magical flying ram (kept in the grove of the war-god Ares). This was the prize sought by Jason, a prince of Iolcus in Thessaly. Jason's father was usurped by his brother King Pelias, who promised to cede Jason the throne if he retrieved the Golden Fleece from King Aeëtes of Colchis. The ram had been sent by Hermes to save the children of the king of Boeotia when their stepmother threatened their lives. One child was killed during the escape, but the other flew safely to Colchis on the ram, where he sacrificed the beast in thanks to the gods, and gave its fleece to King Aeëtes, who kept it guarded by an unsleeping dragon.

Jason gathered a crew (the Argonauts) and set sail in the *Argo* (see pp.82–3) to find the Golden Fleece. When the hero reached Colchis, Aeëtes promised to relinquish the fleece if Jason could perform certain difficult tasks. These he achieved, but Aeëtes would not keep his word. However, the king's sorceress daughter, Medea, bewitched the dragon so that Jason could seize the Golden Fleece and escape back to Thessaly with both the prize and Medea as his bride.

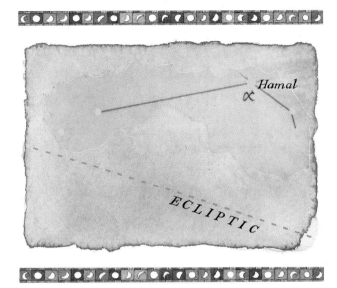

The star map of Aries the Ram, the first sign of the zodiac. The star-group lies just above the ecliptic, and in visual representations its largest star, Hamal, usually marks the ram's eye or horn.

The association of this constellation with the Greek god Ares carries through into astrology with its rulership by the planet Mars (associated with Ares). The constellation of Aries was also frequently dedicated to Athene and Zeus, and to the "Unknown God"; this gives us the clue to a significant reference in St Paul's sermon on the Areopagus, the hill of Mars in Athens (Acts 17:28). Paul establishes his God in place of Zeus when he says "For we are also his offspring". This quotation is based on the strong opening lines of the *Phaenomena* by the poet Aratus (who flourished *c*.315–*c*.245BC): "From Zeus let us begin; him do we mortals never leave unnamed; full of Zeus are all the streets and all the market-places of men; full is the sea and the heavens thereof; always we all have need of Zeus. For we are also his offspring; and he in his kindness unto men giveth favourable signs and wakeneth the people to work."

TAURUS

Taurus the Bull is a striking zodiacal constellation which in Northern skies culminates at midnight in early December. Northwest of Orion, it is identified by its two star clusters, the Pleiades and the Hyades, which form a loose group around the first-magnitude star Aldebaran (Alpha Tauri, pale red), the "Eye of the Bull". Close to the ecliptic, Aldebaran was one of the four Royal Stars which kept watch on the solsticial and equinoctial junctions on the Sun's path 5,000 years ago, where it marked the spring (vernal) equinox. The others were Antares in Scorpio (autumn equinox); Regulus in Leo (summer solstice); and Fomalhaut in Aquarius (winter solstice).

The figure of Taurus shows only the front of a bull, his head lowered as if to charge. The northern horn is marked by a brilliant white second-magnitude star, Al Nath (Beta Tauri).

Because it marked the spring (vernal) equinox from about 4000 to 1700BC, when archaic astronomy was founded in the Mesopotamian civilization of the Euphrates valley, Taurus was among the earliest recorded constellations. The bull symbolism is a recurrent theme, although in the Hebrew tradition, Taurus was associated with an ox. In Persia this constellation represented the bull Mithras, the god who combines the purity and invincibility of the Sun with a warrior-spirit: as

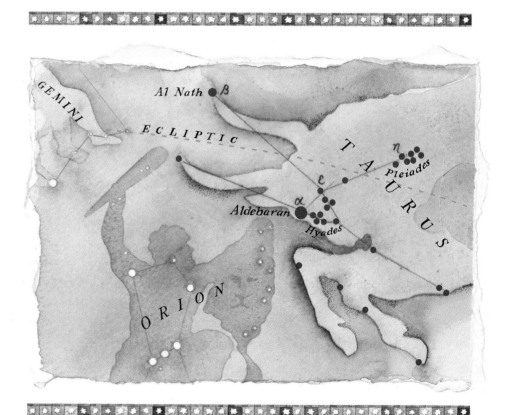

A star map showing the position of Taurus in relation to the constellations Orion and Gemini, and its location on the ecliptic. The red star Aldebaran (Alpha Tauri) marks the eye of the bull and Al Nath (Beta Tauri) the horn. The seven clustered stars of the Pleiades mark the shoulders of the creature, although they too have their own mythological relevance as the Seven Sisters.

The Pleiades as the Seven Sisters, from an Italian manuscript of the 9th–10th centuries AD. Clockwise from the top of the picture they are: Merope, Celeno, Sterope, Maia, Taygeta, Alcyone, and Electra in the centre.

this resulted in an ideal symbol for the Roman legions. Mithraism, a fomidable early rival of Christianity, became widespread throughout the Roman Empire.

For the Greeks Taurus represented the myth of Europa, the beautiful girl seduced by Zeus disguised as a gentle snow-white bull. The girl placed a garland about the creature's neck and mounted playfully on its shoulders. The bull strolled to the seashore but suddenly bounded into the waves, carrying off Europa. When they reached Crete, Zeus ravished her in a willow-thicket.

In the Roman world Taurus was sacred to Bacchus, god of wine. During the festivals dedicated to the god, a bull, strewn with flowers, was surrounded by dancing girls representing the Hyades and the Pleiades.

The first of these star groups, the Hyades, formed the 19th lunar mansion *Pi* in ancient China. Its marker-star was the fourth-magnitude Epsilon Tauri. *Pi* means "net", of the type used to catch birds or rabbits; Orion as the war-lord Tsan was extended to show him waving this net above his head. In the Mesopotamian creation epic, the god Marduk uses the Hyades as a boomerang-like weapon. The Hyades are also associated with the jaw-bone used by Samson to slay a multitude of Philistines. To the Aztecs these stars were an ox's jawbone.

A stone relief of Europa on the back of Zeus disguised as a bull, seen in the skies as Taurus by the ancient Greeks. In a circle around the subject the zodiacal constellations can be seen.

The Pleiades are located on the bull's shoulder around 15° northwest of Aldebaran. This beautiful close cluster of seven stars, like a miniature Plough, occupies an area no larger than the Full Moon. They have fascinated sky-watchers from earliest times, and have often been treated as a distinct star group. The brightest of them is Alcyone (Eta Tauri, third magnitude, greenish-yellow).

In Greek tradition, the Pleiades were widely interpreted as Seven Sisters, an association that has been adopted across many other cultures. It is commonly thought that one of the sisters has dimmed, which has led to the idea of the "weeping sister". However, it is has never been conclusively established which of the stars is affected in this way.

The Pleiades were the 18th Chinese lunar mansion *Mao*, the Mane, among the earliest for which there are records. In China the Mane was a sign of war and execution, associated with barbarians and nomads. In Hindu myth the Pleiades are known as the "Flame", and are dedicated to the fire-god Agni. They are associated with the October–November festival Divali, the Feast of Lamps (in Japanese myth, the Feast of Lanterns). The celebratory quality of the Pleiades is seen in the legends of Australian Aborigines to whom they are young girls playing to young men, in turn represented by the belt-stars of Orion.

URSA MAJOR AND MINOR

For an observer in the Northern hemisphere, the distinctive shape of the seven stars of the Plough or Big Dipper, high above Leo, is the most readily identifiable of all constellations. No part of the Plough ever disappears from the night sky at geographic latitudes above 40°N, and most of its stars are circumpolar for geographic latitudes above 30°N.

The Plough is part of the constellation of Ursa Major, forming the rump and tail of a huge bear, but its importance as a grouping in its own right justifies separate treatment. The pattern suggests a saucepan with a long curved handle, which at the same time is the bear's tail ; the side of the pan away from the handle is marked by the two brightest (second-magnitude) stars of the constellation, Dubhe and Merak (Alpha and Beta Ursae Majoris). These "pointers of the Plough" provide an invaluable reference for the sky-watcher because the arc between them is a virtually precise meridian or north–south line. From Merak through Dubhe the line points directly to the Pole Star some 30° away, and their turning through the night serves the navigator as the hour hand of a celestial clock.

There is a fascinating detail in the second star from the end of the pan-handle. On casual observation we see only a single second-magnitude star Mizar (Zeta Ursae Majoris), but more careful inspection reveals a fifth-magnitude star close by it, to the northeast. This is Alcor (80 Ursae Majoris), and despite its apparent insignificance it has always attracted attention. According to Arab tradition this star has the lowest rank in the celestial hierarchy (Canopus shows the highest). The desert Arabs also used the separation of Alcor from Mizar as a test of good vision; and their saying "He sees Alcor, but not the Full Moon" describes someone who perceives trivial details but loses sight of something obvious. A Teutonic myth says that Alcor was the frozen big toe of the giant Orwandil (equivalent to the classical giant Orion), which Thor broke off and threw into his wagon of the seven stars of the Plough.

This brings us to a major myth-complex of the seven stars, in which they are represented as the waggon or chariot of a god. As well as being the predominant identification in pagan

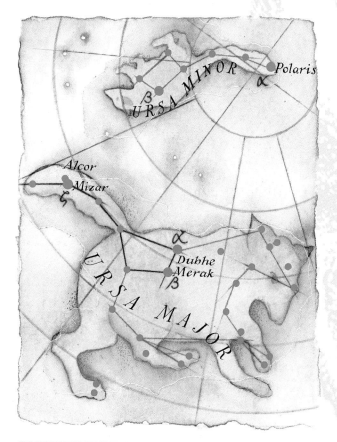

A star map of Ursa Major and Ursa Minor as they are positioned around Polaris (which forms the last star in the tail of the Lesser Bear). The Plough (Big Dipper) part of Ursa Major is picked out in dark red.

Europe, this theme is found in classical Greek and Latin authors, and among the Jews and Arabs. The same image occurs in China, where a relief from *c.*AD147 shows one of the Celestial Bureaucrats being transported in a carriage of the seven stars.

The Indian treatment of the stars as the seven *Rishis*, or sages, has been resonant in modern occultism and theosophy (divine wisdom). The term *rishi* has been shown to relate to the Sanskrit word meaning "bear", reflecting the myth-complex that has become dominant in our modern view of the constellation. Imagery of the Bear has an ancestry dating back to the Greece of Homer, and was widely adopted by classical authors. An unexpected repetition of this theme occurs within several of the North American tribes, who also identify the Pole Star itself as a bear. However, several other North American peoples interpreted the stars of the Great Bear as Seven Brothers. For still others, the pale star Alcor was thought to be a young girl, and, even more in keeping with the European interpretation of the constellation, some saw a girl who was transformed into a bear. The Pawnee people, on the other hand, saw in the stars of Ursa Major, "four men carrying a stick", and in Ursa Minor "four men carrying a baby".

The Greek myth about the Greater and Lesser Bears tells of the beautiful nymph Callisto (derived from the Greek word *kalliste*, meaning "most beautiful"), the daughter of King Lycaon of Arcadia. The girl loved hunting and joined the band of Artemis (in Roman myth, Diana), the goddess of the hunt,

Ursa Major, the Great Bear, known in Arabic by its major star name, Dubhe. The illustration comes from an Arabic manuscript dating from the 18th century.

which required her to stay a virgin. While she was resting one day in the forest, she was raped by the god Zeus, who approached her in the guise of Artemis before revealing himself and ravishing her. Callisto became pregnant, but in order to remain in the entourage of Artemis she tried to conceal her loss of chastity. However, the goddess soon noticed her condition and dismissed Callisto from her company. Callisto then gave birth to a boy, whom she named Arcas.

Hera, Zeus' jealous wife, heard about the birth of her husband's child and cursed the unfortunate Callisto, taking away her seductive beauty for ever and turning her into a bear. Ashamed of her form, Callisto hid away in the forest, while her son grew up to be a hunter himself. One day when Arcas was out hunting, the transformed Callisto recognized him as her son and, forgetting for a moment her bear-features, rushed to embrace him. Startled by the beast Arcas went unknowingly to shoot it with an arrow. However, Zeus intervened: he changed the youth into a bear also, and swung both mother and son into the heavens, where Callisto became the Greater Bear and Arcas became the Lesser Bear. Zeus held them by the tails as he whirled them, and that is why these appendages are both greatly extended in the sky compared with bears in the world below.

Hera, however, wanted further revenge, so Oceanus, the god of the great River Ocean which encircled the Earth, assured her that the two bears would never refresh themselves in his seas. Hence these circumpolar constellations for ever cross the sky without coming down to sea level.

THE MILKY WAY

On a clear moonless night, away from city lights, the hazy band of starlight that we know as the Milky Way can be seen in all its magnificence, stretching across the sky in a vast arc from horizon to horizon. When we look more carefully at this band, especially with binoculars, we can pick out rich clusters of stars in far greater concentrations than anywhere else in the sky. We will be looking directly along the plane of rotation of the vast flat disk of an enormous system of stars. The clouded light is in fact the merged, suffused light of countless stars, too distant from us to distinguish separately, which make up our galaxy. The Sun is just one of the 100,000 million stars in this vast system, around two thirds of the way out from hub to rim, lying on one of its spiral arms. Outside the band of the Milky Way, virtually all the stars we can see are close members of the same system, but their concentrations are relatively sparse because they fall outside the spiral disk of the galaxy. Our galaxy has a diameter of some 100,000 light years. Beyond it in all directions lie almost infinite wastes of space until we reach other star-systems. At two million light years the nearest major galaxy to us, visible as a faint smudge about the size of the Full Moon, is the Andromeda galaxy, in the constellation of Andromeda. The hub of our system, the galactic centre, lies in the constellation Sagittarius (see p.96), where the Milky Way is visibly broader and more dense.

The Milky Way has almost universally been described as a road or river,

Winding a path across the ecliptic through zodiacal Gemini and Sagittarius, the Milky Way (shown here in a cigarette card) has often been seen as a causeway for giants and holy men.

and in several regions of the world a great river has been seen as its terrestrial counterpart. In ancient Egypt the Milky Way was identified with the Nile, in India with the Ganges. In China the Milky Way was of central cosmological importance. Its name was Sky River and its earthly representatives were the Ho or Yellow River, and the River Han. Sky River was thought to have its own permanent Heaven's Ford where the stream breaks in two, the result of interstellar dust clouds close by the star Deneb in Cygnus the Swan (Alpha Cygni). This area of the sky represented the fords and bridges of the main rivers in China. It also plays its part in the popular legend of the industrious weaver-girl and the herd-boy, who are designations of the beautiful star-pair Vega and Altair (Alpha Lyrae and Alpha Aquilae; see p.95). When the girl married a neighbour, who herded cattle and lived on the banks of the Sky River, her father, the Sun-god, grew angry at her lax behaviour and decided to separate the couple: they were forced to live on either side of the river of stars, which is where we see them today. They are allowed to meet just once a year, on the festival of the seventh day of the seventh month. The Sun-god calls a flock of magpies, who form a bridge across the stream, and weaver-girl Vega runs joyfully across. Everyone hopes for clear dry weather for this festival in case the magpie-bridge is swept away by an unusually strong current.

A significant theme that recurs

across various cultures shows the Milky Way as the path of souls. The Sumo of Honduras and Nicaragua believe that Mother Scorpion dwells at the end of the Milky Way, waiting to welcome the souls of the dead; she also gives birth to the new-born and suckles them at her many breasts. The Roman scholar Macrobius (*c.*4th century AD) tells us that the souls of the dead ascend through the sign Capricorn and descend through the sign Cancer; this corresponds with the path of the Milky Way where it intersects the constellations Gemini and Sagittarius. He quite explicitly states that the gateway for the souls is the intersection of the Milky Way and the circle of the zodiac. We find reference to this in the world-view of the Mesoamerican cultures: the Mayan *wakah-ch'an*, or "World Tree", is thought to hold up the sky at this same ecliptic-galactic intersection.

Perhaps one of the most intriguing cosmologies surrounding the Milky Way is that of the village of Misminay in Peru (see pp.162–63). Here the Milky Way is believed to encircle the Earth collecting water from our oceans and rivers, and depositing it around the Celestial Sphere. The water is then returned to the Earth in the form of rain.

The Greek myths offer several different lines of interpretation for the Milky Way. One version of the Origin of the Milky Way concerns Heracles, who was born to Alcmene, the last mortal woman with whom Zeus lay. Zeus intended his son to be a great hero and protector of gods and men, but when

The Milky Way as seen from latitudes around 50° – approximately the view from London, Moscow and Toronto.

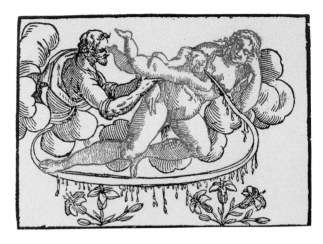

A Renaissance woodcut showing Heracles suckled by the goddess Hera. The spilt milk that splashed into the heavens became the Milky Way; the milk that fell to the ground gave rise to lilies (shown here).

Zeus' jealous wife Hera discovered his infidelity, she directed her envious wrath toward the child. She sent two serpents to kill Heracles as he lay in his crib, but the child strangled them with ease. Zeus determined that his son should become immortal by the milk of a goddess. So, by a ploy, he led Hera to believe that he was an abandoned baby, and thus induced her to suckle the child. The goddess bared her nipple, but the lusty infant sucked with such force that she flung him down in pain. A fountain of milk sprayed from her breast and became the Milky Way.

On the surface, this story appears to have little more than a whimsical astronomical reference. Yet we should not forget that Heracles is a solar hero, modelled on the Mesopotamian Gilgamesh: both have to struggle through twelve tasks like the passage of the Sun through the twelve signs of the zodiac. It is possible that this story disguises a subtle and ancient question of the connection between the Sun's path – the ecliptic – and the circle of the galaxy.

SACRED ALIGNMENTS

Ancient architectural sites, from Stonehenge in England to Teotihuacán in Mexico, show compelling evidence of deliberate alignments to astronomical phenomena, especially solstice and equinox sunrises, and moonrises and moonsets at the major and minor standstills (see pp.18–19), although also, sometimes, to stars or planets. The scientific study of such sites is known as "archeoastronomy". In the absence of documentary records, the precise uses to which such sightlines were put must in most cases remain a mystery. Nevertheless, it is reasonable to hypothesize that their purpose was to ensure, in different ways, the continuity of seasonal cycles, often with an underlying emphasis on fertility.

The pyramids at Giza, Egypt, have been shown to relate in their groundplan to the constellation Orion (associated by the ancient Egyptians with the god Osiris) and with the smaller star-group we know as the Hyades (whose alpha and epsilon stars are shown here: see pp.135–37). The nearby River Nile was interpreted as a terrestrial equivalent of the Milky Way.

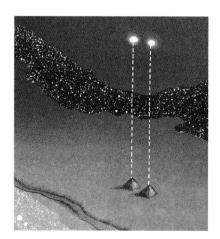

The great urban and ceremonial centre of Teotihuacán, viewed from the Pyramid of the Moon along the Street of the Dead, with the Pyramid of the Sun on the left. An alignment between these two pyramids, running approximately north-south, toward the sacred peak, Cerro Patlachique, is well illustrated by this photograph (see pp.151–53).

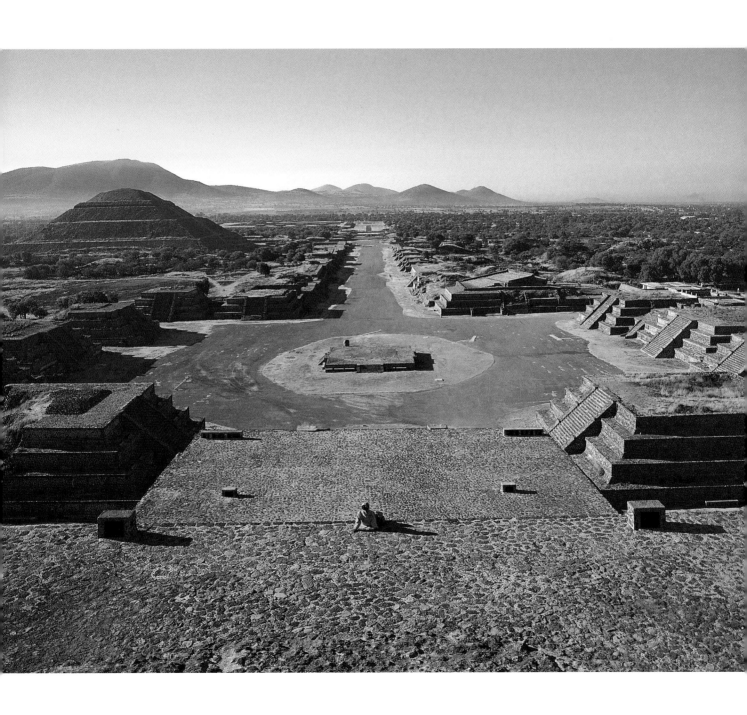

THE SCIENCE OF ALIGNMENTS

All around the world the ruins of ancient civilizations demonstrate an intimate and intricate knowledge of the science of the skies. Some cultures have left writings that show the cycles of the sky as important to the ritual worship of their gods, but mostly the sites themselves are shrouded in mystery. Through archeoastronomical detective work we may discover that one site embodies sightlines to midsummer and midwinter sunrises or sunsets; another aligns to the northernmost setting point of Venus (or did so 2,000 years ago, before precession caused the stars to move out of position: see pp.36–7); a third has a deep chamber that is pierced by a beam of light at sunrise on the shortest day of the year. We may know that the builders held the Sun or Moon as objects of veneration, and that sacrifice, fertility or the cult of the dead may have figured in their beliefs. However, the precise type of ritual or ceremony that took place at most ancient sites is unrecorded, and few scholars would even be prepared to hazard a guess as to its nature.

How were these sacred alignments worked out in the first place? In fact, once a site had been selected, working out solar and lunar alignments could have been a relatively simple, although painstaking, process. A marker at the centre of the monument would have been the starting point. True North (on the axis of the Earth's rotation) could then have been found by marking the setting and rising points of a single star on the horizon, perhaps with stakes, and then finding the midway point between them using a measuring string. The other compass points would follow naturally from this.

The Sun's solstitial rising and setting points and the lunar standstill points could have been located by a process of repeatedly marking, with a set of posts, the relevant point on the horizon, over a period of time. Approaching the extreme point, the posts would get closer and closer together, until finally turning back. More permanent markers could then have been put in place to show the special points of interest. Over time, the builders would probably have gained sufficient understanding of the sky to work out the relationships between the rising and setting points at various times in the cycle, so they would not have needed to observe, say, a complete 18.6 year lunar cycle in order to build a new monument.

Of course, topographical considerations are crucial to the construction of accurate monuments. Many of the sites make use of natural features on the horizon to mark particular points, and these computations would have certainly taken a great deal of time to work out. In addition, very few sites have perfectly flat horizons, and a hill at a critical point could drastically effect a sunrise or moonset position.

When looking for evidence of ancient astronomical monuments, it is important to remain sceptical: at the extreme, almost any two randomly scattered stones could coincidentally indicate a significant astronomical alignment. To be accepted, alignments have to show more evidence of intent. It is important to first establish the intended viewing point: at the Group E temples and pyramids at Uaxactún, for example, there are distinct viewing platforms, while many megalithic monuments have a clear central focus, and sometimes an "altar stone". From such a fixed point, an alignment can be indicated by, for example, a niche in a wall, a distant building or stone (often called an "outlier"), or perhaps a distinct hollow or hump on the horizon. An outlying feature of this kind is known as a "foresight", while the viewing point is termed a "backsight". The greater the distance between the foresight and backsight, the more accurately positioned the alignment can be. This method of establishing a sightline essentially relies on a line between three points: the foresight, backsight and the astronomical event. Another method is that based on a passage or shaft: the chambered tomb at Newgrange in Ireland, for example, was built with a "roofbox" to channel a narrow beam of light, at the midwinter sunrise, into its long passage.

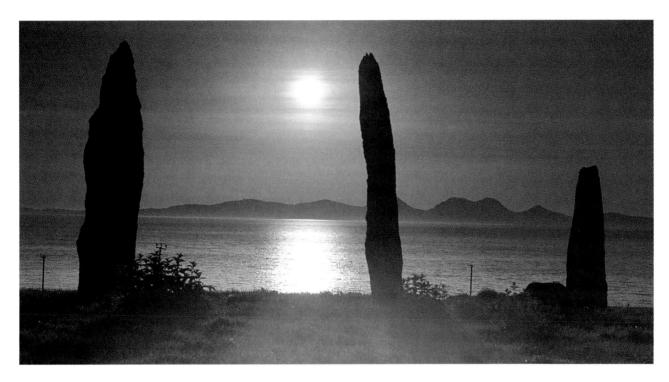

The three standing stones of Ballochroy, on the west coast of Scotland, form a monument in harmony with the landscape. They point over a burial kist (a box of stone slabs) and out to sea, toward Cara Island 7 miles (11km) away which acted as a foresight to the midwinter sunset position. Moreover, a line across the flat face of the centre stone to the mountain of Corra Bheinn, 19 miles (30km) away on the isle of Jura, indicates the position of the midsummer sunset. When the midsummer Sun sinks behind the two breast-like Paps of Jura ("paps" means "breasts"), a ribbon of sunlight dances across the intervening water, like an umbilical cord connecting the viewer with the old Earth Mother. Other alignments in the monument connect it to lunar standstills.

NOTE

In the following chapter, square coloured symbols are used to indicate the midsummer, midwinter and equinox sunrises and sunsets, and the major and minor standstills of the Moon: the symbols correspond with those used in the explanatory diagrams on p.14 (Sun) and p.19 (Moon).

STONEHENGE

ENGLAND

In 1740 the antiquarian William Stukeley noted that the axis of the great grey stones of Stonehenge on Salisbury Plain aligned to the northeast "where abouts the Sun rises when the days are longest". However, the popular belief in a connection between Stonehenge and midsummer goes back much farther, for it was the site of traditional midsummer festivities for many centuries prior to Stukeley's time. In 1223, for example, the Bishop of Salisbury complained (in vain) that the festivities were "vile and indecorous games". They probably harboured too many vestiges of paganism for his liking. Today, of course, it is well known that the midsummer Sun rises over the tall outlying Heel Stone when viewed from the centre of Stonehenge itself. The astronomical aspects of this place, however, are more complex than this, which perhaps explains why Stonehenge has not only been popularly thought of as an "ancient observatory" but has also been closely intertwined with the development of the science of ancient astronomy, or archeoastronomy, throughout the 20th century.

Although antiquarians like Stukeley made comments about possible Sun and Moon alignments at Stonehenge, it was the so-called "father of archeoastronomy", Sir Norman Lockyer, who began the scientific appraisal of this complex site in 1901. Lockyer, a scientist and editor of the scientific journal *Nature*, had previously studied astronomical alignments in Greek and Egyptian temples (see p.140), so it was natural for him to turn his attention to the most famous prehistoric monument in his own country. Lockyer attempted to date Stonehenge by calculating back to the time when

An aerial view of Stonehenge showing the present remains of the inner and outer sarsen rings and the two remaining Station Stones. The Heel Stone is off the picture, bottom right.

the first gleam of the midsummer rising Sun would have been perfectly in line with the monument's axis. This alignment gave Lockyer a range of between 1600BC and 2000BC, roughly the date of what is nowadays called Stonehenge III (we know what Lockyer did not – that the Stonehenge we see is all that remains of a long chain of versions of the structure that spanned many hundreds of years: see p.120). He saw that this line could be extended into the countryside beyond Stonehenge to Silbury Hill in one direction and Castle Ditches in the other (both these hilltops have prehistoric earthworks). He also calculated that a diagonal across the rectangular setting formed by the so-called Station Stones (see plan, opposite page) would give sunrises and sunsets on significant days, such as May Day (May 1). Unfortunately, however, Lockyer presented his material poorly and made several errors, and the archeologists of his day strongly disputed his claims. Nevertheless, his work represented the start of serious archeoastronomical study at Stonehenge.

More sophisticated studies of astronomy at Stonehenge had to wait until the 1960s, when the careful measurements of C.A. Newham showed that the sides of the Station Stones' rectangle gave alignments to key Sun and Moon rising and setting positions. He was not the first to notice some of these – a vicar called Duke had remarked on one of the alignments as long ago as 1846 – but Newham confirmed the full extent of them. Another of the alignments involved the Heel Stone and Station Stone 94, and he claimed that this would have marked the equinox moonrise. Indeed, Newham came

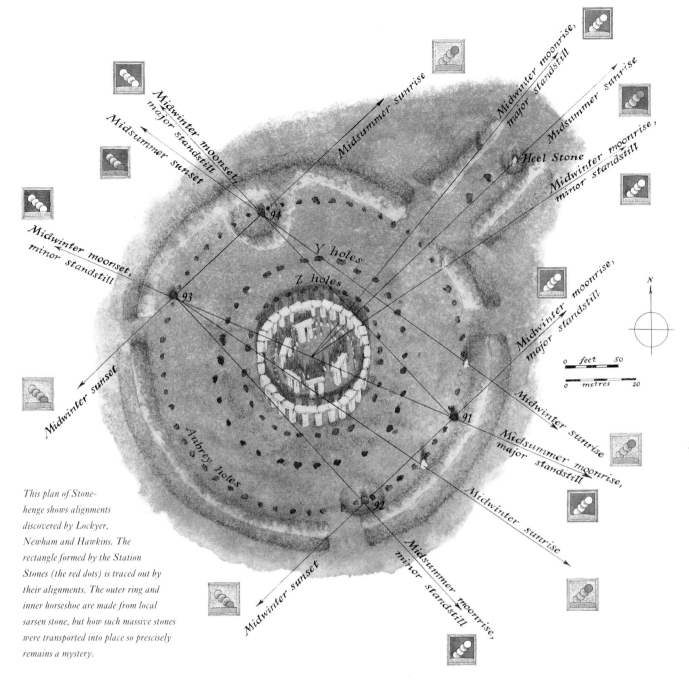

Midwinter moonrise,
major standstill

Midsummer sunrise

Heel Stone

Midwinter moonrise,
minor standstill

Midsummer sunrise

Midwinter moonset,
major standstill

Midsummer sunset

Midwinter moonset,
minor standstill

Midwinter sunrise

Midsummer moonrise,
major standstill

Midwinter sunrise

Midsummer moonrise,
minor standstill

Midwinter sunset

Midwinter sunset

94

93

91

92

Y holes

Z holes

Aubrey holes

N

| 0 | feet | 50 |
| 0 | metres | 20 |

This plan of Stone-henge shows alignments discovered by Lockyer, Newham and Hawkins. The rectangle formed by the Station Stones (the red dots) is traced out by their alignments. The outer ring and inner horseshoe are made from local sarsen stone, but how such massive stones were transported into place so precisely remains a mystery.

to believe that in its earliest stage Stonehenge "was essentially a site for the investigation of lunar phenomena". He felt that postholes that had been discovered in the entrance causeway had been made by poles erected by the builders of Stonehenge to mark the passage of the Moon's movements for over a century, so that they could work out the skyline postions of the Moon in the course of its complex cycle of 18.6 years – the so-called Metonic Cycle. He also noted that one of the thirty uprights supporting the lintels of the outer sarsen circle was thinner than the all others, and suggested that the whole ring might have symbolized the 29½ days of the lunar month (literally "moonth").

117

It now seems likely that Stonehenge was originally laid out on a lunar axis and that this was deliberately realigned by 4° at a later date to form a solar one.

However, if Stonehenge was originally a lunar temple, why does the midsummer Sun rise over the Heel Stone? The fact is that this 37-ton, 16-foot (5m) tall outlier does not exactly mark sunrise on the summer solstice: the Sun rises just to the left (west) of the stone when viewed from the centre of Stonehenge, and this discrepancy would have been greater 5,000 years ago, owing to precession (see pp.23 and 36). In 1979 a stone hole was uncovered a few yards to the west of the Heel Stone. If this marked the position of a now-lost stone, then the midsummer sunrise would have been neatly framed by two great stones, of which only the Heel Stone now sur-

vives. But it is also possible that the hole marks a former position of the Heel Stone itself, which may have been moved when the axis of Stonehenge was changed later in its history. It could even be that the midsummer sunrise connection with the Heel Stone is actually a coincidence. When looking at the outlier from the centre of Stonehenge, the view is through a gap between two uprights in the outer sarsen ring. The gaps on either side give "windows" toward the maximum and minimum moonrise positions (see illustration, below left), the farthest north and south that the moon ever rises in its 18.6-year cycle. The midpoint of this oscillation happens to be marked by the Heel Stone.

At about the same time as Newham was working on Stonehenge, Gerald Hawkins, an astronomer from America's Smithsonian Institution, was also becoming interested in the monument. It was some time before Hawkins became aware of Newham's work, and began to investigate the Station Stones' rectangle himself. He found even more alignments associated with the arrangement of the four stones than Newham did, but to do so he had to incorporate questionable extra markers such as holes found during excavation at Stonehenge, which may never have held stones or poles. Hawkins looked at other aspects of the site, too – in particular, the great sarsen stones at the site that we most associate with Stonehenge. He found that the inner "horseshoe" setting of the great trilithons (freestanding uprights with a lintel stone laid across their tops) yielded sightlines through the gaps between the uprights in the outer sarsen circle toward important solar and lunar rising and setting positions. The gaps between the trilithon uprights are narrow, and they act like gunsights to the wider gaps in the

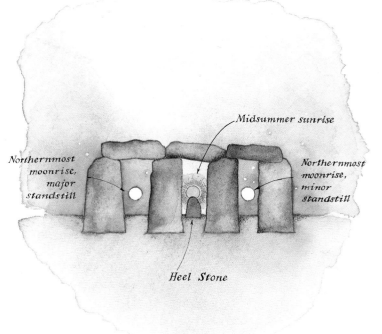

Midsummer sunrise

Northernmost moonrise, major standstill

Northernmost moonrise, minor standstill

Heel Stone

The diagram shows the "windows" made by the outer sarsen ring, perfectly framing the major and minor standstills of the Moon at its most northerly positions, and the midsummer sunrise over the Heel Stone.

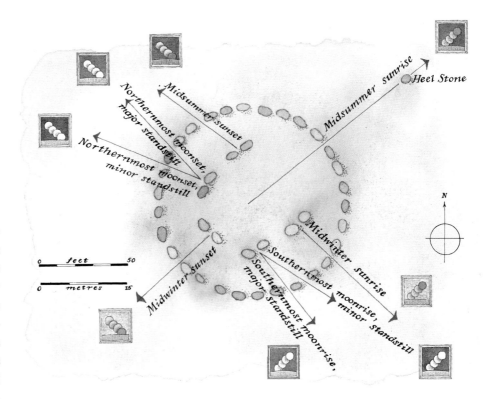

*This diagram illustrates Hawkins'
theory that the sarsen stones provide
sightlines to the most important
rising and setting points of the
Sun and Moon.*

sarsen ring. Hawkins suggested that certain hollows in the trilithon uprights could have actually been carved to allow for the slightly angled squint required for some of the sightlines. None of these lines was extremely accurate (the spaces were too wide) but they did provide "windows" that framed astronomically significant sections of the horizon.

Hawkins also made another ground-breaking observation. He noted that the ring of pits known as the "Aubrey Holes", just inside the circular ditch containing the stones of Stonehenge, numbered 56. Since the Moon takes 56 years to fulfil its eclipse cycle, Hawkins proposed that the pits could be the remains of an eclipse predictor or "computer". He envisaged the use of six rocks as markers, perhaps three of them light in colour and three dark, being moved by one Aubrey Hole a year, and a Moon marker stone moved by one upright a day around Stonehenge's outer sarsen ring, their combinations telling of impending eclipses. Later, astronomer Fred Hoyle offered another version of the Aubrey Hole computer using a different system and fewer markers. Although neither idea has convinced archeologists, Hawkins' book (with John B. White), *Stonehenge Decoded* (1965), enthusiastically explaining how he used computer techniques to establish his findings, caught the public imagination: the idea of modern computers decoding a

Stone Age computer proved a potent image.

Newham and Hawkins noted in 1963, as had the French architect G. Charrière in 1961, that the key astronomical alignments of Stonehenge crossed virtually at right angles, thus allowing the Station Stones to form their near-perfect rectangular setting. This is a function of the monument's latitude. Any great distance farther north or south, and the Station Stones would have formed an irregular groundplan. In fact, Hawkins discovered that one has to go as far south as the thirtieth parallel (the 30°N line of latitude) to be able to place in a regular pattern stones dealing with the same astronomical alignments. Interestingly, this is the same line of latitude as that on which the Great Pyramid at Giza, in Egypt, stands! Is this just a coincidence, or does this curious fact reveal that the builders of Stonehenge knew the dimensions of the Earth? One who thinks so is the independent researcher John Michell, whose scholarly work has led him to feel that he has detected ancient metrological units in the proportions of Stonehenge.

In 1973 the Scottish engineer and astronomer Alexander Thom and his son Archibald, who had surveyed hundreds of megalithic monuments in Britain and northern France, finally turned their attention to Stonehenge. Alexander Thom's work over several decades had revolutionized the whole of archeoastronomy, but he had left his study of Stonehenge until virtually last. The Thoms made a new, accurate survey of the monument, and sought longer (hence more accurate) alignments than had hitherto been claimed. To do this, they decided that outlying landmarks in the the area around Stonehenge were used, in conjunction with sighting posts, to mark important Sun and Moon rising and setting positions. Like Lockyer at the turn of the century, the Thoms envisioned Stonehenge as the centre of landscape-wide cosmic alignments.

The enigma of Stonehenge continues to fascinate. In the late 1980s, meteorologist Terence Meaden observed that the shadow of the Heel Stone penetrates into the centre of the stone ring as the midsummer Sun rises behind it. He suggests that this is symbolic of the Sky Father coupling with the Earth Mother, whose womb Stonehenge may have represented.

While we can never be sure of the details, there can be no doubt that astronomy played a major part in the structure and uses of Stonehenge. We can be equally sure, however, that the monument was never an astronomical observatory. Astronomy would have been used in a cosmological, religious context, as an aid to ritual and ceremony – spirit not science, astrology not astronomy. But such usage does not diminish the skill and accuracy of the observations that were made.

THE PHASES OF STONHENGE

Stonehenge I

The first feature on the site seems to have been a 100-foot (30-metre) diameter timber building, c.3300BC. This had an entrance to the northeast and a narrower one to the south. It may have been a charnel house, or perhaps an observatory for astronomer-priests to view lunar movements from the site. About a century later, Stonehenge I proper was built. A circular ditch-and-bank enclosure was dug (the henge), the Aubrey Holes dug and filled in around the inner rim of the ditch, and, probably, the Heel Stone (and a possible partner) erected outlying to the northeast. There was a causeway opening in the ditch-and-bank to the northeast, and two stones placed there. Timber structures also seem to have been erected at this time.

Stonehenge II

The first remodelling of the site was between 2200BC and 2000BC. The sites' alignment was shifted by a few degrees onto the orientation of the midsummer sunrise. Along this line an earthen avenue about 500 yards (460m) long was built, approaching the entrance from the northeast. The two entrance stones were re-erected along the midline of the avenue. An incomplete circular setting of bluestones was put up within the henge, thought to have been brought there either by human transportation or by earlier glacial action. They were also taken down again during this period, leaving the so-called Q and R holes. The four Station Stones (known as stones 91, 92, 93 and 94 on modern plans of Stonehenge) were erected on the edge of the Aubrey Hole circle either in this phase or at some unknown time after Stonehenge I.

Stonehenge III

This is broken down into three divisions. In IIIa (c.2000BC) the great sarsen structure was erected. Ten huge sarsens were shaped to form the uprights of a horseshoe, with massive lintels on top of each pair, forming five trilithons. An encircling set of 30 smaller sarsen uprights, supporting a lintel ring, was erected. Two other sarsen stones were also put in the entrance to the henge (one is the fallen Slaughter Stone). The bluestones reappeared in IIIb (2000–1550BC). About 20 were set up within the horseshoe. Holes (Y and Z holes) were dug around the outer sarsen ring as if to erect bluestones, but they seem unused. In IIIc the bluestones were rearranged again, and until 1100BC various changes were made to the site, including a considerable extension to the avenue and a turn in its orientation at some distance from Stonehenge.

AVEBURY

ENGLAND

Avebury, about eighty miles (129km) west of London, in Wiltshire, contains the world's most extraordinary collection of Neolithic (New Stone Age) sites. Although less famous than Stonehenge, some twenty miles (32km) to its south, the Avebury complex is conceived on a much grander scale. It is one of the world's best-preserved Neolithic landscapes, and with careful observation it is possible to see how the man-made monuments were sculpted to blend in seamlessly with the natural topography of the surrounding area.

The best-known feature of this sacred landscape is Avebury henge itself, the world's largest stone circle, now encompassing more than half of the village of Avebury. The ditch of the henge, which has an outer bank, was originally 33 feet (10m) deep but has silted up over the ages – although it is undoubtedly still dramatic in appearance. Nearly 200,000 tons of chalk, hacked out with deer antler pickaxes, were quarried to make Avebury's bank. The henge ditch encloses an area more that is than 28 acres (11¹/₂ ha) in extent.

The Barber Stone, part of Avebury henge, the largest circle of Neolithic standing stones in the world. This stone stands in the southwest quadrant of the outer circle.

The surviving standing stones are sited around the inner lip of the henge ditch. Within this huge circle, 1,140 feet (347m) in diameter, are the remains of two smaller stone rings, one in the northern half of the henge, one in the southern half. The northern circle had a central feature of which only two stones now remain, and this is now known as the "Cove". The centre of the southern circle was marked by the "Obelisk", a huge stone, 20 feet (6m) in height and 8 feet (2.5m) in girth. This was sketched in 1723 by the antiquarian William Stukeley, but even in his day it had fallen. Subsequently, it was broken up and removed, but "May poles" celebrating May Day (May 1) were erected on the site until the 19th century. The Obelisk's original position is marked by a large concrete plinth, erected during partial restoration in the 1930s. There are other stone placements within the henge, and running from its south entrance are the remains of two parallel stone rows, the Kennet Avenue, that continued for a mile (1.6km) south to the River Kennet, where there was a huge and mysterious palisaded timber structure, of which there is nothing now visible above ground. At this point the avenue of stones turned east up Overton Hill to a site now known as the "Sanctuary". This was once apparently a sequence of timber buildings or arrangements of ritual poles, like totem poles, but was finally a ring of stones. With great anger, Stukeley saw the stone circle being destroyed. The purpose of the Sanctuary is unknown, but it may have been where the dead were ceremonially laid out: archeologists have found human bones, and evidence of feasts having taken place there.

The henge is dated to *c*.2600BC, and is thought to be contemporary with Silbury Hill, a mile (1.6km) to the southwest. Despite its natural look, Silbury is in fact an artificial mound with a flat, platform-like summit, and a massive substructure of chalk. At 130 feet (40m), it was the tallest feature of this kind in prehistoric Europe. It was once thought to be a Bronze Age burial mound, but excavations in 1969–70 showed that it was

Neolithic, and that there was no burial or chamber in the centre. What archeologists did find, however, was grass almost 5,000 years old preserved in a green state at the heart of the mound, along with flying ants: so that while experts were unable to tell the exact year that Silbury began to be built, they could determine that construction started in the last week of July or the first week in August!

Less than a quarter of a mile (0.5km) east of Silbury Hill is a natural ridge known as Waden Hill. Why did the people of Neolithic Avebury build a huge mound like Silbury, and place it directly alongside a natural ridge of virtually equal height?

To the south of Silbury are the West and East Kennet long barrows. These are among the oldest features within the complex. West Kennet has been excavated, and dated to *c.*3600BC. It is oriented east-west. At the eastern end there is a façade of great stones (megaliths) and an entrance passage into the mound leading to a stone chamber. Side chambers come off the passage. Carefully selected human bones were found in these chambers, and it is thought that ancestral rituals went on here, with rearrangements of the bones taking place over a long

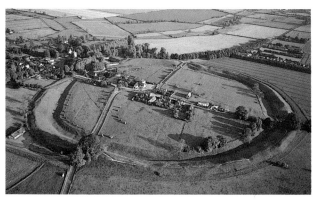

An aerial view of Avebury showing the distinctive ditch-and-bank feature on the outer rim. The remaining stones of the South Circle can be seen clearly, as can those of the outer ring on the south side.

period. It was certainly no ordinary tomb. Eventually, while Silbury and the henge would have been in use, activity at the barrow was closed down, and a great stone erected to block the entrance to the passageway. However this chamber complex takes up only a very small part of the otherwise earthen mound, which stretches for 330 feet (100m) and averages 10 feet (3m) in height. It is thought that it was once shorter, and although the reasons for lengthening it are a mystery, there is at least one theory related to ancient sightlines (see p.124).

There are a few other remains of long barrows around

Far right: *A plan of Avebury henge showing the positions of existing, fallen and lost stones. The Cove and South Circle rings are completed with red dotted lines. Pale areas show roads and buildings.*

Right: *The map shows the features of the Avebury complex including sightlines (blue arrows) to Silbury Hill from two of the barrows, Avebury, and the Sanctuary (see p.123). West Kennet Avenue is shown as two lines of brown dots between Waden Hill and the road.*

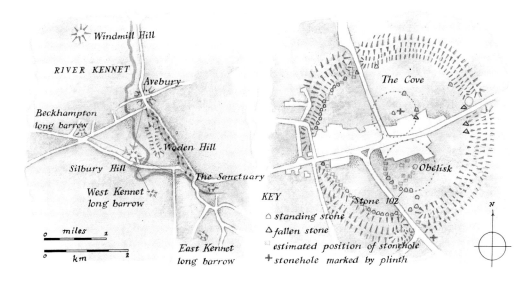

KEY

△ standing stone
△ fallen stone
▫ estimated position of stonehole
+ stonehole marked by plinth

Two southward views of Silbury Hill from the Obelisk stone (from the east side in the left picture, the west side in the right) in Avebury henge. The stone in the foreground is Stone 102. Waden Hill conceals most of Silbury from this position, especially at times of harvest when crops are high, as here.

Avebury, but more significant, overlooking the whole area, is Windmill Hill, a natural feature just over a mile (1.6km) north of the henge. This is the "grandmother" of the whole complex: people were meeting here for unknown purposes *c.*4000BC, before any stones had been erected there, and probably even when barrows like West Kennet were being built and used.

Running through Avebury's sacred geography is the River Kennet, its source the Swallowhead Spring tucked away in the folds of the landscape a bare half mile (nearly 1km) from Silbury. This spring would always have been seen as special, because its waters dried up over the winter months and started magically flowing again in February, emerging from the womb of the Earth Mother. Indeed, even as late as the 18th century the name of the River Kennet was thought by locals to relate to the vulva, and may share the same archaic root as words like "cunning", which originally meant wise. Its waters run in the general direction of the rising Sun, as a consequence of which they were thought to possess healing properties.

Despite this being a well-preserved Neolithic landscape (its amount of tree cover and general appearance now are probably not much different from how they were in the late Neolithic period), there were no astronomical findings at Avebury until recently. The West Kennet long barrow was oriented to the equinox sunrise, but this may have simply been coincidental, because it was oriented east-west; other barrows within the complex show other directional variations. Several researchers have identified possible astronomical associations for the site, but in 1989 a new astronomical dimension was proposed. The present writer spent several years reviewing the whole Avebury complex, to try to see what might have been missed, for here surely there must be some remnants of ancient astronomy. A clue was in the name "Silbury" – perhaps this was a corruption of "Sol Bury", meaning "sun hill"? Particularly intriguing was a legend that a king clad in gold was buried inside Silbury. Was this a mythic image denoting the Sun? It seemed likely that Silbury Hill, rather than the Avebury henge, was the heart of the Avebury complex. It was like the hub of a wheel, on the ragged circumference of which were situated the henge, the Sanctuary, the East and West Kennet long barrows, and another long barrow at Beckhampton. Viewing Silbury from these various Neolithic locations, a curious coincidence was suddenly noted: the skyline always intersected the profile of Silbury Hill between its flat top and the remains of a ledge, never previously explained, which encircled the mound about 17 feet (5m) below the summit. From the Obelisk within the henge, this visual coincidence is particularly dramatic, for the distant horizon dips suddenly to meet the foreground slope of Waden Hill, leaving the very top segment of Silbury "sandwiched" between the two, just visible. This sightline may have been dependent on the harvest, because when the cereal crop on the slopes of Waden Hill is at its height, it virtually masks the view of the great mound. Prehistoric cereals (which were grown at Neolithic Avebury) are known to have been taller, and so the view would have been blocked completely when it was time

for the harvest. This might well relate to the fact that Silbury began to be built in late July and early August – traditional harvest-time. This period is known as Lammas on the Christian calendar, and Lughnasa on the ancient Celtic calendar. As researcher Michael Dames has argued, Silbury may have been a harvest hill symbolizing the bountiful Earth Mother, a possibility enhanced by it being erected so close to the Swallowhead Spring.

From West Kennet long barrow, the view also had special aspects. It is only from the western tip of the long mound that the skyline coincidence occurs. Could this explain why the mound had been extended? Archeologists suspect that this extension probably took place at the time Silbury and the henge were being built, so the timing fits well: the already ancient barrow was perhaps modified to fit in with the new plan. Also, the skyline that intersects the profile of Silbury as

viewed from this position is actually formed by the bulk of Windmill Hill. The sightline is therefore very exact, both vertically and horizontally, and, in a way, links all the various periods of the Neolithic that the complex embraces.

But what was the reason for this skyline coincidence? What was the secret of that top segment of Silbury? In fact, it was an open secret. Looking eastward from the flat summit of Silbury, the bulk of Waden Hill looms large in the foreground, with the distant horizon of the Marlborough Downs visible slightly above it. The present writer suddenly saw that the height of Silbury was just sufficient to visually separate these near and far skylines, and that the contours of nearby Waden Hill remarkably mimicked those of the distant horizon, except for one segment, where the distant skyline dipped down slightly. From a viewpoint on the eroded ledge beneath Silbury's summit, the far horizon exactly coincided with the

top of Waden, but the dipped section dropped just behind it. It was calculated that this section gave a "window" for the rising Sun in the Lammas/Lughnasa period (and also during the early May period, the Beltane of the Celtic calendar, when the Sun again rises from that part of the eastern horizon). It was likely that there would be a "double sunrise" effect during this period as viewed from Silbury Hill's summit and ledge.

Observations from Silbury on August 1 in 1989 revealed just how dramatic this effect actually was. The Sun could be seen to rise over the far horizon if it was viewed from the top of Silbury. Moving swiftly down to the ledge, it was confirmed that the Sun seemed to rise for a second time, a couple of minutes later, over the bulk of Waden Hill: a ceremonial sunrise effect. But there was a further surprise in store. When looking westward from Silbury's summit, the shadow of the great mound is, of course, projected onto the landscape. But out of that shadow was seen a long ray of golden light. It felt to the observer as if Silbury, symbol of the earth goddess, was blessing the crops and the land. It was later found that the effect is an optical illusion caused by refraction in dewdrops. If you stand in a field with your back to the sunrise, a glow is seen around the shadow of your head, known as a "glory". The "Silbury Glory" is a much-magnified version of the same effect, because the observer is 130 feet (40m) up above the ground, and his or her shadow is subsumed by the larger shadow of Silbury. This effect can only happen through the sunrise "windows" of the Lammas/Lughnasa and Beltane festival periods.

The evidence suggests that the great mound represented the earth goddess, and cosmologically united the Earth and the sky within the sacred landscape of the entire complex found at Avebury.

This illustration shows the remarkable "double sunrise" effect found at Silbury Hill during the harvest period of Lammas/Lughnasa, and during Beltane. Viewed from the summit of the hill (shown schematically with an exaggerated slope), the Sun rises over the distant horizon formed by the Marlborough Downs. If the observer moves down the hill to the platform, as shown, the skyline at that point only dips behind Waden Hill, and a few minutes later the Sun appears to rise again over the near horizon of Waden, in exactly the same position as before.

CASTLERIGG

ENGLAND

The English Lake District is a compact landscape of rounded peaks and jewel-like lakes. Here, near Keswick, stands Castlerigg, a stone circle with a slightly flattened groundplan, built at least 4,000 years ago. It is 110 feet (33.5 m) across its longest diameter. There are 38 stones, all but five of them still upright, and ten of these form an enclosure (the Cove) within the main circle.

The Castlerigg stone circle during a winter sunset. The stones are local, and the tallest is almost 7 feet (2m) high and weighs about 15 tons.

Professor Alexander Thom, a leading figure in modern archeoastronomy, studied this monument and found a total of seven solar and lunar alignments. Investigating the groundplan, he was convinced that the flattened circle arrangement of the stones, which he had iden-tifed at other stone circles, was deliberate. Most striking was the skill of the builders in incorporating the astronomical sightlines into the structural geometry of the groundplan. This was especially remarkable because the mountainous nature of the landscape creates highly varied heights along the horizon, so that the Sun or Moon can rise or set at all sorts of odd times. Thom reckoned that to replicate the feat today would need "a large group of surveyors working for an indefinite time fully equipped with modern instruments".

Another astronomical effect at the site was discovered by artist and photog-rapher John Glover in 1976. Having set up his camera within the Castlerigg cir-cle, planning to photograph the mid-summer sunset over the ridge known as Latrigg, Glover happened to glance behind his camera position, away from the sunset, as the Sun edged down to Latrigg. "There at my feet was a wide, dark shadow extending for hundreds of yards ... I was utterly amazed by this and my first reaction was to run down it as fast as I could; I felt projected into one of those fairytale situations when ... a secret path appears to show you the way to a treasure." The setting Sun was causing the tallest stone in the circle to throw a long, regular "shadow path". When surveyed, it was found that the angle from the ridge of Latrigg to the base of the tall stone continues in the slope of the ground beyond the site. This slope enhances the length of the shadow which could thus reach up to 2 miles (3km) beyond the circle. Whether the circle's builders stum-bled across a place where they could mesh the variable horizon heights, astronomy and groundplan geometry, and find a slope at the right angle for the midsummer shadow, or whether they engineered the ground to the southwest, along which the shadow path runs, remains an unsolved mystery.

The effect of the midsummer setting Sun over Latrigg, throwing a long shadow of the tallest stone down the hillside. The gradient and scale are greatly exaggerated for clarity.

Latrigg

Castlerigg

Shadow path

MAES HOWE

SCOTLAND

Precariously poised in the cold ocean reaches off Scotland's northern coast, Maes Howe has the rugged fascination of all those wild windswept places where prehistoric peoples exercised their ingenuity to celebrate the mysteries of the skies. It is a chambered mound on Orkney Mainland, the largest of the Orkney Islands. The site incorporates a passageway opening into a high, impressive chamber with remarkably intact and well-finished stonework. There are small recesses off the main chamber. No finds have been made here, but this is undoubtedly because the monument has been raided numerous times in its history. We know that the Vikings got into it, for example, because they left runic graffiti on one of the stones, and a small but beautiful engraving of a dragon – the Viking emblem. It provides a sobering grasp of the timescales we are dealing with when considering British megalithic sites to realize that we are today considerably closer in time to those Vikings than they were to the builders of Maes Howe.

The passage of Maes Howe is aligned to the midwinter setting Sun, when its dying, golden rays flood into the chamber. But there is an interesting dimension to this orientation that extends its significance. In 1894 Magnus Spence, a schoolmas-

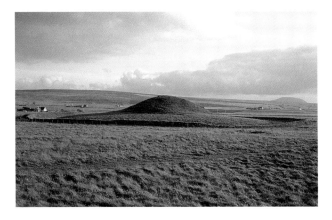

The Maes Howe mound in its wild landscape setting. The passageway of this tomb aligns to the midwinter sunset – and a sightline that passes through the tall standing stone named Barnhouse.

ter on Orkney, detailed his observations into possible astronomical alignments among the monuments of Orkney Mainland. He had noted the midwinter sunset orientation of Maes Howe, but had further realized that the line of the passageway's orientation, if extended out into the countryside beyond, went through a tall standing stone called Barnhouse (visible from the entrance to Maes Howe). The rays of the setting midwinter Sun were not only marked within Maes Howe, but right across the landscape. Spence also discovered that Barnhouse, together with another monolith, the Watchstone, and the centre of the huge Ring of Brogar stone circle, formed an alignment to the midwinter sunrise.

In Spence's time fires were still lit on the Orkney hilltops to celebrate the Celtic festivals (the ancient, eight-fold solar year; see pp.130–31). He found that some of these hills marked rising and setting positions of the Sun along the alignments between the stones of Orkney. To him, the movements of the Sun according to the ancient Celtic calendar were encoded in the very landscape of his island.

A view from the entrance chamber of Maes Howe outward as the midwinter setting Sun lights up the passageway.

CALLANISH

SCOTLAND

Callanish, on the northwest coast of the Isle of Lewis, in Scotland's Outer Hebrides, is an evocative prehistoric structure that distils all the poetry of the Moon and its cycles. The main site, Callanish I, has some fifty standing stones laid out in a design resembling the (later) Celtic Cross. The central circle measures 41 feet (12.5m) at its widest and has 13 stones marking its perimeter. Within the circle are the remains of a chambered cairn. Running

north is a dramatic avenue of stones. To the south, a row of stones runs in a true meridional (north-south) direction. Shorter stone alignments run asymmetrically to the east and west of the circle.

Gerald and Margaret Ponting, who are well-respected amateur archeoastronomers, made the remarkable discovery that at the time of its most southerly major standstill (see p.19) the Moon "skims" the glittering stones of Callanish as it travels on

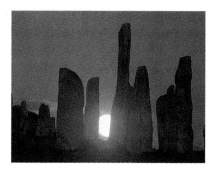

This photograph, taken by Margaret Ponting in 1987, shows the most southerly moonset behind the stones of Callanish.

its low arc across the horizon between its rising and setting points. It rises out of the Pairc hills, which from Callanish are shaped like a woman on her back and are sometimes called the Sleeping Beauty (her Gaelic name is *Cailleach na Mointeach*, the old Woman of the Moors, the Earth Mother), passes along the body of Sleeping Beauty and sets into the Clisham range on the nearby island of Harris. To an observer at the end of the Callanish avenue the Moon appears to sink into the stones of the central circle.

The Pontings also identified the phenomenon of "re-gleamings" in the landscape of this site. At times when the Moon sets by appearing to slide into the side of a hill on the horizon, it can shortly afterward flash briefly into view again when passing a "notch" in the hill. For example, Stone 8 at Callanish I has a flat side that faces a re-gleam position of the extreme northerly moonset.

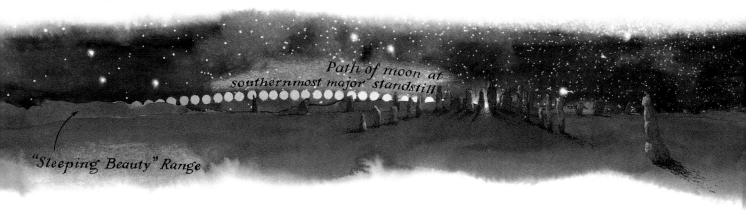

Path of moon at southernmost major standstill

"Sleeping Beauty" Range

The path of the Moon at its southernmost major standstill, behind the stones of Callanish. Every 18.6 years the Moon is symbolically born out of the Earth Mother, represented by the Sleeping Beauty range of hills, and dies into the sacred stone circle. The illustration shows that, furthermore, as the Moon sets behind the stones, there is a "re-gleaming" effect, where the Moon for a moment just flashes upon the horizon: Stone 8 aligns to this position.

LOUGHCREW

IRELAND

Two of the cairns that make up the Loughcrew complex lying near the small town of Oldcastle, Co. Meath, Ireland, receive mysterious visitations from the Sun – echoing the legend that Loughcrew was the cemetery of Queen Tailtiu, foster mother of the Sun-god Lugh. The monuments are primarily Neolithic chambered mounds made up of heaps of rocks. These cairns are dotted for approximately 3 miles (5km) along the spine of the Loughcrew hills, known in myth as *Slieve na Callaigh*, the Hill of the Witch. The folk-tale that gives rise to this name describes how the cairns fell from the apron of an old hag called *Caillaigh Waura* or *Cailleach Bhéarra* as she hopped from one peak to another.

The most important of the two cairns is Cairn T, atop Carnbane East. It is 120 feet (36.5m) in diameter, and its exterior was once faced in white quartz; it is noteworthy that the Irish word "Carnbane" means "white cairn". The entrance to Cairn T is oriented just south of east, and a passage leads to a main chamber which has three side-chambers. Both passage and main chamber have richly-carved stones, in particular the backstone

Rectangles of light pass over Stone 14 during the days around the equinoxes, until the sunbeam perfectly frames the solar symbol.

(Stone 14) of the end recess of the main chamber. Among the prehistoric designs on this backstone are circular, rayed motifs resembling Sun symbols. Their meanings are now clear as a result of the work of the American researcher Martin Brennan, who discovered in 1980 that the rising Sun shines into the chamber on the days around the equinoxes each year. The sunbeams probe into the passage until they reach Stone 13 (which has a small "sunburst" carving and juts out into the passageway), when they suddenly burst into and across the main chamber, reaching Stone 14. Channelled by the configuration of the stones in the passage, and a sill-stone (a horizontal stone fixed edgewise into the ground) a short distance in front of Stone 14, the beam of light is shaped into a fairly regular rectangular form. As the Sun rises, this rectangle drops slowly across Stone 14, ultimately making a perfect frame for the most complete of the stone's solar symbols. This has eight rays which may represent the eight primary divisions of the solar year: the summer and winter solstices in June and December, the two equinoxes, and the "cross-quarter days", in early February, May, August and November – Imbolc, Beltane, Lughnasa and Samhain as they were called in the old Celtic eight-fold calendar.

Brennan noted that the shape of the sunlit rectangle differed between the spring (vernal) and autumn equinoxes, because the angle of the sunbeams varied between these two times of the year. The Sun's path through the sky is higher in spring and lower in autumn. Between 1986 and 1990, Tim O'Brien conducted further observations. He was able to see and photograph the light as it passed across Stone 14. Around the main symbol, he noted carvings of vertical spines with regularly-spaced horizontal lines across them, like grading or scale marks. He discovered that the horizontal "ruler" lines marked the edges of the rectangular patch of sunlight, registering its shifting angular position day to day on the backstone. O'Brien confirmed that the sunbeams into the cairn could only reach the backstone on the days around the equinoxes and was also able to show that the cairn builders could have measured solar motion with sufficient accuracy to identify the leap-year cycle of four years.

NEWGRANGE
IRELAND

A gigantic chambered mound in Co. Meath, Ireland, New-grange, dated to at least 32,000BC, is one of the oldest roofed structures in the world. It was known as *Bru na Boinne*, the palace by the Boyne, and was where the ancient Lords of Light were said to dwell, an association reflected in the fact that the great monument plays host to the rising midwinter Sun.

The mound is 36 feet (11m) high and 300 feet (90m) in diameter, and all around its base are 97 kerbstones, three of which are decorated by carvings. Kerbstone 1 is richly incised with spiral and lozenge designs and is on the south-eastern side of the mound, at the entrance to a passage which extends 62 feet (19m) into the mound to a corbelled

A plan of the mound, showing the location of the passage entrance into the chamber and the lightbeam of the winter solstice sunrise.

stone chamber, 20 feet (6m) high. The passage is about 4 feet (1.5m) in height, and its floor rises steadily from the entrance to the chamber, which has three side-chambers (recesses), one at its far end (opposite where the passage enters the chamber) and one at either side. There are stones decorated with rock art in the passage and in the chamber recesses, including a famous

A cross-section and elevation of Newgrange, showing the midwinter sunrise beam piercing through the roof-box, down the passage and onto the backstone.

CROSS-SECTION

PLAN

0	feet	20
0	metres	6

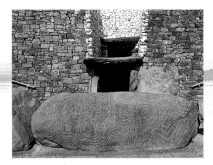

The entrance stone and roof-box. The carved patterns are easily seen, although the vertical line, dividing the stone in half, is now very faint.

triple spiral carving in the end recess. Surrounding the structure is a large, but incomplete, stone circle.

Rumours began to circulate from at least the 19th century that on a special day sunlight entered Newgrange. In 1909 Sir Norman Lockyer pointed out that Newgrange, then a ruin, was oriented to the midwinter solstice. Excavations at the site between 1962 and 1975, under the directorship of Michael J. O'Kelly, uncovered a curious rectangular opening above the passage entrance. The top lintel of this structure, which O'Kelly called the "roof-box", was an engraved slab. He suspected that the purpose of this was to admit a shaft of sunlight into the chamber: a line drawn from the backstone of the end recess in the central chamber, through the roof-box, aligns to the midwinter sunrise of 5,000 years ago. On December 21 1969 O'Kelly became the first modern observer of the Newgrange sunbeam phenomenon. A pencil-beam of direct sunlight shot through the roof-box, along the passage and across the chamber floor as far as the basin stone in the end recess. Owing to precession (see pp.23 and 36) the Sun's rising position at midwinter has moved slightly over the millennia, so that the roof-box sunbeam cannot now reach to the very back of the end recess. Nevertheless, the effect was scarcely diminished. "As the thin line of light widened to a 7-inch (17cm) band and swung across the chamber floor," O'Kelly observed, "the tomb was dramatically illuminated." "At 10.04am (British Standard Time) the 7-inch (17cm) band of light began to narrow again and at exactly 10.15am the direct beam was cut off from the

Midwinter sunrise

tomb." Direct sunlight through the passage doorway cannot reach as far as the chamber because of the upward slope of the passage floor and the arrangement of the upright stones or "orthostats" of the passage walls. "For 17 minutes, therefore, at sunrise on the shortest day of the year, direct sunlight can enter Newgrange ... through the specially-contrived narrow slit which lies under the roof-box at the outer end of the passage roof."

Between 1986 and 1988 the Irish researcher Tim O'Brien made special studies of the phenomenon. He recorded the maximum length of the lightbeam on the chamber floor at just greater than 10 feet (3m). His time-sequence photographs show it like the glowing hand of a clock sweeping across the floor. He learned that two of the passage orthostats, known as L20 and R21, lean in to one another to form a triangle that sculpts the sunbeam from the roof-box. In 1989, Tom Ray, an astronomer at the Dublin Institute for Advanced Studies, provided statistical proof that the midwinter sunbeam event at Newgrange occurs by design and not by chance, confirming the long journey from legend to scientific fact made by this great Irish monument.

However, the site provides one extra surprise. The carvings on the entrance stone, Kerbstone 1, are divided by a vertical line. Moreover, diametrically opposite is Kerbstone 52, also richly carved, with a broad, vertical line dividing it in half. Both these stones stand on the line of the midwinter sunbeam at Newgrange, so it seems that the vertical markings represent the solar alignment.

A detail of the spiral (possibly solar) markings on Kerbstone 52.

GAVRINIS

FRANCE

The chambered mound of Gavrinis is situated on a small island off the south coast of Brittany in the Gulf of Morbihan. In Neolithic times this gulf was a fertile plain, with wide rivers and a considerable population. However, it was inundated by the sea, which probably gave rise to the Breton legend of Ynys, the drowned island. This ancient drowning is revived as the boat from Larmor-Baden takes Gavrinis visitor past the islet of Er-Lannec, whose great stone circle is lapped by the waves.

The Gavrinis mound, dated to *c.*3500BC, is a rocky cairn, over 26 feet (8m) high. The 6¹/₂-feet (2m) high entrance passage runs along for almost 39 feet (12m) before opening into a rectangular chamber. However it is not so much the dimensions that strike the visitor, as the rich rock art within the monument. No less than 23 of the 29 upright, flat stones forming the walls of the passage and the chamber are covered in densely packed, linear patterns, making this the most richly carved chambered mound in Europe. The motifs include concentric rings and curves, chevron patterns, serpentine wiggles and triangular shapes. Some experts have seen stylized goddess figures, axe heads and fern designs in these flowing lines, but these are merely interpretations. More than anything, the overall effect is like the "psychedelic art" of the 1960s. Some archeologists consider the markings to be depictions of internal optical effects (known as *entoptics*) produced within the visual cortex of the brain during hallucinogenic trance. Hitherto unexplained Neolithic pottery items are now being interpreted as braziers for burning cannabis. To the entranced Neolithic ritualist, such mental patterns, charged with magic, might have seemed like messages sent from the spirit world, worthy of being recorded for ever on the rocks.

It is against such possibilities that the astronomy of this site must be placed, as one component only of a whole spiritual and ritual environment. A view down the passage from the left-hand side of the chamber entrance, toward Stone 1 at the passage entrance, gives an orientation to the midwinter sunrise. But the main axis of the passage itself is set toward the southernmost moonrise at major standstill. These solar and lunar lines intersect halfway along the passage, level with Stone 7 – one of the few undecorated stones in Gavrinis. Being rock crystal, this stone may have glowed white in the rays of the rising Sun and Moon at the appropriate times. The mystical impact of this would have been great; and if it is true that the celebrants in Gavrinis were in trance states, the mysterious effects of the light-play must have been greatly enhanced.

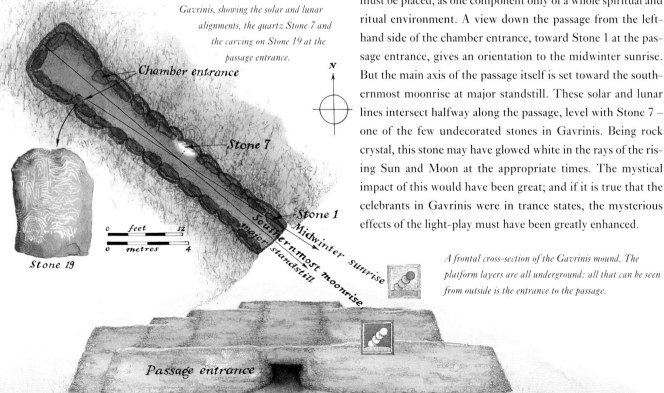

A plan (below left) of the chamber at Gavrinis, showing the solar and lunar alignments, the quartz Stone 7 and the carving on Stone 19 at the passage entrance.

Chamber entrance

N

Stone 7

Stone 19

0 feet 12
0 metres 4

Stone 1

Midwinter sunrise

Southernmost moonrise, major standstill

Passage entrance

A frontal cross-section of the Gavrinis mound. The platform layers are all underground: all that can be seen from outside is the entrance to the passage.

ER GRAH

FRANCE

Er Grah, also known as Le Grand Menhir Brisé ("The Great Broken Menhir") or Pierre de la Fée, lies broken on a peninsula on the northern side of the Bay of Quiberon, Brittany. When whole, this gigantic stone would have been more than 66 feet (20m) long. It is now in four pieces, lying with the tapering top toward the east; its roughly oval cross-section is certainly the result of having been worked to smooth it into shape. The collective weight of these blocks has been estimated at up to 342 tons. The stone is not local, but of a harder granite, the nearest known source of which is almost 2¹/₂ miles (4km) distant. No one knows when the megalith fell. Some have said that the stone was brought down by lightning or an earthquake, or that it tipped over and shattered while being erected and so never stood at all.

If Er Grah was ever a true standing stone, it would have been the tallest there has ever been. The only person to suggest this huge stone's function was Professor Alexander Thom, the great archeoastronomical pioneer. He realized that when upright Er Grah would have been visible from all around the Bay of Quiberon, and felt sure that it had served as an astronomical foresight (the farthest of a group of points marking an alignment) from locations around the bay. He further surmised that it had been used for observations of all eight extreme rising and setting points in the minor and major standstills of the Moon's cycle. Surveying the site, Thom and his team checked the eight directions along which unobstructed sightlines would have had to exist if the stone could ever have been used as a lunar foresight, and confirmed that the stone when standing would have been visible from various points along all the necessary sightlines. The next stage was to seek the observing stations, the "backsights", from which viewing would have been made. No one knew what form such locations might have taken, but it was decided to check for any Neolithic site on each of the sightlines. The team could find

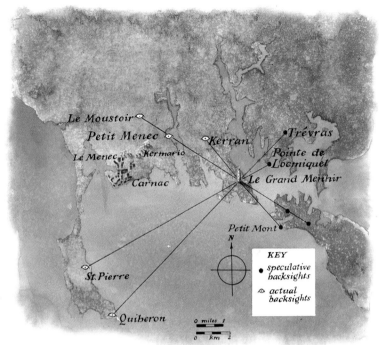

This map shows the area around Er Grah and the backsights found by Alexander Thom and his team. Apparent from this are the remarkable distances from which the great stone would have been visible when standing.

no surviving sites on three of the eight lines, but on the other five various possibilities were identified, although at least one of these has since been shown to be inaccurately placed.

Thom's proposal for Er Grah has come under fierce criticism. Statisticians have shown that there are so many megalithic remains in the Quiberon area that some would fall by chance on any lines drawn from the great stone. Other critics have said that those backsights found were all so dissimilar in type, ranging from mounds to passage-graves to single menhirs, that they are unconvincing as purpose-built Neolithic viewing stations. Nevertheless, it would be premature to dismiss the possible astronomy at Er Grah completely. Failure to find observation sites on some of the lines does not mean that they never existed. Thom's hypothesis remains the only attempt so far to explain the enigma surrounding this ancient megalithic giant.

DIE EXTERNSTEINE

GERMANY

A group of five weathered sandstone fingers, each about 100 feet (30m) high, Die Externsteine, in the Teutoberger Wald district near Detmold, is weirdly shaped, suggesting some ogre-like creature of the imagination. Some researchers maintain that this was a centre for pagan worship until Christianization by Charlemagne in AD772; and it is claimed that an image of the pagan "Tree of Life", the Irminsul, adorning the summit of one of the rocks, was destroyed by the Frankish king. Others have suggested that early Christian worship took place here from the beginning. Whatever the truth, the site presents a bizarre appearance, with steps, apparently going nowhere, carved out of the sandstone pillars, a feature like a sarcophagus hewn out of a giant boulder, and caves or "rooms" honeycombing the lower reaches of some of the pillars. Fairly recent pagan usage is evidenced by an over-

A 1920s map by Wilhelm Teudt showing the orientation of the chapel to the midsummer sunrise and major lunar standstill. The chapel window is shown as two blocks on the northeast side. The sun- and moonrises occur over two distant peaks, shown as contours.

Moonrise major standstill

Midsummer sunrise

6,4 km

6,1 km

N

NW

NO

W

NW

O (90°)

SO

SW

S (0°)

hanging rock segment that from certain angles looks like a man with his arms raised, as if tied to the rock. It has been proposed that this is the Germanic god Odin hanging on the World Tree. While critics have rightly pointed out that this is a natural feature, it is known to have been worked long ago with tools, presumably to enhance its human appearance.

However, the site must have been Christianized at some point, because another rock has a bas-relief of Christ's descent from the Cross, in which one figure stands on a bent Irminsul, as if to show the victory of Christianity over paganism.

The most fascinating feature is a chapel hewn out of the rock high on the central pillar known as "Tower Rock". This may have been a pagan chapel partially destroyed during Christianization, or it may have been an ancient Christian chapel: no one knows. It has an alcove on its northeast side, containing a small "altar", with a circular window behind. It has been noted from at least 1823 that the rising midsummer Sun shines in through this aperture when viewed from a niche in the opposite wall. Nowadays the effect is lost because the outer walls and roof are missing, but when the chapel was enclosed, this would have been a dramatic sight from the dark interior. On the altar there is a slot, into which a crystal or a gnomon was perhaps fitted, to throw rainbow light-beams or a shadow into the niche. The window was also believed to frame the Moon at its northernmost rising position.

In 1925 Wilhelm Teudt studied the chapel, and concluded that distant landmarks on the skyline were visible through the chapel's window, marking solar and lunar events. Teudt had traced such alignments across Germany to validate his theory of an ancient German high culture. He was sure that Die Externsteine had been a Germanic solar temple. His ideas were taken up by the Third Reich for propaganda, and the rocks became a Nazi centre. One can still see the imprint in the base of one pillar where the Nazi eagle emblem was once positioned.

THE GREAT PYRAMID

EGYPT

One of the Seven Wonders of the ancient world, the Great Pyramid, situated with other pyramids on the Giza plateau just southwest of Cairo, has a volume so vast that it could swallow St Peter's in Rome, St Paul's and Westminster Abbey in London, with the cathedrals of Milan and Florence thrown in for good measure. It would have been even more commanding in its pristine state, when its smooth, gleaming white stone facing was in place, and perhaps with a golden tip at its now truncated apex. The pyramid has captured imaginations all through recorded history, and so it is not surprising that the edifice

The Great Pyramid serves as the tomb of Khufu, who like all Egyptian pharaohs was believed to be divine. In the burial chamber lies his mummified corpse.

tions, as is the Sphinx, a short distance to the southwest of the Great Pyramid, whose eyes gaze out at the equinox sunrise position.

The internal passages and shafts of the Great Pyramid have also come under scrutiny – for example, by the 19th-century astronomer-antiquarian Richard Proctor, who considered that the structure had been used as an observatory. Among other suggestions, he pointed out that the Grand Gallery up to the King's Chamber was aligned with the local celestial meridian, and that its opening (which points southward) could have been used to time the

has become the object of countless theories, fantasies and fallacies. When one cuts through these, however, few hard data are to be found concerning its astronomical functions. Like the Sphinx beside it, the Great Pyramid guards its secrets well.

The Pyramid was built *c.*2600BC, supposedly as a tomb for the pharaoh Khufu (whom the Greeks called Cheops). The legendary precision of its construction is fully justified: the north and south sides are aligned east-west to an accuracy of less than $2\frac{1}{2}$ arc minutes, and although the pyramid's base covers 13 acres (5ha), the discrepancy in the lengths of any of the sides nowhere exceeds 8 inches (20cm). That the four sides of the pyramid are set so accurately to the cardinal directions indicates that the ancient Egyptians were able to make precise astronomical measurements and transfer them with great skill to the ground. The King's Chamber, high up and deep within the bulk of the pyramid, is also oriented to the cardinal direc-

transit of the stars if the pyramid had ever been open to the skies, as it may have been before it was filled in.

More interestingly, the Egyptologist-astronomer team of Professor Alexander Badawy and Dr Virginia Trimble suggested in 1964 that the so-called "ventilation shafts" connected to the King's Chamber may have considerable astronomical and cosmological significance. There are two of these shafts, opening respectively in the north and south walls of the King's Chamber, and leading all the way through the surrounding mass of the pyramid to the outside. They have a 9-square-inch (60 sq cm) section, which Badawy pointed out could hardly have functioned as air tubes for the chamber, and in any case no other Egyptian tombs were known to be ventilated. What the team did find, however, was that the north shaft aligned to the star Thuban in its uppermost arc in the sky, while the southern shaft aligned onto the transit across the sky of the

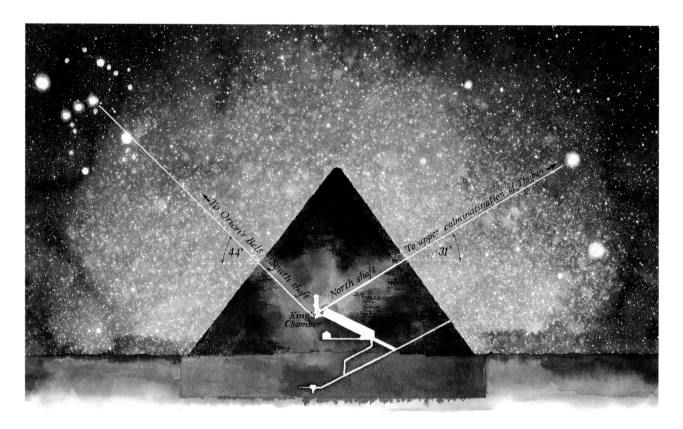

This cross-section shows the stellar alignments of the shafts of the Great Pyramid. Leading from the King's Chamber, the south shaft has been discovered to align with Zeta Orionis in the belt of Orion (the constellation

associated with the Egyptian god Osiris), while the north shaft aligns to Thuban – the Pole Star to the ancient Egyptians – at its culmination (the highest point it reaches in the sky, shown here as 31°).

three prominent stars forming the "belt" of Orion in 2700–2600BC. According to the "Pyramid Texts" – engraved prayers found inside Fifth- and Sixth-Dynasty (2498–2181BC) pyramids 15 miles (24km) from the Great Pyramid – Thuban was the equivalent of the Pole Star: its description as an "Imperishable Star" in ancient Egyptian terminology means that it was circumpolar. It was to the Imperishable Stars that the pharaoh's spirit journeyed after death, there to "regulate the night" and "send the hours on their way". The pharaoh's spirit also made a celestial trip to Orion, the constellation that to the ancient Egyptians symbolized Osiris and the great cycle of birth, life, death and resurrection. Here the pharaoh, in the company of Osiris, maintained the round of the seasons.

Badawy and Trimble therefore raised the possibility that the shafts leading from the King's Chamber were to allow the pharaoh's soul to travel to the heavens to perform its post-mortem duties. A new twist has been given to this idea by the Egyptologist Robert Bauval, who used an astronomical computer to discover that five of the seven Fourth-Dynasty pyramids on the Giza plateau – the Great Pyramid, Abu Roash, the Pyramid of Chephren, the Pyramid of Menkaura and Zawiyet El-Aryan – were laid out on the ground relative to one another in the pattern of the stars forming the Orion constellation. Their configuration symbolically hid Osiris in the land, bringing the god to earth. Bauval calculated that the south shaft was specifically targeted on Zeta Orionis in the belt of Orion, and

HYADES

Epsilon Tauri

Alpha Tauri (Aldebaran)

Gamma Orionis (Bellatrix)

Alpha Orionis (Betelgeuse)

Delta Orionis (Mintaka)

Epsilon Orionis (Alnilam)

Zeta Orionis (Alnitak)

Beta Orionis (Rigel)

Kappa Orionis (Saiph)

ORION

THE MILKY WAY

The Bent Pyramid

The Red Pyramid

AREA CORRESPONDING TO THE MILKY WAY

Zawiyet El-Aryan

Pyramid of Menkaura

Pyramid of Chephren

The Great Pyramid

Abu Roash

N

The locations of the pyramids on the Giza Plateau provide a terrestrial map of the stars of Orion and the Hyades. In six out of the seven instances, the dimensions of the pyramids are approximately in proportion to the magnitude of the stars. Furthermore, the Milky Way is mirrored remarkably closely by the River Nile.

that the Great Pyramid represented that star in the "map" on the ground. The positions of the other two Fourth-Dynasty pyramids on the plateau, the Red Pyramid and the Bent Pyramid, related to the stars Epsilon Tauri and Aldebaran – the Hyades – representing Set, the murderous brother of Osiris in Egyptian skylore. In this overall plan, Bauval realized, the Nile represented the course of the Milky Way. Furthermore, he worked out that a shaft leading from the Queen's Chamber in the Great Pyramid was oriented to Sirius, identified by the ancient Egyptians with Isis, the wife of Osiris.

The earliest-known names of the pyramids tend to support a "star map" interpetation. The Red Pyramid, for example, was known as "Snefru Gleams", and Abu Roash was referred to as "King Djedefre is a Sehedu Star"; in the latter case it is possible that Sehedu is a name referring to Orion. Moreover, a set of documents termed the *Hermetica*, which was probably compiled by the last few Egyptian initiates, states that "Egypt is an image of heaven ... all the operations and the powers which rule and work in heaven have been transferred to the earth below".

KARNAK

EGYPT

Karnak is a large temple complex based around the Great Temple of Amun, on the northern fringe of modern-day Luxor, originally the Greek town of Thebes, the ancient capital of Egypt. Before the Middle Kingdom (2040–1786BC) the town was not especially significant, but it did host a local cult of the god Amun. Eventually, this rose to great influence when the throne of Egypt passed to Thebes in the Middle Kingdom. The place developed in importance and the temple of Amun was enlarged and embellished, becoming Egypt's leading cult-centre. The Karnak complex is composed of the Great Temple plus smaller temples and a range of shrines and chapels, all surrounded by a mud-brick wall enclosing an area half a mile square (1.3 sq km), called the Precinct of Amun. Only a few structures from the Middle Kingdom now remain, and most of what can be seen dates to the New Kingdom (1567–1085BC). Entrance is from the west, the direction of the nearby Nile, along a causeway flanked by ram-headed sphinxes.

Visually, the dominant feature of the Great Temple of Amun is its main axis,

which slices through the various pylons, halls and shrines as well as through the sanctuary (the oldest part of the temple). Although additions and alterations to the Great Temple came and went through the centuries, this axis was always respected. Such a powerful axial line was bound to attract seekers of ancient astronomy in Egypt. Sir Norman Lockyer studied it during his Egyptian sojourn toward the end of the 19th century, and concluded that it was directed westward across the Nile to the midsummer sunset in 4000BC. He visualized the last rays of the Sun shining into the inner sanctum within the sanctuary, perhaps illuminating the idol of Amun. However, there were problems with this claim. Lockyer had calculated it in theory, but in 1891 British Army engineer P. Wakefield saw that the view of the setting Sun was blocked by the Theban Hills forming the skyline beyond the Nile: hence the theory did not work in practice. In 1921 the axis was scrutinized by F.S. Richards, who said that the line was directed too far north for midsummer sunset in 4000BC: to have been accurate the sunset indicated by the axis would have worked instead for the ridiculously remote date of 11,700BC.

This illustration shows the alignments found at Karnak by Lockyer and Hawkins. The midsummer sunset alignment was thought by Lockyer to have occurred in 4000BC, but in 1921 F.S. Richards disputed this theory, claiming that this alignment could only have been valid in 11,700BC. Hawkins later discovered that the axis of the temple aligned to the midwinter sunrise between 2000 and 1000BC.

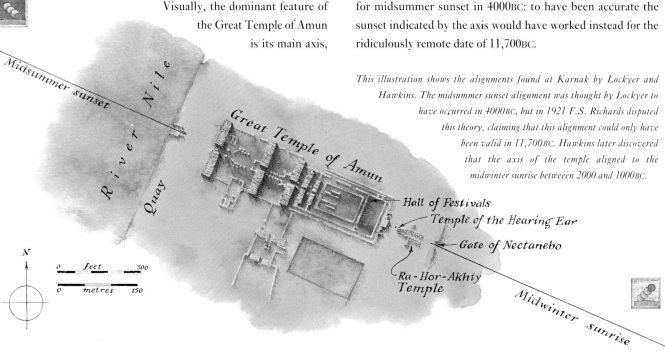

138

The situation was untangled by the indefatigable Smithsonian Institution astronomer Gerald Hawkins. He felt that the axis had been used in the other direction – an axis, like an argument, has two sides. However, he found that the Hall of Festivals, built by Thutmose II in 1480BC back-to-back with the eastern end of the sanctuary complex, blocked the line of sight eastward. This was clearly why Lockyer had looked west. But Hawkins found "astronomical clues" in hymns of praise "to that god that appears at dawn" in the

The Colossi of Memnon flanked the entrance of a mortuary temple. Strange sounds issuing from one of them in antiquity were thought to have oracular significance.

Temple of the Hearing Ear to the east just beyond the Hall of Festivals. Further east in the same block as the Temple of the Hearing Ear is the Temple of Ra-Hor-Akhty, the easternmost structure on the axial line before the Gate of Nectanebo in the eastern precinct wall. "Ra-Hor-Akhty" means "Sun (god)-Rising, Sun-Brilliant on the Horizon", which also heartened Hawkins. Recalculating the axis, he found that its eastward alignment was to the midwinter sunrise between 2000 and 1000BC. Visual obstruction was still a problem, but the answer was found in an upper chapel of the sanctuary complex, called the High Room of the Sun, where an alabaster altar, in front of a square aperture in the wall, dedicated the roof temple to Ra-Hor-Akhty. On the wall was a depiction of a pharaoh genuflecting toward the aperture and apparently making a gesture of greeting to the rising Sun. Hawkins found the aperture allowed a view of the skyline clear of obstruction.

In 1989 the American astronomer Ronald Lane Reese photographed the midwinter sunrise along the axis. He did not use Hawkins' roof chapel, but watched from the entrance to the Great Temple on the western side of the precinct. This allows a clear view through to the top of the Gate of Nectanebo. He saw the Sun "stand" over the gate a few minutes after sunrise, the sole witness to this event. Popular awareness has still not caught up with this astronomical secret of Amun.

After his discoveries in the Precinct of Amun, Hawkins crossed the Nile to the west bank. On his way up to the Valley of the Kings, he passed two 60-foot (18m) statues, which had been known to the ancient Greeks as the Colossi of Memnon. The northern statue was severely cracked during an earthquake in 27BC, after which it issued weird sounds at sunrise, variously described as musical notes, a trumpet blast and a cord snapping. It became famous in ancient Greek times as an oracle. The cause of the sounds remains unexplained: suggestions have ranged from the wind blowing through the cracks to energy effects within the stone, stimulated by the rising Sun's rays resonating as pressure waves within the cracks and becoming audible. However, the Roman military governor Septimius Severus had the statue clumsily repaired around the beginning of the 3rd century AD. The oracular sounds – the "voice of Memnon" – ceased.

Hawkins noted that the mortuary temple that had existed behind the statues was also dedicated to Ra-Hor-Akhty. Estimating the axis from the orientation of the statues, he calculated that it, and the sightless stares of the Colossi, were aligned to the rising Sun on midsummer's day.

DENDERA

EGYPT

The temple of Dendera, 30 miles (48km) north of Luxur, was the home of the goddess Hathor. Today, only her huge columned main temple remains intact, the surrounding chapels and smaller temples having been reduced to ruins long ago. All these survivals date from the Ptolemaic period (305BC–AD30), but the site itself is much older.

Inscriptions at Dendera (and other Egyptian temples) refer to a foundation ceremony, the "stretching of the cord". In this the pharaoh stretched a loop of cord between two poles to align the foundations with a particular star or constellation. At Dendera, the cord was aligned to the Bull's Foreleg (the Plough or Big Dipper). Although in terms of ancient Egyptian history the Ptolemaic period is relatively recent, there is little doubt that this ceremony is of much greater antiquity.

Sir Norman Lockyer, an early pioneer of archeoastronomy, investigated stellar alignments in Greek and Egyptian temples during the 1890s. At Dendera he became intrigued by the remains of the temple of Isis immediately to the south of the great temple of Hathor, and calculated that in 700BC the axis of the temple had been oriented to the heliacal rising of Sirius, the brightest star in the sky, and equated with the goddess Isis. The Earth's orbital motion puts Sirius in the daytime sky for part of the year, making it invisible, but when the cycles of the heavens bring it back to the night sky, it first appears

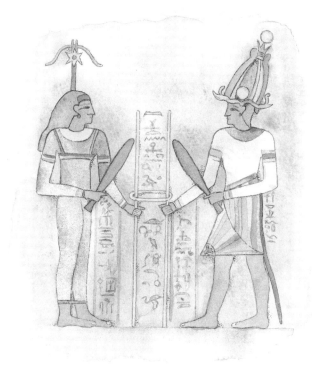

The stretching of the cord ceremony at Dendera, from a mural. The god (left) and pharaoh (right) wear headdresses displaying stellar and solar motifs.

An image of the circular zodiac found on a chapel ceiling at Dendera. The zodiacal constellations are picked out in green. They are in the order that we know them, from the first sign (Aries, on the right) moving in a clockwise direction.

at dawn, when it is visible for a short time before sunrise: this first reappearance is called its heliacal rising. In ancient Egypt, the annual event occurred at the solstice, as well as coincidentally at the time of the yearly Nile flood, and marked the start of the new year (see p.78).

Dendera boasts several astrological features, including a circular zodiac on one of the eastern roof chapels – the only one found in ancient Egypt. It is of a type developed by the Babylonians, but there is a less familiar version in an aisle of the main temple, showing the sky-goddess Nut arching over an unusual sequence of zodiacal signs – a testimony to the magical, symbolic role of the skies in the Egyptian imagination.

HASHIHAKA

JAPAN

The holy mountain, Miwayama, rises above the fringe of the Yamato plain in the heart of Japan. Remains of various ancient sites near the mountain have revealed astronomical orientations, among them the Hashihaka mounded tomb, less than a mile from the northwest slope of Miwayama.

Constructed in the *zempokoen* or "keyhole" style (so called because of the groundplan), this tomb probably dates from the Kofun period (AD300–700), although it has not yet undergone full archeological investigation. It has a total southwest-northeast length of 886 feet (270m). The "top", round part of the "keyhole" rises to 89 feet (27m) in height, and probably contains the burial chamber. Built with stones and pebbles, the monument is now overgrown with trees, creating a keyhole-shaped copse which rises out of the uninspiring flat landscape immediately surrounding the site.

A pond or a moat fed from the nearby Anashi river formerly encircled three-quarters of the monument's perimeter, but now only two large ponds remain, the northerly of which contains a small hillock in its northwest corner. This islet, known as a *baicho* ("escorting hillock"), is probably artificial.

The researcher Stephan Peter Bumbacher, who has checked Hashihaka for astronomical orientations, found that the *baicho*'s location was significant: from it you can see a distinctive protuberance on Miwayama directly over the top of the burial mound, marking the precise point on the skyline where midwinter sunrise occurs. Bumbacher went on to find that an alignment running along the axis of the monument from a platform on the front section directly over the top of the round mound strikes the summit of a large hill nearly two miles (3.2km) to the northeast, marking the midsummer sunrise position from Hashihaka. The mounded tomb was thus keyed through its topography in an astronomical orientation, a phenomenon seen at sites the world over, reflecting the ancient identification of earth and heaven as an indivisible whole.

It also seems likely that a profound symbolism was in operation at this site, reflecting the beginnings of rice cultivation, the change from hunting and gathering to farming. Agricultural people need calendars, and this meant Sun-watching. One early Japanese emperor was named Mimaki-irhiko-inie-no-Sumeramikoto, meaning "Emperor, Sun setting between two honourable firm peaks, fifty balls, sow". The solar reference is obvious, and the "fifty balls" probably relates to the fact that in Japan rice was usually sown about fifty days after the spring (vernal) equinox. Bumbacher suggests that Hashihaka's orientations could embody a perception that the spirit of the dead ruler was instrumental in maintaining the cycle of the seasons. And perhaps this association in turn contributed to the maintenance of power for a ruling elite.

An aerial photograph showing the remarkable "keyhole" mound at Hashihaka – an imperial burial chamber with alignments to the midsummer and midwinter sunrises. The trees cover a structure made largely of stones and pebbles.

VIJAYANAGARA

INDIA

Founded in the 14th century, the city of Vijayanagara, about 200 miles (320km) southwest of Hyderabad, was one of the largest cities in the world in its day. It was laid out as a mandala – a religious diagram used as a meditation aid in various Indian and Tibetan Buddhist traditions, and to provide a groundplan design in Hindu temple architecture. Temples could symbolize "Mount Meru", the mythical cosmic mountain at the centre of the world, above which shone the Pole Star, centre of the heavenly sphere. The temple mandala was the "Vastupurusha Mandala", and this established the boundaries of the sacred enclosure, aligned to the cardinal directions.

The researcher John M. Fritz has suggested that the whole royal city of Vijayanagara can be understood as a sacred site, containing the same mandalic spatial relationships as the classic Hindu temple. With the astrophysicist John McKim Malville, Fritz studied more than 150 temples and shrines within the city, and found that while many aligned north-south, some temple axes were significantly skewed from the cardinal directions. The researchers realized that these skewed temples aligned to local hills which had been worked into the whole cosmological pattern. The sky, the temples and the local topography had been fused together into a whole. They guessed that the priesthood and aristocracy would have responded to the plan of cardinal directions, but that the peasantry may have found the local topography more meaningful.

Looking north one night along the distinctive north-south axis of Vijayanagara, Malville saw these elements powerfully synthesized. Seen from within a ceremonial gateway on the axis, the Virabhadra Temple stood on the summit of Matanga Hill, with the Pole Star shining above the temple: "Who ... could doubt that Vijayanagara was once a magical city, sanctioned and protected by gods and myth?"

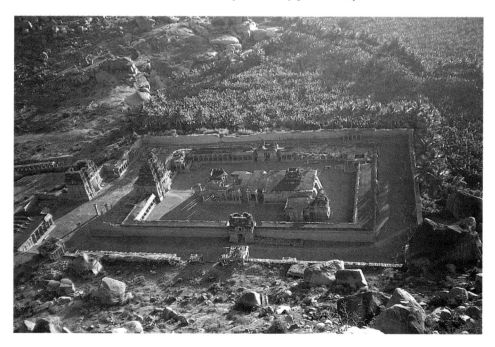

The temple of Tiruvengalanatha at Vijayanagara – just one component in the city's vast cosmic diagram.

GAO CHENG ZHEN

CHINA

"World centres" – locations that marked the symbolic navel of the world – are found in most traditional cultures. For the ancient Greeks, this centre was Delphi; for the Inca, it was Cuzco (see p.161); even in medieval Christendom, Jerusalem was shown at the centre of maps. In China during the Han era (AD25–220), the town of Yang-chheng, now Gao cheng zhen, southeast of Luoyang, represented the world axis. Ancient texts suggest that a gnomon (a shadow-throwing device) was installed there 2,000 or more years ago. Shadows vary in length at different times of the year and at different places on the Earth, and can be used to measure both time and distance.

In AD725 the Buddhist monk I Hsing put a gnomon 8 feet (2.5m) high at Gao cheng zhen, one of a whole series on a single north-south line almost 2,200 miles (3,540km) in length. Over this distance, measurement of the gnomon's shadows would show variations sufficient for geographical distances to be calculated. This was a geodetic or Earth-measuring use of astronomy. The system also worked for calendrical calibration by comparing shadow-lengths at different times of year.

In the 13th century a more sophisticated device was built at Gao cheng zhen by the astronomer Guo shou jing, consisting of a pyramidal tower. Projecting from its north face is a wall, "The Sky Measuring Scale", which was water-levelled by nar-

row troughs, and was calibrated. The shadow cast by the tower was measured on the wall at noon on the summer solstice, and again at noon when the midday Sun was at its lowest, on the winter solstice. Measurement of the differences in the length of these shadows enabled Guo shou jing to estimate the length of the year with great exactitude. Such science was used to confer cosmological authority on the imperial rulers of China.

The pyramidal tower at Gao cheng zhen is 40 feet high (12m) with a 120-foot (37m) low wall, the Sky Measuring Scale, used to make precise calendrical calculations.

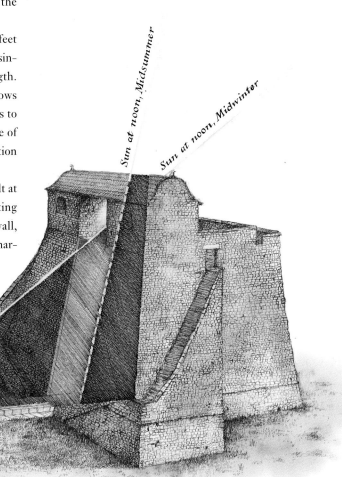

Sun at noon, Midsummer

Sun at noon, Midwinter

Sky Measuring Scale

143

CAHOKIA

USA

The largest prehistoric community in what is now the United States, Cahokia, in southern Illinois, was a Mississippian Indian city and ritual complex, occupied *c.*AD700–1500. At its height, the complex covered some 6 square miles (15.5 sq km) and had a population of 20,000. The remains cover 3½ square miles (9 sq km) and include 68 mounds, including the tallest prehistoric earthwork in North America, Monks Mound.

Originally, there were more than 120 mounds, consisting of three types: platform mounds with flat tops that supported buildings such as temples; conical mounds used mainly for burials; and ridge-topped mounds, also used for burials but primarily employed as geographic markers. Five of the eight ridge-tops fix the extreme limits of the mound area, and three align with Monks Mound to form a meridian, a north-south line: Cahokia was laid out to the cardinal points.

Monks Mound, which rises in four terraces to more than 100 feet (30.5m) was the hub of Cahokia's ceremonial landscape, the centre of the Four Directions. On the southwest corner of the first terrace stood a temple precisely on the course of the north-south line through the Cahokia complex. This shrine would have appeared as a meridional marker silhouetted against the sky when viewed from ground level. Running south from this position, the meridian passes ridge-top mound (mound 49), between the so-called Twin Mounds, across the southeast end of ridge mound 72, and on to the massive southern-most ridge mound (mound 66).

Mound 72 is particularly interesting, as excavations have revealed that a huge pole some 3 feet (90cm) in diameter once stood at

Monks Mound in Cahokia is more than 100 feet (a little over 30m) high. This view is taken from the southeast and shows the two great ceremonial stairways.

the exact point where the meridian passes through. The work also showed a succession of earlier mounds on the same spot, containing a series of burials numbering more than 250 skeletons. The main burial, that of a 45-year-old man, was surrounded by rich grave goods including uncut mica sheets and several hundred finely wrought arrowheads. This was obviously a place of special significance, and perhaps played a key part in some kind of cosmic symbolism.

On the summit terrace of Monks Mound the Mississippians had constructed a timber building 105 feet (32m) by 48 feet (14.6m), with an estimated height of 50 feet (15.2m). This was presumably the king's dwelling, or a temple. A massive pole erected outside this building may have been a Native American version of the World Tree. Of this pole the American mythologist Joseph Campbell wrote that "its symbolic function, as representing the axial height joining earth and sky, is evident".

In 1961 the archeologist Warren Wittry and his team found evidence indicating that to the east of Monks Mound, just south of the east-west line, there had been a succession of five timber circles ("Woodhenge"), which he carbon-dated to a period around AD1000. The third circle in this sequence, 410 feet (125m) across, and now partially reconstructed, had poles on its eastern circumference marking three key sunrise positions – midsummer, equinox and midwinter. But this Sun circle also had symbolic value: not only did a perimeter pole mark the equinoctial sunrise as viewed from the Sun-watcher's pole, but so did Monks Mound looming on the skyline. The Sun would have appeared to rise out of the mound, and there-

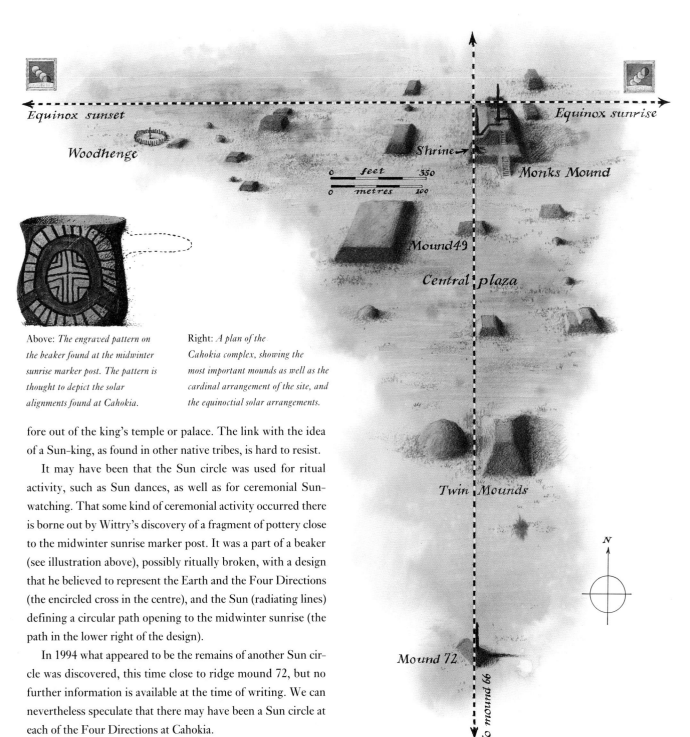

Equinox sunset

Woodhenge

Shrine→

Monks Mound

feet 350

metres 100

Mound 49

Central plaza

Equinox sunrise

Twin Mounds

N

Mound 72

To mound 66

Above: *The engraved pattern on the beaker found at the midwinter sunrise marker post. The pattern is thought to depict the solar alignments found at Cahokia.*

Right: *A plan of the Cahokia complex, showing the most important mounds as well as the cardinal arrangement of the site, and the equinoctial solar arrangements.*

fore out of the king's temple or palace. The link with the idea of a Sun-king, as found in other native tribes, is hard to resist.

It may have been that the Sun circle was used for ritual activity, such as Sun dances, as well as for ceremonial Sun-watching. That some kind of ceremonial activity occurred there is borne out by Wittry's discovery of a fragment of pottery close to the midwinter sunrise marker post. It was a part of a beaker (see illustration above), possibly ritually broken, with a design that he believed to represent the Earth and the Four Directions (the encircled cross in the centre), and the Sun (radiating lines) defining a circular path opening to the midwinter sunrise (the path in the lower right of the design).

In 1994 what appeared to be the remains of another Sun circle was discovered, this time close to ridge mound 72, but no further information is available at the time of writing. We can nevertheless speculate that there may have been a Sun circle at each of the Four Directions at Cahokia.

CASA GRANDE

USA

Casa Grande – the name is Spanish for "big house" – is a mysterious four-story structure standing in an otherwise almost vanished prehistoric village in southern Arizona, built and used by the Hohokam people. The Hohokam – "those who have gone" – appeared in the area *c*.300BC, probably from Mexico, and were active up until the 14th century AD. Little is known about them, but it is clear that they were remarkably accomplished canal engineers, using irrigation techniques that allowed them to farm in the desert. They were also fine jewelers, and they seem to have lived peacefully. Their culture reached its height between AD1000 and AD1400.

Abandoned by 1450, Casa Grande was not visited by Europeans until 1694, when a Jesuit missionary described it "as large as a castle". Although now it is in a moderately ruinous state (it has a protective metal roof over it), enough survives for us to appreciate its structure. Some 35 feet (10.7m) high on a base of 60 feet by 40 feet (18m by 12m), its walls of sunbaked caliche mud, which have deeply entrenched foundations, are 5½ feet (2m) thick at their bases, tapering to 2 feet (70cm) at full height. The building had more than 600 roof beams of pine, juniper and fir, and it was necessary to import these from more than 50 miles (80km) away. The structure as a whole contained 11 rooms, with a top story consisting of a single room, rising as a smaller unit above the lower stories. It is a curious building, and is still not fully understood by archeologists. Nevertheless, its special importance is evidenced by the effort that clearly went into its construction – after all, it is still standing,

whereas the other village buildings at this site have all but disappeared back into the desert.

Perhaps the strangest features of Casa Grande are the two apertures on each of the upper corners of its west wall, one circular, the other square. Researchers have shown that the southerly of these two, the square opening, gives a sightline to an extreme setting point of the Moon during its cycle of 18.6 years, while the round aperture opens to the midsummer sunset. The single-roomed top story also has apertures in its fabric that align variously to significant Sun- and Moon rises.

Most authorities believe that Casa Grande was some kind of observatory, but a clue to its deeper significance may lie in an observation of 1887 by Frank Hamilton Cushing, an anthropologist who had lived for five years with Pueblo Indians a little further north. Cushing noted that the building's floorplan resembled the pattern laid out in the ceremonies for consecrating the cornfields by neighbouring Hopi natives. This insight was developed by another anthropologist, David Wilcox, who proposed that the astronomical function of Casa Grande expressed concepts enshrined in the cornfield consecration ceremonies, according to which the central area of the cornfield represents the Hill of the Middle, with the surrounding areas of the field representing the "Hills" of the four cardinal directions plus the zenith and the nadir. In this view, Casa Grande is a three-dimensional concretization of the ceremonial pattern, with the central tier of rooms representing the nadir, zenith and "Middle" or World Centre; the rooms around represent the Four Directions.

The square window of the Casa Grande, on the right of the picture, aligns to the southernmost setting point of the Moon. The round window, to the left, opens to the midsummer sunset.

CHACO CANYON

USA

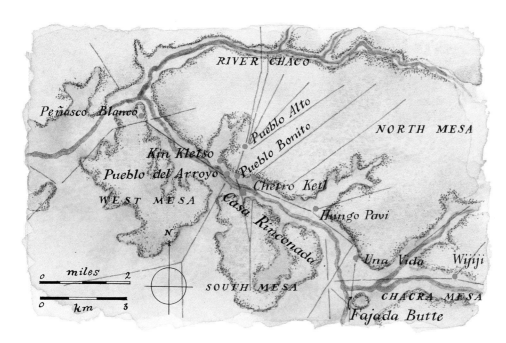

This map of Chaco Canyon pinpoints all nine of the Great Houses which lie along both sides of the canyon floor. The red square denotes the location of Casa Rinconada, and Fajada Butte is also shown. The straight lines (in brown) are the mysterious "roads" that radiate for many miles from the canyon.

Chaco Canyon was inhabited by the Anasazi people – which means the "Ancient Ones" in the language of their Navajo successors – a thousand or more years ago. The Anasazi first appeared in the last few centuries BC, probably from Mexico, and reached their cultural height between AD900 and AD1300. They were not only accomplished builders and road and canal engineers, and great traders, they also seemed to have been adept at ceremonial astronomy. The culture collapsed during the 14th century, and the people broke up into what are now the various Pueblo peoples of the American Southwest.

The canyon is a broad, shallow sandstone gorge cutting east-west across the Chaco Plateau, an area of arid mesa country in New Mexico. It lies at the heart of the San Juan Basin which spreads across what is known as the "Four Corners" region, where New Mexico, Colorado, Utah and Arizona meet. Archeologists now think that Chaco, though possessing a per-

manent population, was primarily a ritual centre that attracted much larger numbers of people from the vast landscape around at certain times of each year.

Scattered along the canyon floor are the ruins of nine "Great Houses", multi-storied "villages" of terraced pueblo buildings with walls, courtyards, storage pits and many *kivas* – large ceremonial chambers. The Great Houses also seem to have been essentially ceremonial buildings. The largest was Pueblo Bonito, said to be the largest prehistoric ruin in the United States, covering three acres (1.2ha) and containing 800 rooms, two great *kivas* and 37 smaller ones. All the Chaco Great Houses were built between AD900 and AD1115. The tumbled ruins of a further 150 Great Houses have been identified spread out around the canyon for tens of miles.

Many of these outlying buildings are on mysterious straight "roads": engineered features up to 30 feet (9m) in width, now

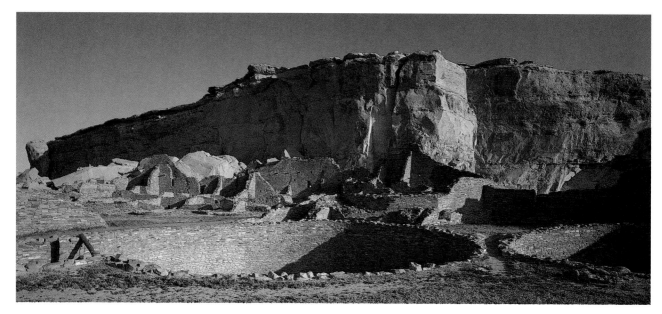

A view of Pueblo Bonito, the greatest of all the Great Houses in the Chaco Canyon. In the foreground are two Great Kivas – circular chambers built for

ceremonial purposes. The complex is laid out on a strictly cardinal plan, divided into eastern and western sectors by a low meridional wall.

148

virtually invisible at ground level. Some have been traced running for up to 50 miles (80km) or even further, passing through special gateways in walls alongside Great Houses and converging on the canyon. Some roads run, for long stretches, parallel to each other. Why a people who had neither horses nor wheeled vehicles wanted such features is unknown. Where some of the roads reach the canyon rim, large staircases, with a ceremonial air about them, are to be found hewn out of the living rock of the canyon walls. Many researchers think that the roads, too, had ceremonial rather than utilitarian functions, or, at least, served multiple purposes.

At various locations along the canyon walls are rock paintings and carvings, some Navajo and others Anasazi, and these are thought to have marked positions for Sun-watcher priests. In relatively recent times, and still today to some extent, Pueblo peoples such as the Hopi and Zuni had a tradition of Sun priests who watched the rising Sun against the local skyline throughout the year. When sunrise occurred at certain horizon features, the Sun priest would announce that specific ceremonies or the planting of particular crops were impending.

A white-painted symbol with depictions of rays streaming out from four sides may be seen near Wijiji Pueblo, the easternmost ruin in Chaco Canyon. We may presume that this is a Sun symbol, since a person standing near it is able to witness the winter solstice sunrise as it emerges from behind a natural sandstone pillar on the canyon rim opposite.

Ancient astronomy still functions at Chaco. On a high ledge near the summit of Fajada Butte, a 430-foot (130m) sandstone outcrop at the southeastern entrance to the canyon, three fallen slabs lean against the rock wall. One late morning shortly after the summer solstice in 1977, the artist Anna Sofaer observed a sliver of sunlight suddenly project through a gap between the slabs onto the shaded area of the rock wall behind. On that wall she found two spiral rock carvings. The sliver of sunlight, or "Sun Dagger", was cutting almost through the centre of the spiral design. Subsequent study of this site showed that at noon on the winter solstice, when the Sun shines at a lower angle in the sky, two Sun Daggers project between the slabs, perfectly framing the larger spiral carving. At the equinoxes, one long sliver of sunlight cuts the large

spiral just to one side of its centre, while another, shorter, Sun Dagger bisects the smaller carving. There could hardly be stronger evidence of an Anasazi solar calendar cycle.

Earlier on midsummer morning, a little after the solstice sunrise, the Sun casts a beam of light through a curious aperture in the northeastern wall of the great *kiva* at Casa Rinconada, shining across the circular chamber to strike one of six irregularly spaced wall niches: the impact would have been remarkable when the the *kiva*'s roof was still in place. Critics have hypothesized that the *kiva* might have had an external structure built against it where the aperture is situated, sabotaging the effect; however, despite such reservations, the argument for a solar alignment is persuasive.

A similar solar event has tentatively been noted at Pueblo Bonito. As midwinter approaches, a slice of sunlight flashes through an unusual corner aperture in an upper room within the complex, and is projected onto a wall. As the days toward midwinter progress, this sliver of sunlight broadens until by the morning of the solstice it casts a rectangle of light.

The very structures of Casa Rinconada and Pueblo Bonito, directly across the canyon floor from one another, speak of astronomical awareness. Casa Rinconada is aligned to the four

Two details showing how the spiral designs carved on an outcrop of Fajada Butte (see illustration, above right) are traversed by "daggers" of sunlight at the solstices. Spiral motifs represent the Sun in numerous cultures across the world.

Midsummer, noon Midwinter, noon

The leaning rock slabs at Fajada Butte, which channel shafts of sunlight onto spiral designs carved on the outcrop behind, in a deliberate contrivance of solar symbolism (see also illustration, below left).

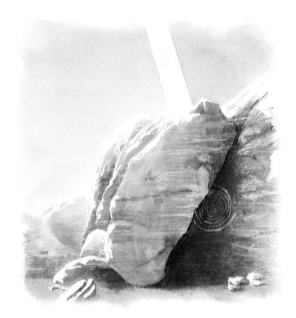

149

cardinal directions, its two large, T-shaped entrances precisely aligned north-south. Moreover, this alignment also gives a sightline to Pueblo Alto, a ruined Great House high on the rim of the north wall of the canyon, where one of the major "roads" comes in off the desert. Pueblo Bonito was similarly laid out on a cardinal plan, divided into western and eastern halves by a low wall that lies on a virtually exact meridian (north-south) line.

The vestiges of ceremonial astronomy that still linger among the Pueblo peoples of today lend valuable clues to the solar architecture and symbolism of a mysterious, but undeniably great, lost civilization.

HOVENWEEP

USA

Consisting of six groups of Anasazi (see p.147) buildings approximately 800 years old, Hovenweep National Monument straddles the border between southeast Utah and southwest Colorado. The sites, in and around the edges of small box canyons, were not even documented until 1874, and the buildings are today much as the Anasazi people left them, except for the depredations of time. There are towers on the canyon floors, next to precious water sources, and clusters of other buildings perched on the edges of canyons or even on top of rock outcrops. Some doorways open out onto empty space, and were presumably reached by rope ladders. Theories about the purposes of the site abound, but there are no firm answers.

The group of D-shaped towers and walls called Hovenweep Castle rises to 20 feet (6.1m) in height, and it is here that the archeoastronomer Ray Williamson suggests one possible set of astronomical events. The tower on the western side contains a room with two small apertures in the walls aligning respectively to the summer and winter solstice sunsets, while the outer and inner doors line up to the equinoctial sunsets. The chances of all three alignments happening just by chance are one in 216,000, so we may assume that these solar lines were deliberately created.

Further along the canyon are the ruins of a structure that archeologists call Unit-Type House, where in the east room are four slits, two of which align to the midsummer and midwinter sunrises respectively, while another is oriented toward the equinoctial sunrises. A wall inside this room is so angled that it presents a perfect surface to receive the sunbeams through each of these apertures on the appropriate days.

Williamson has also noted possible astronomical events at other Hovenweep sites. At Cajon Ruins, shadows cast between the two main buildings at sunrise and sunset through the year could have been used as a solar calendar, and a panel of ancient rock art beneath an overhang close to another building group, Holly House, seems to interact with a "serpent" of sunlight cast on it at midsummer. This serpent-shaped lightplay, and the form of the rock art (which includes two circles, each with a central dot, probably symbolizing the Sun), are thought to enact certain myths and rituals of the Hopi, another Pueblo people, who were possibly descended from the Anasazi.

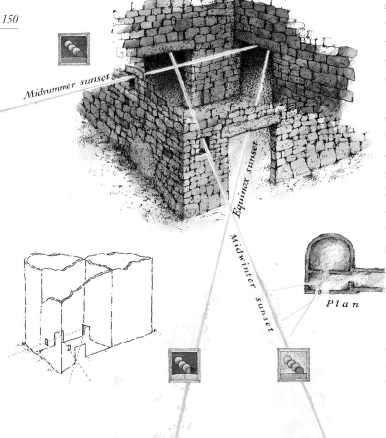

Midsummer sunset

Equinox sunset

Midwinter sunset

Plan

The largest diagram shows the eastern room of Hovenweep Castle. Midsummer and midwinter sunsets stream in through apertures on the western and southern walls, while the light from the equinox sunset comes in through the southern doorway. The plan below shows the D-shape of the back of the room.

TEOTIHUACÁN

MEXICO

A great urban and ceremonial centre about 30 miles (48km) northeast of modern-day Mexico City, Teotihuacán was laid out in the 1st century AD, reaching its cultural peak between AD350 and AD650. At that time it had a population of some 200,000 and extended to around 10 square miles (26 sq km). Consisting of temples, shrines, plazas, dwellings and workshops, it was larger than any city in Europe. By the 8th century, however, it had been destroyed by fire and abandoned, perhaps owing to an insurrection rather than an invasion.

No one knows who the builders of Teotihuacán were, but their great religious and economic centre dominated the Valley of Mexico and beyond for more than 1,000 years prior to the Aztecs, who encountered its awesome ruins and considered it the source of all civilization. It was they who named it Teotihuacán, the Birthplace of the Gods. In Aztec mythology, it was where Nanahuatzin, a dying god, jumped into a ceremonial fire which the four creator gods (representing the four cardinal directions) were too fearful to enter. Thus turned to flame, Nanahuatzin became the "Fifth Sun", the Aztec sun of the present cosmic age. His companion, Tecciztecatl, joined him in the sacrificial fire and became the Moon. The Fifth Sun agreed to orient the world by his rising and to organize the passage of time. The Aztecs decided that the larger of the two pyramids which dominate Teotihuacán was dedicated to the Sun, the smaller to the Moon.

Teotihuacán was laid out to a four-part plan, but, interestingly, it was not primarily oriented to the four cardinal directions. Instead, it was organized to an angle of 15.5° east of

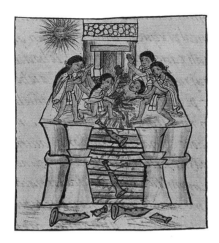

Human sacrifice (shown here in a Spanish illustration) was a vital part of ancient Meso-american religion: the Aztecs believed that the gift of a human heart would appease the Sun-god.

north. This originally puzzled archeologists and astronomers, who observed that this orientation had been strictly applied throughout by the city's builders, for not only did the streets and many of the buildings adhere to this established axial plan, but even the course of the San Juan River, which runs through the site, was canalized to conform. This skewed north-south central axis is marked by the great ceremonial way which the Aztecs called the Street of the Dead. The street extends for 1½ miles (2.4km), aligning on the Pyramid of the Moon at its northern end (and to a notch in Cerro Gordo, the city's sacred mountain and water source). The Pyramid of the Sun is set just to the east, its sides oriented in parallel with the smaller companion structure.

The tiered bulk of the Pyramid of the Sun rises to well over 200 feet (60m). Its western side faces toward Cerro Colorado and Cerro Maravillas, both of which may have been regarded as sacred to the Teotihuacános. However, researchers have sought a primarily astronomical answer to the mystery of the city's odd orientation. It turned out that the beginnings of the answer lay underground, beneath the Pyramid of the Sun.

It is now realized that the site of Teotihuacán originated as a result of the existence and ritual use of a cave lying beneath the Pyramid of the Sun. The cave consisted of four lobes with an extension originally created by a flow of volcanic lava. In plan it resembled a four-leafed clover with a long stem (as the astronomer John B. Carlson has put it). Archeologists have found clear evidence of ritual and ceremony inside the cave. The cosmological significance of the four lobes would have

151

been apparent to the Mesoamerican builders of Teotihuacán, because they, like all indigenous Mesoamericans had a conception of the universe based on the four cardinal directions. They also granted great significance to the inter-cardinal directions – northeast, south-east, southwest, northwest. However, the cave had more to offer than this: by a remarkable coincidence, the lava tube passage aligns to the setting point of the Pleiades constellation, which had great symbolic import for ancient Meso-americans. The heliacal (first pre-sun-rise) annual appearance of the Pleiades heralded the first of the two occasions each year when the Sun passes directly overhead, through the zenith, at the latitude of Teotihuacán. At noon on these days shadows dwindle to nothing, and it was believed that the Sun-god visited the Earth briefly at these moments. Furthermore,

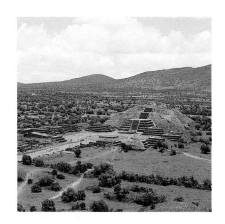

A view of the Pyramid of the Moon at Teotihuacán, showing the courtyard in front of it and the end of the Street of the Dead. The original surrounding buildings are now in ruins.

it so happens that at the latitude of Teo-tihuacán the Pleiades themselves pass close to the zenith.

The Pyramid of the Sun was eventu-ally built directly over the cave and was oriented along the line of the lava tube passage, thus also aligning to the point where the Pleiades set in AD150. Also in the alignment were the mountain peaks toward the Pleiades' setting point, and these no doubt became sacred moun-tains because of the association. The American archeoastronomer Anthony F. Aveni realized that this was the founding line on which the angled ori-entation of the city was based. The skewed northern axis of Teotihuacán derives in turn from the drawing of a perpendicular line across this Pleiades-inspired east-west axis.

The east-west axis actually crosses the Street of the Dead a

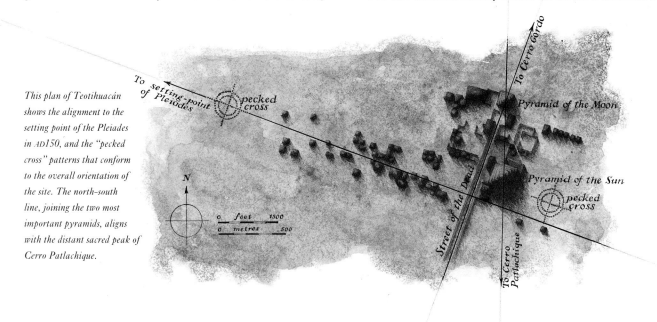

This plan of Teotihuacán shows the alignment to the setting point of the Pleiades in AD150, and the "pecked cross" patterns that conform to the overall orientation of the site. The north-south line, joining the two most important pyramids, aligns with the distant sacred peak of Cerro Patlachique.

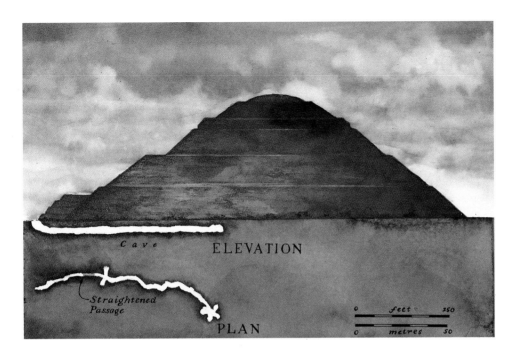

ELEVATION

Cave

Straightened Passage

PLAN

0 *feet* 150

0 *metres* 50

A combined cross-section and plan of the Pyramid of the Sun. The plan shows the clover-leaf chamber (reflecting a fourfold conception of the cosmos) and the lava tube extension, partly straightened to align with the setting point of the Pleiades constellation.

short distance south of the Pyramid of the Sun. Careful observation revealed evidence suggesting that the axis may have been marked out by "benchmarks" of pecked crosses. One of these, just south of the Pyramid of the Sun and on the eastern edge of the Street of the Dead, is punched into the plaster floor of a complex of ruins known to archeologists as the Viking group. It consists of two concentric rings of pecked holes, quartered by two pecked lines crossing at the circles' common centre. The whole marking measures about a yard (1m) across. Another such circular motif, with a similar number of pecked holes, was found two miles (3.2km) to the west on a boulder on Cerro Colorado. Today, more than thirty similar pecked designs have been found on the floors of buildings at the site or on rock outcrops. Once it had been established that the axis of the pecked crosses along the Street of the Dead aligned with the Teotihuacán grid, the mystery was solved: "Teotihuacán north" had precedence over astronomical north. The orientation of Teotihuacán was cosmological, its axial plan evolving from a ritual cave whose configuration matched the skylore – the mythologized astronomy – of the times.

Despite this adherence to a skewed cosmological plan, however, the more usual cardinal directions were also embedded in the layout of Teotihuacán: the Pyramid of the Sun and the Pyramid of the Moon form a north-south alignment which passes through another sacred peak, Cerro Patlachique; and some of the buildings within Teotihuacán acknowledge this orientation rather than "Teotihuacán north".

Near the summit of Cerro Gordo, and therefore on the line of the Street of the Dead, is a variation on the pecked cross motif: a quartered circle with a spiral-like appendage connected to it. This may be a rendering of a serpent, which is interesting because within Teotihuacán, at the southern end of the Street of the Dead, is the Citadel complex, and here, inside the plaza, is a seven-tiered pyramid covered with carvings depicting the god Quetzalcoatl, the Plumed Serpent. The American engineer Hugh Harleston has suggested that the dimensions of the steps on this structure provide a mathematical basis for a Mercator-like projector of the Earth. If this is not simply fanciful speculation, it would mean that the builders of Teotihuacán knew the dimensions of the Earth itself.

UXMAL

MEXICO

The skylore of the Maya people of Mesoamerica has come down to us only in fragments. Their cosmos was multi-layered: there was a nine-levelled underworld; a middle, human world; and a heavenly upper realm supported, as if on pillars, by four gods, the Bacabs. Connecting all was the *axis mundi*, a huge tree along which the souls of the dead, as well as gods, could travel. In one myth the Sun and Moon orginally inhabited heaven, but were banished to earth for lewd behaviour. Lunar light is paler than solar light because the Sun blinded their Moon in one eye in a fit of jealousy. It was also believed that each night between sunset and sunrise the Sun would

journey through the underworld as the jaguar-god.

The ruined Maya city of Uxmal, in western Yucatán, about 50 miles (80km) south of Mérida, is a major architectural site of this culture. The complex flourished *c*.AD600–900 after the great southern Maya centres had been abandoned, but it had been occupied at least as far back as the early centuries AD.

In 1586 a Franciscan visitor, Alonzo Ponce, wrote a detailed account of the city, mentioning in particular a *mul* (pyramid), on top of which stood the building today known as the House of the Magician, where "they took the Indians who were to be sacrificed and then killed them. ... Close to this *mul* and behind

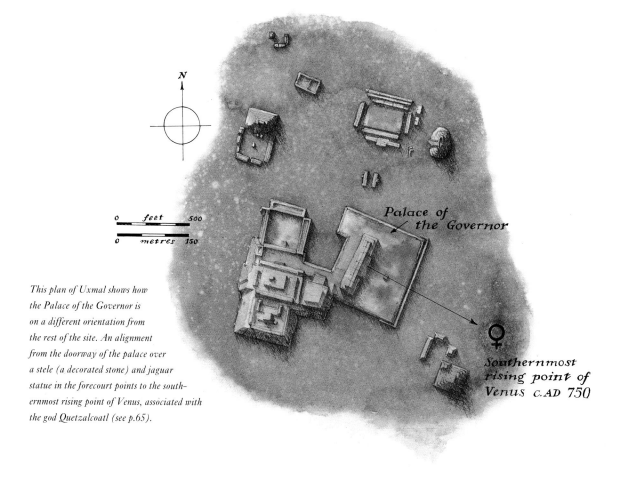

Palace of the Governor

Southernmost rising point of Venus c.AD 750

This plan of Uxmal shows how the Palace of the Governor is on a different orientation from the rest of the site. An alignment from the doorway of the palace over a stele (a decorated stone) and jaguar statue in the forecourt points to the southernmost rising point of Venus, associated with the god Quetzalcoatl (see p.65).

it on the west ... four very large buildings [today known as the Nunnery Quadrangle] are set in a square form. ... Another very large building [the Palace of the Governor] built on a *mul* made by hand is of an extraordinary sumptuousness and grandeur."

A particularly intriguing structure at Uxmal is the "Dwarfs' House". Built on the summit of a pyramid, it is far too small for human occupants, and many observers believe that this and similar structures elsewhere were intended for the use of spirits or supernatural beings.

Most of the buildings in the city share a roughly cardinal orientation (actually 9° east of north). However, the rectangular, (98.2m) 322-feet long Palace of the Governor, an impressive monument clad in a mosaic of some 20,000 sculptured stones, is noticeably skewed from this: its long axis is turned 19° clockwise from the usual axis, so that its frontage faces southeast. It sits on a stepped platform which is itself on a natural elevation. A sightline directly out of the central doorway in the building's façade passes over a cylindrical stele (a carved stone slab) and a platform supporting a double-headed jaguar sculpture to a pyramid on the skyline a few miles away. This has been identified by the American astronomer Anthony F. Aveni as a large pyramid in another ruined Maya centre, Nohpat. Viewed from the central entrance of the Palace, this marks the southernmost rising point of Venus.

Venus was a major player in Mayan cosmology, one of the Twins (Hunahpu) in the Maya's epic poem, *Popol Vuh* (the other Twin being the Sun), associated with warfare and death. Sacrificial victims were sometimes painted blue, the symbolic colour for Venus, prior to death. The association between Venus and Uxmal's Palace of the Governor was further emphasized by hundreds of stone mosaic "Chac" masks along the upper façade, the lower eyelids of each one carved with a glyph representing Venus.

Maya priests had almanacs recording the cycles of Venus,

The double-headed jaguar sculpture in the courtyard of the Palace of the Governor. It falls on a sightline from the centre of the Palace to the southernmost rising point of Venus.

which were keyed into their overall calendar, so that they could identify propitious times for ritual combat and sacrifice. This was a complicated business. Five 584-day Venus cycles fortuitously equal eight 365-day solar cycles, so an eight-year Venus almanac was devised. But that in turn had to mesh with the Maya's 260-day Sacred Almanac, which involved a cycle combining a sequence of 13 sacred numbers with another of 20 named days. The result of this computation was a 104-year Great Venus Almanac, which incorporated 65 Venus cycles and 146 Sacred Almanacs!

An interesting twist to the Uxmal-Nohpat sightline is that it is marked on the ground by a straight sacred way, a *sacbe* ("white road"). These causeways have been found to link numerous ancient Maya cities, and some of them run for tens of miles – though most are now in a highly overgrown state.

Some researchers believe that the astronomical alignments found at Maya centres were in effect transcribed onto the ground on a huge, territorial scale.

CHICHÉN ITZÁ

MEXICO

Chichén Itzá, in the Yucatán Peninsula, was an important ceremonial centre during both the Maya and Toltec periods. "Old Chichén" was built by the Maya *c*.AD600–830. However, it is thought by some that a breakaway group of Toltecs (warrior people from highland Mexico) took Chichén Itzá by force in AD987, constructing new buildings about a mile northeast of the older city, and modifying some existing Maya buildings.

According to the American archeoastronomer Anthony F. Aveni, the Caracol at Chichén Itzá (so called because its internal winding staircase resembles the spiral of a snail's shell) is one of "the most secure examples of the incorporation of a horizon-based astronomy in architecture". It consists of a two-tiered rectangular platform supporting a cylindrical tower, at the top of which are three surviving "windows", really horizontal shafts, that open westward. As long ago as the 1920s, the American archeologist Oliver Ricketson suggested that these

Above: *El Castillo at Chichén Itzá: a pyramid that exhibits a spectacular "shadow play" at the equinoctial sunsets.*

Below: *A plan of the Caracol at Chichén Itzá, showing the astronomical alignments. The main plan shows the square platform on which the round tower stands, with descending ceremonial staircases to the west. The inset (above right) shows the room in the upper part of the tower.*

156

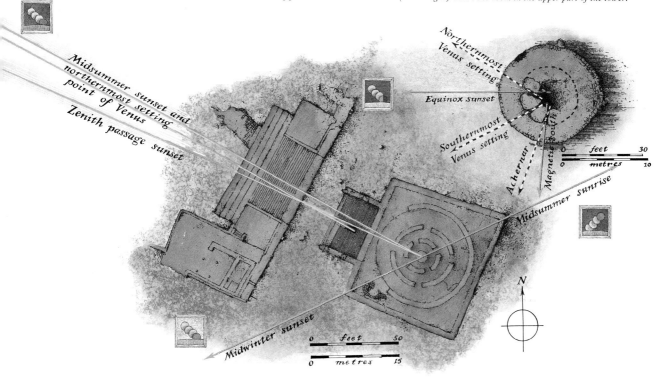

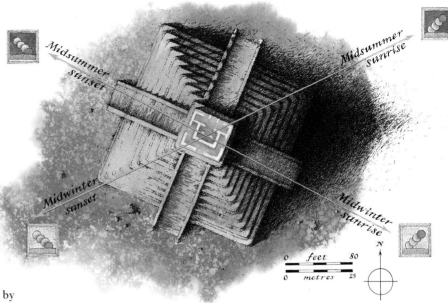

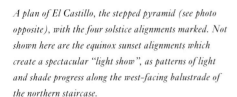

A plan of El Castillo, the stepped pyramid (see photo opposite), with the four solstice alignments marked. Not shown here are the equinox sunset alignments which create a spectacular "light show", as patterns of light and shade progress along the west-facing balustrade of the northern staircase.

openings could have been used for astronomical sighting. The surrounding terrain is flat, and there are no distant hills or peaks to act as foresights for astronomical sightlines, but Ricketson proposed that accurate sightings might have been achieved by looking out of these shafts *diagonally* – for example, from the inside right to outside left jamb of the opening. This gives a "gun-sight" method of lining up two points on a specific place on the horizon. Used in this way, the shafts do yield significant astronomical events. The sighting lines in the wider window (window 1), and the next opening (window 2), have been found to frame perfectly the northern and southern extreme setting points of Venus, which in Maya cosmology represented the plumed serpent god Kukulcan, the equivalent of the Toltecs' and Aztecs' Quetzalcoatl. Moreover, the inside-right-to-outside-left diagonal of window 1 aligns to the equinox sunset, framing a tiny "wedge" of visible sky into which the disk of the setting equinoctial Sun fits perfectly.

The tower stands on a platform, one diagonal of which aligns to the Sun's midwinter setting position in one direction and its midsummer rising point in the other. A niche containing a pair of columns in the platform's main stairway is skewed at an angle to the upper platform itself, and Aveni discovered that this was oriented on the northern Venus extreme.

About 800 yards (730m) northeast of the Caracol stands the stepped pyramid called El Castillo, known also as the Temple of Kukulcan, towering to 75 feet (23m) in height. In 1566

Diego de Landa, bishop of the region, wrote that "This structure has four stairways looking to the four directions of the world, with 91 steps to each that are killing to climb." Adding together the four lots of 91 steps gives 364, and adding the top platform, effectively the top step shared by all the stairways, gives 365. The Maya had a complex calendar, but one of their measures was the 365 solar days of the year that we use for our calendar today; and since other structures elsewhere in the Mayan domain contain 365 features, archeologists are confident that this was deliberate numerology.

Also, El Castillo's orientation reveals an amazing solar "light show" on the evenings of the equinoxes. As the Sun sets, the northwest corner of the pyramid throws a serrated shadow onto the west-facing balustrade of the ceremonial staircase that climbs the structure's northern face. This creates a slowly moving pattern of triangles of light and shade, appearing one at a time, until seven triangles are strung down the balustrade to touch a carving of the Kukulcan serpent at the bottom. Thus the movement of the feathered serpent out of the pyramid at the equinox is powerfully evoked in a famous event witnessed by thousands of tourists at the spring equinox.

UAXACTÚN

GUATEMALA

Midsummer sunrise

Midwinter sunrise

Equinox sunrise

ELEVATION

Uaxactún, in the Petén rain forest of Guatemala, is a Mayan ceremonial centre of the Early Classic period (AD250–450). Three cross-shaped petroglyphs almost identical to those at Teotihuacán (see p.152) have been found pecked into one of the buildings, and similarly oriented, indicating a very early foundation for the city. From the 1920s archeologists began to suspect that a group of buildings consisting of a pyramid and temples (Group E) was a solar observatory, but exact findings were not made until 1978 by Anthony F. Aveni. He showed that, if viewed from the pyramid, the equinox Sun is seen to rise over the top of the central

temple of three, which stand on a north-south line on a platform to the east. In addition, the midsummer sunrise would occur along an edge of the northern temple as viewed from the pyramid, and the midwinter sunrise would slide out along the edge of the southernmost temple. Aveni suspects that the sides of the central temple may also have marked key sunrises on other dates in the complex Mayan calendar.

However, this complex must have been for ceremonial Sun-watching rather than precise observation, as the Sun-priest's position would have been too close to the foresights for the sightlines to have been precise.

A diagram of the solstice and equinox sunrise effects at the Group E temples, Uaxactún. The viewing positions, from a staircase, are shown in the pyramid plan (right); the elevation (above) suggests how the Sun at the solstices would have appeared to climb the outer sides of the outer temples.

N ←

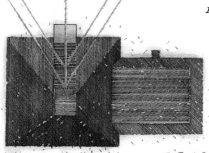

PLAN

0	*feet*	100
0	*metres*	30

CUZCO

PERU

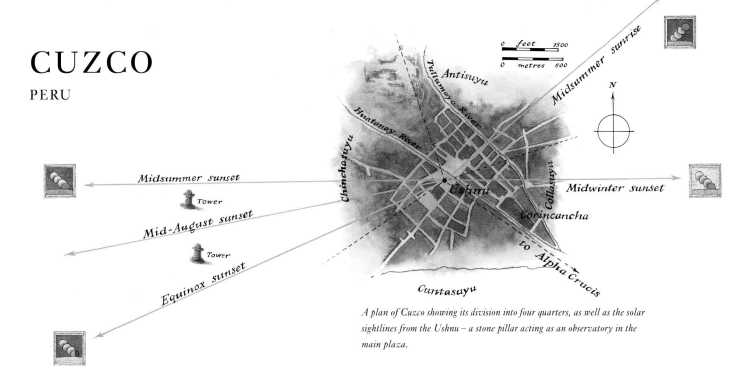

A plan of Cuzco showing its division into four quarters, as well as the solar sightlines from the Ushnu – a stone pillar acting as an observatory in the main plaza.

The Inca people, who rose to supremacy over other Andean groups in the 14th century, called their capital Cuzco – the "navel" (of the Earth). Its symbolic planning was instigated by the emperor Pachacuti in 1440, who canalized the Huatanay and Tullumayo rivers through the city, and laid out the main buildings to a grid pattern oriented intercardinally (southwest-northeast, northwest-southeast). The Andean people's intercardinal direction system derives from their observation of the behaviour of the Milky Way in the night sky over a period of about 12 hours in which it appears to divide the sky, and the horizon, intercardinally (see p.162).

If Cuzco was the navel of the Inca empire, then the Corincancha, the Inca temple of the Sun, was the navel of Cuzco itself. It was aligned to the June solstice sunrise (midwinter at the latitude of Cuzco), when the emperor, the Inca, would have sat in a recess sheathed with gold plates and set with precious stones. The solstitial sunbeams would have struck the recess, making it shimmer around the Inca resplendent in glory as the "Son of the Sun".

Overlooking the point where the two Cuzco rivers meet, the Coricancha marked the centre of 41 *ceques* (alignments), radiating out through sacred places and sacred peaks called *huacas*.

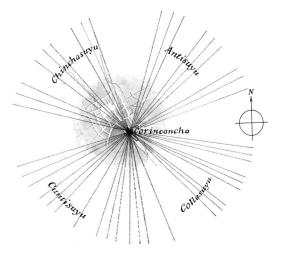

A plan showing the ceques (alignments) radiating from Cuzco's sacred centre.

There were between three and thirteen *huacas* on any one *ceque*, totalling 328 in all (the number of days in the Inca year), representing a giant terrestrial ceremonial calendar, based on the sidereal lunar month of 27 1/3 days.

People living along a particular *ceque* would have had to prepare and organize the appropriate ceremonies when the time of year related to their *ceque*. The ceremonial year rotated, as it were, through the *ceque* system.

MISMINAY

PERU

The "intercardinal" cosmological direction system of the Andean peoples has been thoroughly examined by the anthropologist Gary Urton. Concentrating his research at Misminay, a small community of Quechua descendants of the Inca, Urton found that the ancient cosmology still lives.

In the Andes the Milky Way (see pp.110–111) is a very striking feature of the night sky. Its band of diffuse starlight girdles the Celestial Sphere, so that when half of it is visible in the sky, the other half is not. The plane of this ring of starlight, however, is offset by that of the Earth's rotation, so that its rising and setting patterns seem to "tumble". As it rises, it rolls up from the east, spanning the sky. When its course crosses the zenith, it stretches out in a great diagonal – say, northwest-southeast. Twelve hours later, after the Earth has turned, the band of the other hemisphere of the Milky Way passes through the zenith, its axis running northeast-southwest. Thus, the motions of the Milky Way have the effect of cutting two lines across the sky, crossing at the zenith and dividing the sky into four quarters.

The zenith point where this notional "crossing" of the two halves of the Milky Way occurs is called Cruz Calvario (the Cross of Calvary) by the people of Misminay, who mirror this cosmic scheme in the layout of the community on the ground. Two intercardinal paths cross at a point marked by a small chapel in the centre of the village. This is the Crucero (Cross). The southeast-northwest path is called Chaupin Calle, meaning "middle path", and links surrounding points on much the same level (that is, altitude) as Misminay. The other, south-

The snow-clad Andes, in the region of Misminay, a village 16 miles (25km) from Cuzco. The anthropologist Gary Urton has made a detailed study of cosmological beliefs in the area.

west-northeast path is known as Hatun Raki Calle, meaning the "path of the great division". This path follows a descending slope. Urton points out that Chaupin Calle symbolically represents the horizontal, and Hatun Raki Calle the vertical.

The irrigation canals in Misminay also follow this X-shaped pattern, running alongside the courses of the paths – a water pattern that has much significance for the people, to whom the Milky Way is *Mayu*, the "river", thought to carry water from the cosmic ocean in which the world floats and to redistribute it as rain. To the inhabitants of Misminay, the nearby Vilcanota River, which flows from southeast to northwest, is a reflection of the Milky Way. The Calvario likewise mirrors the Crucero beneath – an invisible axis can be imagined connecting the two.

This plan, clearly a vestige of that employed by the Inca, but now using Christianized terms, underpins the whole worldview of the local people. When standing at the Crucero, for example, one can see specific features on the skyline that have mythological import for them. In particular, there are the sacred mountains or *apus*, their peaks representing the points where earth and sky meet. The northerly sector – that is, the quadrant between the northwest and northeast arms of the intercardinal plan – is the realm of the ancestors, of the dead. Thus, the name of the main peak there, Apu Wanumarka, means "the storehouse of the dead". It is also the direction where the ancestors of the present-day inhabitants of Misminay are said to have first settled.

The Milky Way provides further symbolism for the

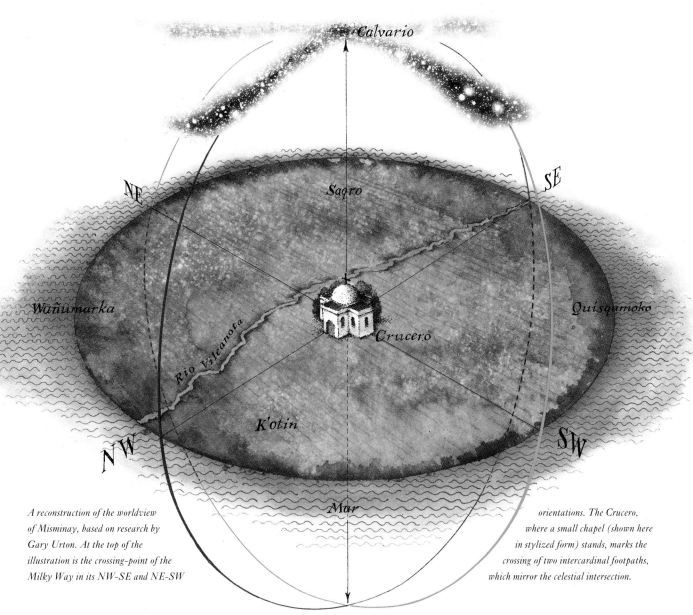

A reconstruction of the worldview of Misminay, based on research by Gary Urton. At the top of the illustration is the crossing-point of the Milky Way in its NW-SE and NE-SW

orientations. The Crucero, where a small chapel (shown here in stylized form) stands, marks the crossing of two intercardinal footpaths, which mirror the celestial intersection.

Andeans, in a way unfamiliar to the Western mind. As a system made up of billions of stars, it effectively represents the view to and through the centre of our own galaxy, but between us and this "wall" of starlight, patches of interstellar dust create dark shapes by blocking out the Milky Way's light. The Andeans regard these patches as "dark constellations" and give them specific names, such as the Adult Llama, Baby Llama, Fox, Toad and Serpent. These constellations (collectively termed the "Pachatira") are linked with fertility and the rains: for example, when Alpha and Beta Centaurii ("the eyes of the llama") rise before dawn in late November and December, earthly llamas are born.

MACHU PICCHU

PERU

The spectacular remains of Machu Picchu, the "city in the sky", are some 60 miles (97km) north of Cuzco. Because of its position on the saddle of a mountain 8,000 feet (2,440m) aloft in the Andes, this Inca citadel was never discovered by the Spanish. The site consists of cultivation terraces, stone houes, temples, plazas and residential compounds clinging to a ridge between two peaks, Machu (old) Picchu and Huayna (new) Picchu. The citadel, which is reached by a stairway consisting of more than 3,000 steps, was rediscovered by Hiram Bingham, of Yale University, in 1911. Archeologists have shown that the earth in the cultivation terraces, which supported the city's population, must have been carried up by hand in small baskets, and that the rock on the summit was smoothed and flattened to form a level ground for the temples and plazas.

Archeoastronomers have found two interesting features at Machu Picchu. The most important of these is the Intihuana, the "hitching post of the Sun". The major Inca festival of Inti Raymi (Inti was the Sun god) took place at the winter solstice (June 21 in the Southern hemisphere). Each year at this time, the Inca priests performed a ceremony to "tie the Sun" to prevent it from swinging ever farther north in its daily arc and be lost for ever. The Inca were known to have other *intihuanas* in their empire, but because of their religious significance the Spanish conquerors destroyed them: the Intihuana at Machu Picchu is the only one known to have survived.

Situated on top of a natural spur, this curious object is carved out of a single piece of granite. It consists of an upright about one foot (30cm) high emerging from an asymmetrical platform composed of a variety of planes, facets, recesses and

A general view of Machu Picchu, a superb Inca citadel precariously balanced midway between the jungle and the clouds. The Incas worshipped Inti, the Sun-god, who was the divine ancestor of the Inca royal family. Other gods revered were Viracocha (the supreme creator deity), Mama Kilya (the goddess of the Moon) and Ilyap'a (the rain god).

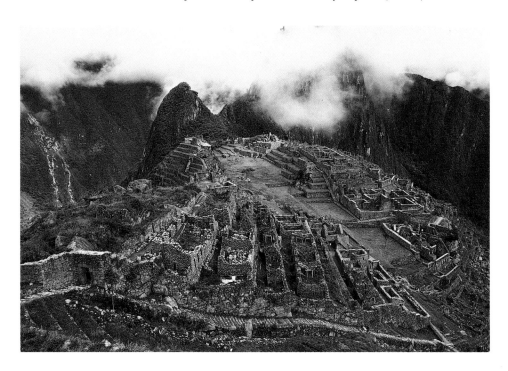

projections. The upright of the Intihuana is assumed to be a shadow-throwing device, a gnomon, like that on a sundial. The Smithsonian Institution astronomer Gerald Hawkins noted that its shadow could be read to within half an inch (1.25cm), the equivalent of a quarter of a degree. He also observed that the solstices and equinoxes, and even variations in the lunar cycle, could all be "read" by the object.

The other point of astronomical interest at Machu Picchu is the Torreon. This now roofless rectangular temple structure, with a curved eastern wall, has a window facing northeast which centres on the midwinter sunrise. Beneath the window is an altar-like rock which has been carved in such a way that a cleft cut horizontally, at right angles to the window, divides the rock in half. When the midwinter Sun rises above the San Gabriel peak to the northeast, its light floods in through the window, with a shadow from the window edge running parallel to the carved cleft in the rock. This was discovered by the astrophysicist David Dearborn in 1980. He and his colleagues have suggested that a frame may have been hung on knobs which still protrude from an otherwise featureless wall, supporting a plumb line which would have thrown its shadow along the cut edge on the altar stone on the date of the solstice.

This window in the Torreon also opens toward the rising place of the Pleiades, while the temple's southeast window aligns to the rising stars in the tail of Scorpio, known as *Collca* (the Storehouse) to the native people. Gary Urton (whose work on the sacred astronomy of the Andean people has been described on p.162) noted that the Pleiades constellation is referred to by the same name, so there may be some association indicated by these two window directions.

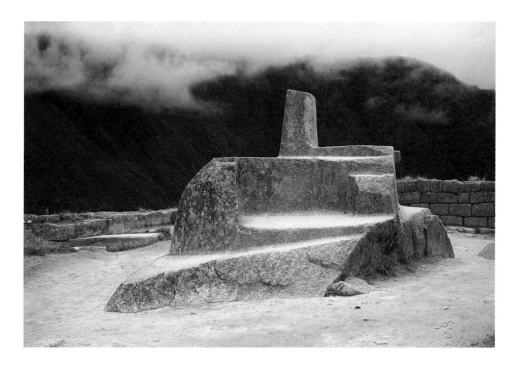

The "hitching post of the Sun", or intihuana. *Inca priests would symbolically tie the Sun to the pillar with a mystical cord to prevent it from disappearing.*

MEDIEVAL EUROPEAN SITES

The practice of aligning temples to heavenly bodies is found not only in prehistoric and pagan times, or in Eastern cultures: it also survived into medieval Christian Europe. This is partly an effect of the early Church's policy of Christianizing pagan traditions, but even today churches and graves tend to be aligned east-west, with church altars at the east, toward the rising Sun (the direction from which, according to Christian cosmology, the Second Coming will occur).

Often, medieval churches were supposedly aligned, however, to the point of sunrise on the day of the saint to whom they were dedicated, rather than to the east. A survey of almost 300 English churches by the Reverend Hugh Benson in the 1950s revealed that a significant proportion were indeed aligned to sunrise on their patron saint's day. He also found that the very ancient St Piran's church in Cornwall was aligned to a prehistoric earthwork over two miles away – the point where the Sun would have risen on August 15 in the 7th century.

It also seems that in early Europe astronomy was used in a more complex way, although very little documentary evidence has survived. Chartres in France is one place that contains clear indications of medieval sacred astronomy. The epitome of Gothic cathedrals, this magnificent building was constructed on the site of the chief Druidic centre of the Celtic

Emperor Charlemagne's throne in the octagonal chapel of Aachen Cathedral, Germany – a marble artefact of the 8th century AD. On midsummer's day, a sunbeam would have penetrated the chapel to spotlight the emperor's face or crown.

Carnutes, where the Romans subsequently erected a shrine. Some scholars argue that the sanctity of the site even predated the Iron Age Celts, being marked by a Neolithic mound covering a stone chamber or dolmen. The cathedral's foundation may also have associations with the return of the Knights Templar from their Crusade to the Holy Land. The Templars, a military religious order established in 1118, had based themselves at the Temple of Solomon in Jerusalem, where it is believed that they were looking for the lost Ark of the Covenant. Reliefs carved on the exterior of Chartres Cathedral depict enigmatic scenes relating to the Ark.

Another mysterious feature of Chartres is the fact that at noon on the summer solstice, when the Sun is at its highest, a ray of sunlight shafts through a small area of clear glass in the window dedicated to St Apollinaire on the western side of the south transept. This shaft falls on a flagstone which differs from those around it, being larger, differently coloured, set at an angle, and, most significantly, incorporating a small, round metal disk. The solstitial sunbeam falls on this metal marker.

It is hard to accept the view of some scholars that this is all coincidence. This denial may be seen in the light of concerted attempts to dissociate Chartres from numerous pre-Christian elements which other researchers believe to have been built into the cathedral's remarkable fabric by the master masons.

Another great cathedral that may have special astronomical interest is that of Aachen, in Germany, close to the borders with France and Holland. The presence of hot springs on the site, believed to have healing properties, gave the place an importance that goes back at least to the Celts, Germanic peoples and Romans. In the 8th century AD, Charlemagne decided to build his imperial palace there, creating a "second Rome". A Christian who suppressed paganism in his territories, Charlemagne brought to his court scholars and artists from all over Europe, and aimed to revive the arts and sciences of antiquity. His octagonal palace chapel, sited over the Roman baths, lies at the core of the present cathedral. In the late 1970s the German photographer Hermann Weisweiler, while waiting for the best light for a photograph, witnessed a ray of sunlight suddenly flash through an upper window of the octagonal chapel at exactly 90°. Impressed by this event, Weisweiler carried out further research which revealed the cathedral chapel to be a veritable sundial. At noon on June 21, the summer solstice, a ray of light fell directly onto the golden ball hanging from the chapel's domed ceiling, where the "Barbarossa chandelier" depicts the heavenly Jerusalem. On the same day, a ray

would also have illumined the face (or crown) of Charlemagne as he sat on his throne, which was used for coronations throughout the Middle Ages. At midwinter noon the Sun shines on a mosaic depicting Christ between the Alpha and Omega symbols, representing the Beginning and the End. When Charlemagne stood up from his throne, he alone would have been able to see the equinoctial sunrise beaming horizontally through an upper window. And, for good measure, a sunbeam shines on the throne on April 16 – Emperor Charlemagne's birthday.

The cathedral of St Lizier, France, studied by three French researchers in 1981, has a central axis aligned to the equinoxes, and this line extends east and west to two other churches. Two crosses situated over a mile (1.6km) away on either side of the cathedral mark the midsummer sunrise alignment through this site, while the midwinter sunrise alignment runs through the cathedral from the holy hill of Mount Redon in the northwest to the chapel at Marsun in the southeast.

At Elm, in the Swiss canton of Glarus, a natural rock tunnel 60 feet (20m) in diameter, known as St Martin's Hole, pierces through the Tschingelhorner mountain which towers over the village to the southeast. According to the legend this tunnel was created when the saint hurled his iron-tipped staff at a giant. Each year close to the equinoxes, the morning Sun shines through this hole and for two minutes illuminates the tower of Elm church with a ray of sunlight just over 3 miles (5km) in length. This event obviously predates the Christian era, but it is significant in terms of medieval sacred astronomy that the builders chose that spot for their church. In support of this interpretation is that fact that there are four more such holes in the Alps through which sunlight strikes a church.

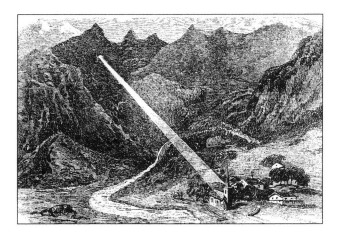

A print showing an equinoctial morning sunbeam piercing a nearby mountain to fall on Elm church, Switzerland.

GLOSSARY

*Words in **bold italic** type have their own entries in this glossary.*

Anima Mundi The World-Soul: the spiritual essence apportioned by the Demiurge in the creation of the Celestial Sphere (see p.31).

archeoastronomy The scientific study of archeological sites with respect to astral and planetary alignments.

ascendant The first *mundane house*, centred around the point on the eastern horizon where the *zodiac* rises.

asteroid belt An area of planetary debris within the solar system lying mostly between the planets Mars and Jupiter.

axis of rotation An imaginary line through a planet, from its north to south poles: the axis around which the planet rotates.

backsight A viewing position for an astronomical alignment. To establish an alignment with a celestial event (such as midsummer sunrise), a *foresight* (for example, a point on the horizon) is also needed. A line extended from the backsight through the foresight aligns to the celestial event.

binary A double star, made up of two associated stars orbiting around a mutual centre of gravity.

cardinal directions The compass points: north, south, east and west.

celestial equator The projection of the Earth's equator onto the *Celestial Sphere*.

celestial meridian From any particular point on Earth, a line on the *Celestial Sphere* passing overhead and joining the North and South Celestial Poles.

Celestial Pole The North or South Pole on the *Celestial Sphere*.

Celestial Sphere An imaginary transparent globe encircling the Earth, used by astronomers for locating the positions of heavenly bodies.

circumpolar Literally, moving "around the pole". The term is used of stars that, from a particular *latitude* on the Earth, are seen to revolve around the *Celestial Pole*, never dipping below the horizon.

conjunction The alignment of a *superior planet* with the Sun and Earth, when the planet is on the opposite side of the Sun from the Earth.

cosmogony A description of the genesis of the cosmos.

cosmology The science of the universe as a systematic whole.

cross-quarter days The four days at the midpoints between the *equinoxes* and the *solstices:* February 1 (Imbolc in the Celtic calendar), May 1 (Beltane), August 1 (Lughnasa/Lammas) and November 1 (Samhain).

culmination The highest point in the sky reached by a heavenly body as its crosses the meridian: that is, where its angle to the horizon is at its greatest. (Strictly, this is termed the *upper* culmination.)

declination The angle from 0° to 90° at which a heavenly body appears to stand above or below the *celestial equator*, corresponding to latitude on the Earth. Together with *right ascendant*, declination is a coordinate for locating the position of a star.

descendant The seventh astrological *mundane house*, at the point on the western horizon where the *zodiac* sets.

Earthlight Sunlight reflected back onto the dark patches of the crescent Moon from the Earth's clouds and oceans.

ecliptic The imaginary plane centred on the Sun and passing through the Earth's orbit. The planets of the solar system lie on this plane.

elliptical orbit An orbit shaped like an ellipse: the Moon and Halley's comet provide examples.

elongation The angular distance between the Sun on the one hand and a planet or the Moon on the other.

equinoctial colure A circle on the Celestial Sphere running through the Celestial Poles and passing through the spring (vernal) and autumn *equinox* points.

equinoxes The two points in the year (March 21 and September 23) when the Sun crosses the *celestial equator*: at these times, day and night in the Northern and Southern hemispheres are of equal length. The spring (vernal) equinox occurs midway between the winter and summer *solstices*; the autumnal equinox occurs midway between the summer and winter solstices.

First Point of Aries The point on the *ecliptic* where it crosses the *celestial equator,* marking the beginning of the zodiacal sign Aries. The Sun reaches this point at the spring (vernal) *equinox.*

Five Agents The five elements of Chinese astrology: Wood, Fire, Metal, Earth and Water.

foresight A marker for an astronomical alignment. It may be a feature of the landscape situated on the horizon, or an architectural feature such as a pyramid or tower. See also *backsight*.

geocentric The term used to describe a system of

planetary motion centred around the Earth. This system, set out in detail by Claudius Ptolemy in the 2nd century AD, was superseded by the Copernican Sun-centred system.

geodesy A scientific method of measuring vast distances, allowing for the Earth's curvature.

glyph A symbol found on stone reliefs or in ancient manuscripts, used to denote a sign of the *zodiac* or a planet. The term has become widely used to describe the sigils (see p.5) derived from the ancient glyphs.

gnomon A shadow-throwing device, such as that found on a sundial.

Harmony of the Spheres A Platonic system relating the planetary orbits and the planets' interactions with each other to the notes of the musical octave.

heliacal rising The first appearance of a planet or star after it has been invisible for part of the year owing to its *conjunction* with the Sun.

Hermetic arts Occult arts deriving from the magical, astrological and alchemical practices of the mythical Hermes Trismegistos (see p.63).

hsiu In Chinese astrology, one of 28 lunar mansions established along the equator.

individuation A term borrowed from alchemy, used by the psychologist Carl Jung to describe the achievement of psychic wholeness.

inferior conjunction A direct alignment of an *inferior planet* with the Earth and the Sun, when the planet lies between the two.

inferior planets Mercury and Venus: the planets that lie closer to the Sun than the Earth does.

intercalation The periodic insertion of an additional unit of time into the calendar to keep it in line with celestial cycles. For example, the insertion of an extra day each fourth (leap) year compensates for the fact that the solar year is 365¼ days, not 365 days.

intercardinal Term applied to those points of the compass midway between the four *cardinal directions*: that is, northeast, southeast, southwest and northwest.

Lammas/Lughnasa The Celtic festival held on August 1 to celebrate the harvest period. See *cross-quarter days*.

latitude The angular distance of a specific point on the Earth's surface from the Earth's equator.

line of nodes An imaginary line through the plane of the *ecliptic* joining the two lunar *nodes*.

macrocosm The universe or cosmos as a whole, as distinct from the *microcosm*.

magnitude (stellar) The brightness of a star, originally ranked according to a numerical system of 1 (very bright) to 6 (only just visible by the naked eye). Negative numbers are now used for those stars that are exceptionally bright. Astronomers observe a distinction between real and apparent magnitude; in this book, and in common usage, "magnitude" describes the latter.

major lunar standstill The time in the Moon's 18.6-year (Metonic) cycle when its rising point on the eastern horizon is at the farthest distance from its setting point.

megalith A huge upright stone positioned in prehistoric times, often as part of a stone circle.

meridian A north-south line, running between

the North and South Celestial Poles and passing through the *zenith*.

meridional In a north-south direction.

microcosm A working system that obeys the laws of, or participates in the nature of, the *macrocosm*. One example is the Zodiacal Man (see p.38), a model of the universe as a whole.

midheaven The tenth astrological *mundane house* of the *zodiac*, sited due south on the horizon.

minor lunar standstill The time in its 18.6-year (Metonic) cycle when the rising and setting points of the Moon on the horizon occur at their closest distance. See also *major lunar standstill*.

mundane houses The twelve 30° sections of the sky used by astrologers as coordinates to describe the positions of a planets in the sky at a particular location and time.

mythopoeic A term applied to the most profound part of the creative imagination used in myth-making.

nadir The point on the *Celestial Sphere* that lies directly beneath the observer – that is, on the opposite side of the Earth.

New Age The age of Aquarius, said to be due to dawn in the year AD2813, when the First Point of Aries will passes into the constellation of Aquarius as a result of *precession* of the equinoxes.

New Moon The first of the lunar phases when the Moon lies between the Earth and the Sun, and is therefore invisible.

nodes The two points on the Moon's orbit where it crosses the *ecliptic*.

opposition The direct alignment of a *superior*

planet with the Earth and Sun, when the Earth lies between the planet and the Sun.

penumbra At a total solar eclipse, a ring of paler shadow surrounding the central region where the Sun is blocked completely by the Moon.

petroglyph A rock carving or incision, usually prehistoric.

Polaris The Northern *Pole Star*, in Ursa Minor, which in the current era lies close to the North Celestial Pole.

Pole Star A star lying on or close to the Celestial Pole (North or South), traditionally serving as an aid for navigation.

precession The wobble of the Earth's axis, in a movement akin to that of a gyroscope, forming a complete cycle over a period of 25,828 years. Strictly speaking, this is precession of the *equinoxes* (see pp.22-3); the precession of the *nodes* is the wobble of the Moon's elliptical orbit (see pp.11-19).

Ptolemaic A term applied to the teachings of Claudius Ptolemy, a Greek thinker of the 2nd century AD. In particular it describes a geocentric (Earth-centred) system of the universe, prior to the acceptance of a Sun-centred (heliocentric) system.

Right Ascension (RA) The time measured in hours, minutes and seconds (up to 24 hours) between the moment when the *First Point of Aries* crosses the *meridian* and the moment when a particular heavenly body crosses the same point on the meridian. Together with *declination*, this is one of the coordinates for describing the location of a star.

Royal Stars Four stars marking the four equinoctial and solsticial junctions on the Sun's path in Persia 5,000 years ago. They were Aldebaran (Alpha Tauri: vernal equinox), Antares (Alpha Scorpio: autumn equinox), Regulus (Alpha Leonis: summer solstice) and Fomalhaut (Alpha Aquarius: winter solstice).

sarsen stone A large stone of silicified sandstone, used in megalithic monuments (eg Stonehenge).

satellite A heavenly body, usually a moon, that orbits another heavenly body.

sexagenary A term applied to a system of calendrical counting on a base number of sixty.

solstices The longest and shortest days of the year, when the Sun is highest and lowest in the sky respectively, and appears to "stand still". In the Northern hemisphere the summer solstice occurs on June 21, and the winter solstice on December 21. The dates are reversed for the Southern hemisphere.

Sothic calender The Egyptian calender, based on the *heliacal rising* of the star Sirius, used to predict the Nile floods in ancient Egypt.

standstill, lunar See *major lunar standstill* and *minor lunar standstill.*

Station Stones Four stones, numbered 91 to 94, at Stonehenge, forming the corners of an approximate rectangle, the side of which align to key astronomical events (see pp.116–19).

superior conjunction A direct alignment of an *inferior planet* with the Earth and the Sun, when the planet lies on the opposite side of the Earth from the Sun.

superior planet A planet whose orbit around the Sun is greater in diameter than the Earth's.

synchronicity A non-causal connecting principle, mysteriously linking seemingly unrelated events. The term was used by the psychologist Carl Jung.

transit The period when a heavenly body crosses the *meridian* of the observer; or when an *inferior planet* appears to cross the disk of the Sun.

trilithon A pair of freestanding stone uprights with a lintel stone laid across their tops.

Tropic of Cancer The imaginary line around the Earth's surface +23.5° above the equator. The Sun is overhead at this point at noon at the Northern summer solstice.

Tropic of Capricorn The imaginary line around the Earth's surface -23.5° below the equator. The Sun is overhead at this point at noon at the Southern summer solstice.

True North The direction in which the Earth's rotational axis points, in the Northern hemisphere.

zenith The point on the *Celestial Sphere* directly above an observer standing at a particular point on the Earth.

zodiac An imaginary band across the heavens, through the centre of which the *ecliptic* passes. The band is divided into twelve equal parts of 30° each – the twelve signs of the zodiac. For the glyphs (sigils) of each sign, see p.9.

zodiacal constellations The twelve constellations that relate historically to the twelve signs of the *zodiac.*

BIBLIOGRAPHY

Aratus 'Phaenomena', *Callimachus, Lycrophon and Aratus* (translated by Mair, A.W. & Mair G.W.), Loeb Classics 129, Cambridge, Massachusetts: Harvard University Press and London: Heinemann (1989)

Atkinson, R.J.C. *Stonehenge*, London: Pelican (1979)

Aveni, A.F. *Skywatchers of Ancient Mexico*, Austin, Texas: University of Texas Press (1980)

Aveni, A.F. (ed.) *World Archeoastronomy*, Cambridge, England and New York: Cambridge University Press (1989)

Bischof, Marco 'Alpine Lightshows', *The Ley Hunter*, No. 113 (1990)

Brennan, Martin *The Stars and the Stones*, London: Thames and Hudson (1983)

Bumbacher, Stephan Peter 'The Astronomical Significance of Early Japanese Architectural Structures', *Shadow* (1993)

Burl, A. *Megalithic Brittany*, London: Thames and Hudson (1985)

Burl, A. *The Stone Circles of the British Isles*, New Haven, Connecticut and London: Yale University Press (1976)

Carlson, John B. 'Romancing the Stone, or Moonshine on the Sun Dagger', *Astronomy and Ceremony in the Prehistoric Southwest*, Carlson J.B. & Judge, W.J. (eds.), Maxwell Museum of Anthropology (1987)

Dante (Dante Alighieri) *Divine Comedy*, London: Penguin

de Santillana, Giorgio & von Dechend, Hertha *Hamlet's Mill: Myth and the Fame of Time*, Boston: Gambit (1969)

Devereux, Paul *Secrets of Ancient and Sacred Places: The World's Mysterious Heritage*, London: Blandford Press (1993)

Devereux, Paul *Symbolic Landscapes* Gothic Image (1992)

Friedel, David & Schele, Linda & Parker, Joy & Morrow, William *Maya Cosmos – 3,000 Years on the Shaman's Path*, New York (1993)

Gauquelin, Michael *Neo-Astronomy – A Copernican Revolution*, London: Penguin/Arkana (1991)

Gettings, Fred *The Arkana Dictionary of Astrology*, London: Penguin/Arkana (1990)

Graves, Robert *The Greek Myths* (vols 1 & 2), London and New York: Penguin (revised 1960)

Graves, Robert *The White Goddess*, London: Faber and Faber (1961)

Hadingham, E. *Lines to the Mountain Gods, Nazca and the Mysteries of Peru*, London: Harrap and New York: Random House (1987)

Hagen, Victor W. von *Highway of the Sun*, Duell, Sloan & Pearce (1955)

Hartung, Horst 'The Secrets of Charlemagne', review of Hermann Weisweiler's *Das Geheimnis Karls des Grossen Astronomie in Stein: Der Aachner Dom*, Bertelsmann Verlag (1981), *Archeoastronomy*, VIII:1–4 (1984)

Hawkins, Gerald with White, John B. *Stonehenge Decoded* (1973)

Hawkins, Gerald *Beyond Stonehenge*, London: Hutchinson (1973)

Hinckley, Richard & Dover, Allen *Star Names – Their Lore and Meaning* (1963)

Hughes, David *The Star of Bethlehem Mystery*, London: Dent (1979)

Jung, Carl J. *Synchronicity: An Acausal Connecting Principle* (translated by Hull, R.F.C.), Princeton: Bollington

Kaler, James B. *Astronomy!*, New York: Harper Collins College Publishers (1994)

Kenton, Warren *Astrology: the Celestial Mirror*, London: Thames and Hudson (1989)

Krupp, E.C. *Echoes of the Ancient Skies*, New York: Harper and Row (1983)

Krupp, E.C. *In Search of Ancient Astronomies*, Doubleday (1978)

Krupp, E.C. 'The Serpent Descending', *Griffith Observer* (September 1982)

MacKie, Euan *Science and Society in Prehistoric Britain*, Elek (1977)

Manilius *Astronomica* (translated by Goold, G.P.), Loeb Classics 489: Cambridge, Massachusetts: Harvard University Press and London: Heinemann (1977)

Malville, John McKim 'Astronomy at Vijayanagara: Sacred Geography Confronts the Cosmos', *The Spirit and Power of Place*, National Geographic Society of India (1993)

Malville, John McKim 'Mapping the Sacred Geography of Vijayanagara', *Mapping Invisible*

Worlds, Edinburgh: Edinburgh University Press (1993)

McMann, Jean *Loughcrew – The Cairns*, After Hours Books (1993)

Michell, John *A Little History of Astro-Archeology*, London: Thames and Hudson (1989)

Millon, René 'The Place Where Time Began', *Teotihuacán*, Berrin, K. & Pasztory, E. (eds.), London: Thames and Hudson (1993)

North, John *The Fontana History of Astronomy and Cosmology*, London: Fontana Press (1994)

O'Brien, Tim *Light Years Ago*, Black Cat Press (1992)

Oppelt, Norman T. *Guide to Prehistoric Ruins of the Southwest*, Pruett (1989)

Pennick, Nigel & Devereux, Paul *Lines on the Landscape*, Robert Hale (1989)

Ponting, Gerald & Ponting, Margaret *New Light on the Stones of Callanish*, private (1984)

Ptolemy, Claudius *Tetrabiblos* (translated by Robbins, F.E.), London: Heinemann and Cambridge, Massachusetts: Harvard University Press (1980)

Reese, Ronald Lane 'Midwinter Sunrise at El Karnak', *Sky and Telescope* (March 1992)

Schafer, Edward H. *Pacing the Void – T'ang Approaches to the Stars*, California University Press (1977)

Sofaer, Anna & Zinser, Volker & Sinclair, Rolf M. 'A Unique Solar Marking Construct', *Science*, 206:4416 (19 October 1979)

Spence, Lewis *The Gods of Mexico*, London: T. Fisher Unwin Ltd. (1923)

Staal, Julius *Patterns in the Sky*, London: Hodder and Stoughton (1961)

Temple, Robert K.G. *The Sirius Mystery*, London: Destiny (1995)

Thom, A. *Megalithic Sites in Britain*, Oxford, England: Oxford University Press (1967)

Urton, Gary *At the Crossroads of the Earth and the Sky: An Andean Cosmology*, Austin, Texas: University of Texas Press (1981)

Wilhelm, Richard (translator) *I Ching or The Book of Changes*, London: Penguin/Arkana (1983)

Williamson, Ray A. *Living the Sky*, Norman, OK: University of Oklahoma Press (1984)

Wood, John Edwin *Sun, Moon and Standing Stones* Oxford, England: Oxford University Press (1980)

INDEX

PICTURE CREDITS & ACKNOWLEDGMENTS

p.9: Images/Charles Walker Collection; p.10: Bridgeman Art Library/Bonhams: p.11 Bridgeman Art Library/British Library; p.26 Images/Charles Walker Collection; p.27: The Pierpont Morgan Library/Art Resource NY; p.28 Michael Holford; p.29: from Gods of the Egyptians (vol.1) by E. Wallis Budge, courtesy of the Trustees of the British Museum; p.30-1: Images/Charles Walker Collection; p.32: Bridgeman Art Library/St John's College Library, Oxford; p.33: from The Tables, an accompanying volume to Dante's Divine Comedy, 1872; p.34: Michael Holford; p.36: (top) e t archive/Bodleian Library, Oxford; p.36: (bottom) Scala; p.37: Images/Charles Walker Collection; p.38: e t archive/Trinity College, Cambridge; p.39: e t archive/Sta Cruz Museo, Toledo; p.40: Duncan Baird Publishers; p.41: British Museum, London; p.42: Images/Charles Walker Collection; p.43: (top) Images/Charles Walker Collection; p.43 (bottom) courtesy of the Maître de Chapelle de la Cathédrale de Saint-Lazare, Autun; p.44: Israel Antiquities Authority, Jerusalem; p.45: Bridgeman Art Library/Bibliothèque Nationale, Paris; p. 46 (background) Bridgeman Art Library/Fitzwilliam Museum, Cambridge; p.46 (foreground) e t archive/Victoria and Albert Museum, London; p.47: Bridgeman Art Library/British Library, London; p.48-9 Images/Charles Walker Collection; p.50 Images/Charles Walker Collection; p.51: Ms. Stein 3326, Department of Oriental Manuscripts, British Library, London; p.52: Images/Charles Walker Collection; p.53: e t archive/Bibliothèque Nationale, Paris; p.54: (background) American Museum of Natural History, New York; p.54: (foreground) e t archive/Biblioteca Marciana, Venice; p.55: Collection Bibliothèque Municipale de Dijon; p.56: e t archive/Historika Museet, Stockholm; p.57: (left) British Museum; p57: (right) e t archive, Egyptian Museum, Cairo; p.58-9: Images/Charles Walker Collection; p.60: Images/Charles Walker Collection; p.61: (left) André Held; p.61: (right) Bildarchiv Preussischer Kulturbesitz; p.62: Images/Charles Walker Collection; p.63: Bridgeman Art Library/National Museum, Stockholm; p.64: Werner Foreman Archive/Liverpool Museum; p.65: Scala/Museo del Terme, Rome; p.66: Images/Charles Walker Collection; p.67: e t archive/Museo Arquelogico Napoli; p.68: Master

and Fellows of Trinity College, Cambridge; p.69: British Museum; p.70: Images/Charles Walker Collection; p.71: Royal Library, Copenhagen; p.72: British Museum; p.73: Scala/Museo Nazionale Reggio di Calabria, Italy; p.74-5: Images/Charles Walker Collection; p.77: Images/Charles Walker Collection; p.79: Images/Charles Walker Collection; p.80: Bridgeman Art Library/Bibliothèque Nationale, Paris; p.83: Images/Charles Walker Collection; p.84: Images/Charles Walker Collection; p.86: The Pierpont Morgan Library/Art Resource, NY; p.87: Image Select; p.89: Ms Marsh 144, Bodleian Library, Oxford; p.90: Ms Marsh 144, Bodleian Library, Oxford; p.93: (top) e t archive; p.93: (bottom) Images/Charles Walker Collection; p.94: Klášter Premonstrátu na Strahove/ Michel Krob; p.95: Bridgeman Art Library/Lauros-Giraudon; p.97: e t archive/Glasgow University Library; p.99: Bridgeman Art Library/Bibliothèque Nationale, Paris; p.101: Images/Charles Walker Collection; p.104: e t archive/British Library; p.107: (top) Ms Harley 647 f.4v, British Museum, London; p.107: (bottom) Museum of London; p.109: Images/Charles Walker Collection; p.110: Mary Evans Picture Library; p.111: (left) Mary Evans Picture Library; p.111: (right) Images/Charles Walker Collection; p.113: Images/Horizon; p.115: Images/Glover; p.116: Images; p.121: Images/Charles Walker Collection; p.122: Images/Charles Walker Collection; p.126: Images/Glover; p.127: (top) Mick Sharp; p.127: (bottom) Charles Tait; p.128: Margaret Curtis; p.131: Images/Charles Walker Collection; p.135: Robert Harding Picture Library/Watts; p.139: Images/Charles Walker Collection; p.140: Mary Evans Picture Library; p.141: Archaeological Institute of Kashihara, Japan; p.142: John Collings: p.144: Paul Devereux; p.146: Paul Devereux; p.148: Images/Charles Walker Collection; p.151: Art Resource/Biblioteca Laurenziana, Florence; p.152: Images/Charles Walker Collection; p.155: Robert Harding Picture Library; p.156: Images; p.160: Robert Harding Picture Library/Rennie; p.162: Images/Horizon/Walter; p.163: Zefa; p.164: Archiv fur Kunst und Geschichte/Erich Lessing.

The Authors and Publishers would like to acknowledge the following experts and researchers whose theories or research, particularly on archeoastronomical sites, have been drawn upon for this book:

Eugene Antoniadi, Anthony F. Aveni, Prof. Alexander Badawy, Robert Bauval, Rev. Hugh Benson, Hiram Bingham, Charles Boyle, Martin Brennan, Stephan Peter Bumbacher, John B. Carlson, G. Charrière, Frank Hamilton Cushing, Michael Dames, David Dearborn, James Frazer, John M. Fritz, Leo Frobenius, Michel Gauquelin, Fred Gettings, John Glover, Gerald Hawkins, William Herschel, Fred Hoyle, David Hughes, Lucien Lévy-Bruhl, C.A. Newham, Sir Norman Lockyer, John McKim Malville, Terence Meaden, John Michell, Tim O'Brien, Michael J. O'Kelly, Gerald and Margaret Ponting, Richard Procter, Tom Ray, Ronald Lane Reese, F.S. Richards, Oliver Ricketson, Giorgio de Santillana, Anna Sofaer, Magnus Spence, Julius Stahl, William Stukeley, Wilhelm Teudt, Prof. Alexander and Archibald Thom, Dr. Virginia Trimble, Gary Urton, Herthes von Dechend, P. Wakefield, Hermann Weisweiler, John B. White, David Wilcox, Ray Williamson, Warren Wittry.